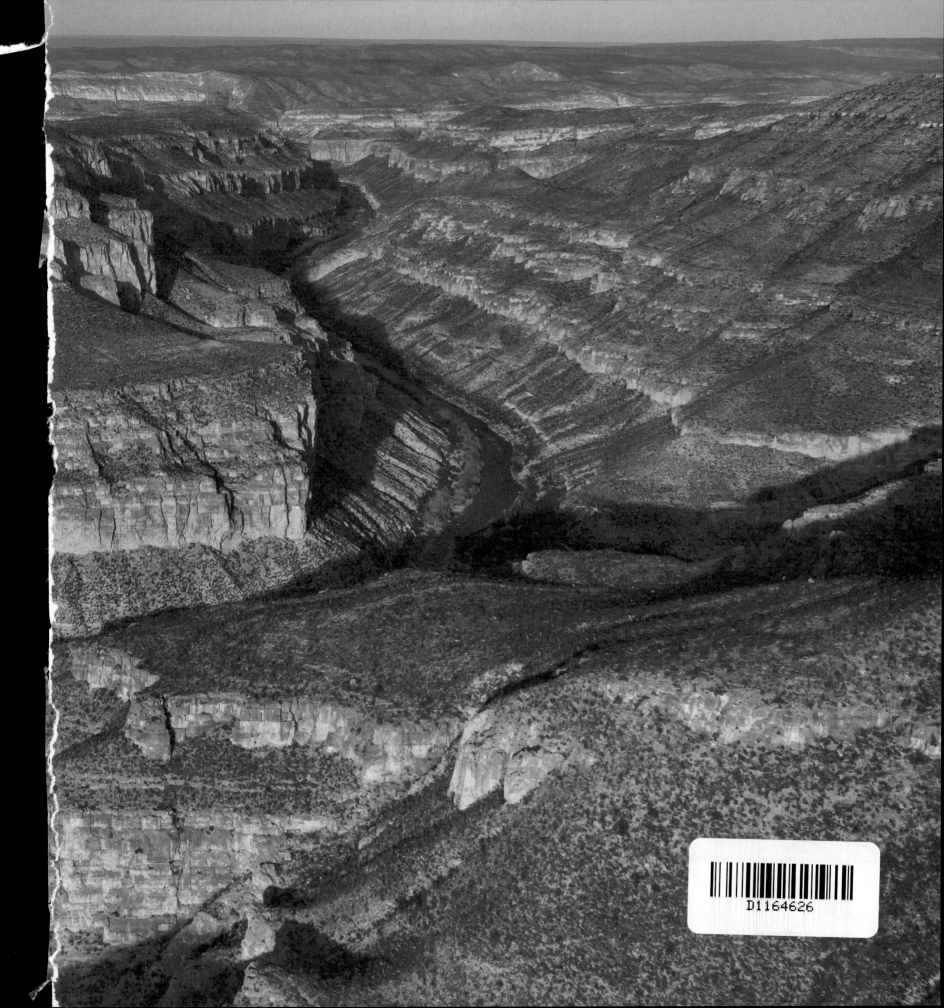

THE RIVER AND THE WALL

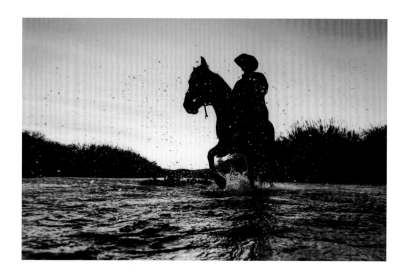

RIVER BOOKS, sponsored by

THE MEADOWS CENTER
FOR WATER AND THE ENVIRONMENT
TEXAS STATE UNIVERSITY

Andrew Sansom, General Editor

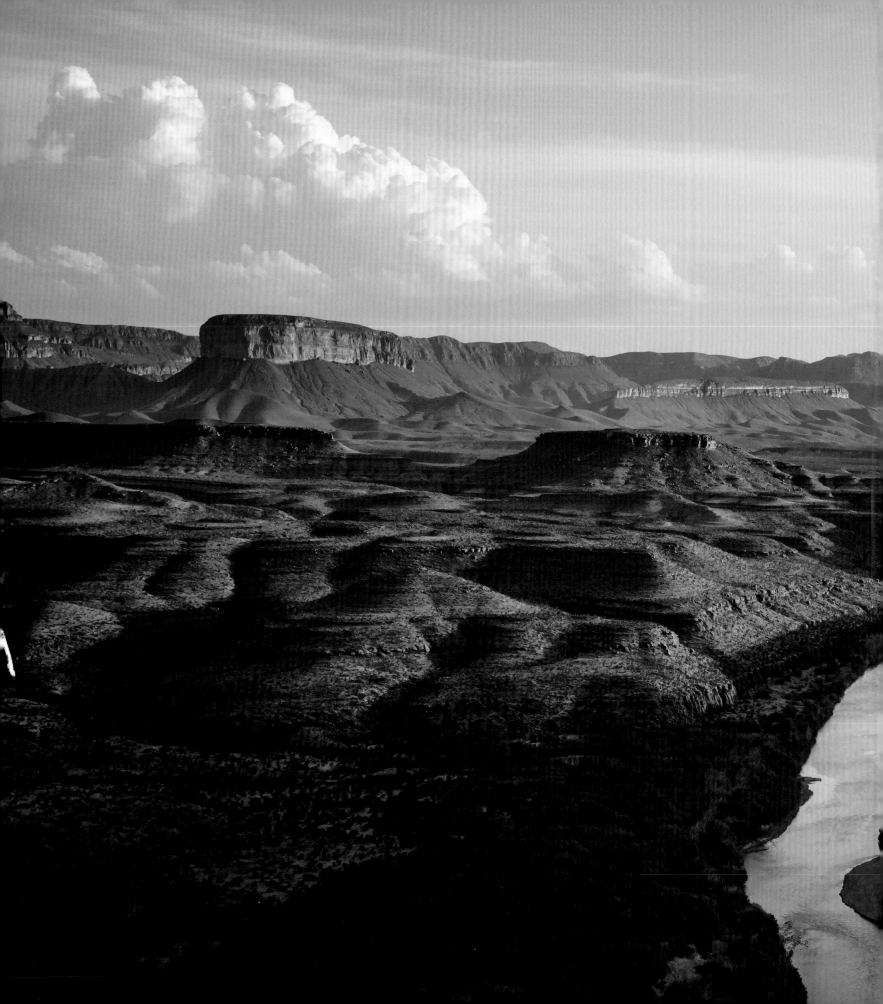

THE RIVER
AND
THE WALL

BEN MASTERS

with Austin Alvarado, Filipe DeAndrade,
Jay Kleberg & Heather Mackey

and Geny Alvarado, Katy Baldock, Becky Jones,
Korey Kaczmarek, Colin McDonald & Hillary Pierce

FOREWORD BY ANDREW SANSOM

Texas A&M University Press College Station

This paper meets the requirements
of ANSI/NISO Z39.48–1992 (Permanence of Paper).
Binding materials have been chosen for durability.
Manufactured in China through FCI Print Group

Library of Congress Cataloging-in-Publication Data

Names: Masters, Ben, 1988– author.
Title: The river and the wall / Ben Masters.
Other titles: River books (Series)
Description: First edition. | College Station: Texas A&M University Press,
 [2019] | Series: River books
Identifiers: LCCN 2018054369 (print) | LCCN 2018052864 (ebook) | ISBN
 9781623497804 (cloth: alk. paper) | ISBN 9781623497811 (ebook)
Subjects: LCSH: Rio Grande (Colo.-Mexico and Tex.)—Description and travel. |
 Lower Rio Grande Valley (Tex.)—Description and travel. | Border
 security—Environmental aspects—Texas—Lower Rio Grande Valley. | Natural
 history—Texas—Lower Rio Grande Valley.
Classification: LCC F392.R5 M379 2019 (ebook) | LCC F392.R5 (print) | DDC
 917.64/404—dc23
LC record available at https://lccn.loc.gov/2018054369

Photography by
Collin Baggett
Katy Baldock
Phillip Baribeau
McKenzie Barney
Filipe DeAndrade
Korey Kaczmarek
Ben Masters
Hillary Pierce
Charles Post
Erich Schlegel
Brandon Widener

Maps by Jacob White and Josh Cross

TO THE RIO GRANDE,
MAY YOU ALWAYS FLOW
TO THE GULF OF MEXICO.

CONTENTS

The Rio Grande Valley: Laredo to the Gulf

The River's End

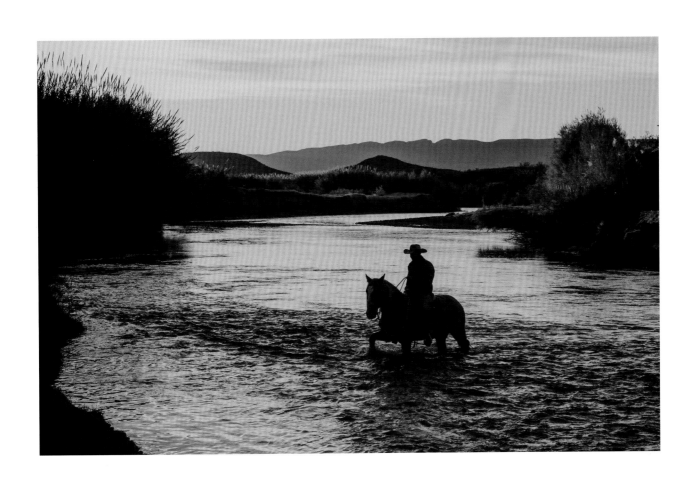

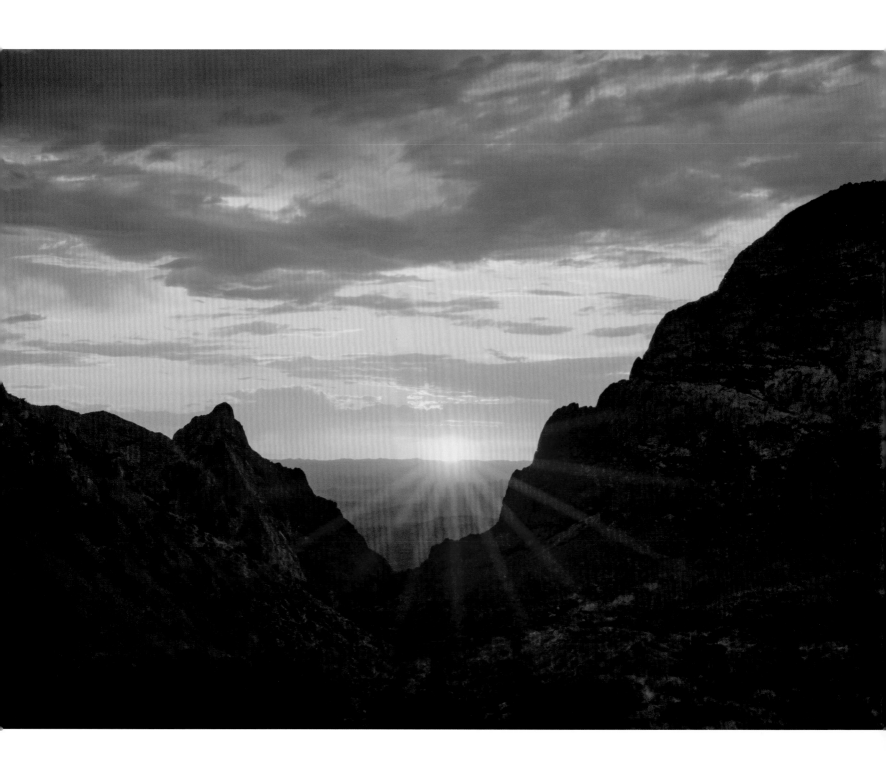

FOREWORD

I was working as a junior aide in the Department of the Interior in Washington, DC, many years ago, when the newly elected Texas Land Commissioner, Bob Armstrong, walked into my office. Armstrong had begun efforts to purchase a huge ranch located along the Rio Grande upstream from Big Bend National Park to create a new state park. One of the many things I remember about that first meeting, and the start of what became a lifelong friendship, was that though the ranch included forty-six miles of Rio Grande frontage, two of the three highest waterfalls in Texas, and an entire extinct volcanic caldera, all Bob could talk about was the stars. His enthusiasm reminded me at the time of a wonderful quote I had read somewhere by Vincent Van Gogh, creator of the famous painting *Starry Night*: "For my part I know nothing with any certainty, but the sight of the stars makes me dream."

In the years that followed, despite Bob's valiant and persistent efforts, the Texas Legislature refused to approve his recommendation to purchase the Big Bend Ranch as a state park. A decade later, in the early 1980s, I returned to Texas and went to work for The Nature Conservancy. By this time, Bob had become a member of the board and had by no means given up on the idea of acquiring the ranch, owned at the time by Robert O. Anderson of New Mexico, the founder of the oil company Atlantic Richfield. At Armstrong's urging, I took over negotiations with the Anderson family and visited the ranch for the first time. My initial experience in Big Bend country both stunned and enthralled me,

and I became a devoted fanatic of the region for life.

Although even our now-combined efforts to protect Big Bend Ranch continued to be unsuccessful, I did have the privilege of working with brothers Houston and Ed Harte to add their seventy thousand-acre ranch in the Rosillos Mountains to Big Bend National Park. I also purchased an additional ten thousand acres, which closed an unprotected gap between the national park and the Black Gap Wildlife Management Area downriver. This region is one of the most biologically diverse in the hemisphere, and two parts of it have been designated as international biosphere reserves by the United Nations Educational, Scientific and Cultural Organization (UNESCO).

Among my most treasured memories of the Big Bend region are float trips down the Rio Grande with former Texas governor Ann Richards, who, I think, loved the river even more than I do, if such a thing were possible. Forming the international border between Texas and Mexico, the Rio Grande flows more than 1,200 miles from El Paso to the Gulf of Mexico. Its lower reaches on the Texas side form the Lower Rio Grande Valley, which is also one of the most biologically important zones in the Americas. In fact, the amazing avian diversity found in what we Texans call "the Valley" has resulted in the area becoming in recent years quite possibly the top destination for bird-watchers in the world.

Years later, when I was executive director of the Texas Parks and Wildlife Department, TPWD established the World Birding Center

in an effort to both promote ecotourism in the Valley and protect its rich natural resources. This was one of the best ideas to emerge from the department during those years. I wish I could say the idea was mine because I am so proud of having been a part of it.

The headquarters of the World Birding Center is located in Bentsen-Rio Grande Valley State Park. As explained by the talented Ben Masters and his colleagues in *The River and the Wall*—the latest volume in River Books, a series published through a unique partnership of The Meadows Center for Water and the Environment at Texas State University and Texas A&M University Press—a border wall would destroy the park, making it virtually unusable. A wall would rip apart the park, leaving it so fragmented that it would be virtually unusable. Creating a barrier would impact some of the rarest species of wildlife in the world and disrupt the natural wonders of the region.

A milestone was finally reached when Bob Armstrong was appointed to the Texas Parks and Wildlife Commission, and I resumed negotiations for the purchase of Big Bend Ranch. We were finally able to close the deal and acquire more than 300,000 acres of what is now the largest state park in Texas and the third largest state park in the United States.

Thus, the protection of these and other precious natural resources along the great river that forms the Texas-Mexico border has been hard won, and my fervent hope is that this new book and the accompanying documentary will help call attention to the fact that the proposed border wall threatens to destroy these habitats forever.

Before Bob Armstrong passed away, we gathered once again at Big Bend Ranch State Park to commemorate the twentieth anniversary of the acquisition. In view of the significance of the event in my own life, I arranged for my family to join us at the park. My grandson, Alex, age five at the time, lived with his parents in New Jersey. When he returned home after the celebration, his kindergarten teacher instructed the class to select an animal that migrates and tell where it would migrate and why.

He selected an eagle and wrote in the lettering of a five-year-old child that he would migrate to Big Bend, so he could see the stars.

—ANDREW SANSOM
General Editor, River Books

My thanks go to Ed and Kathie Cox and Will and Pam Harte, who created the Texas Natural Resource Conservation Publication Endowment for books like this one.

THE RIVER
AND
THE WALL

THE RIVER
AND THE WALL

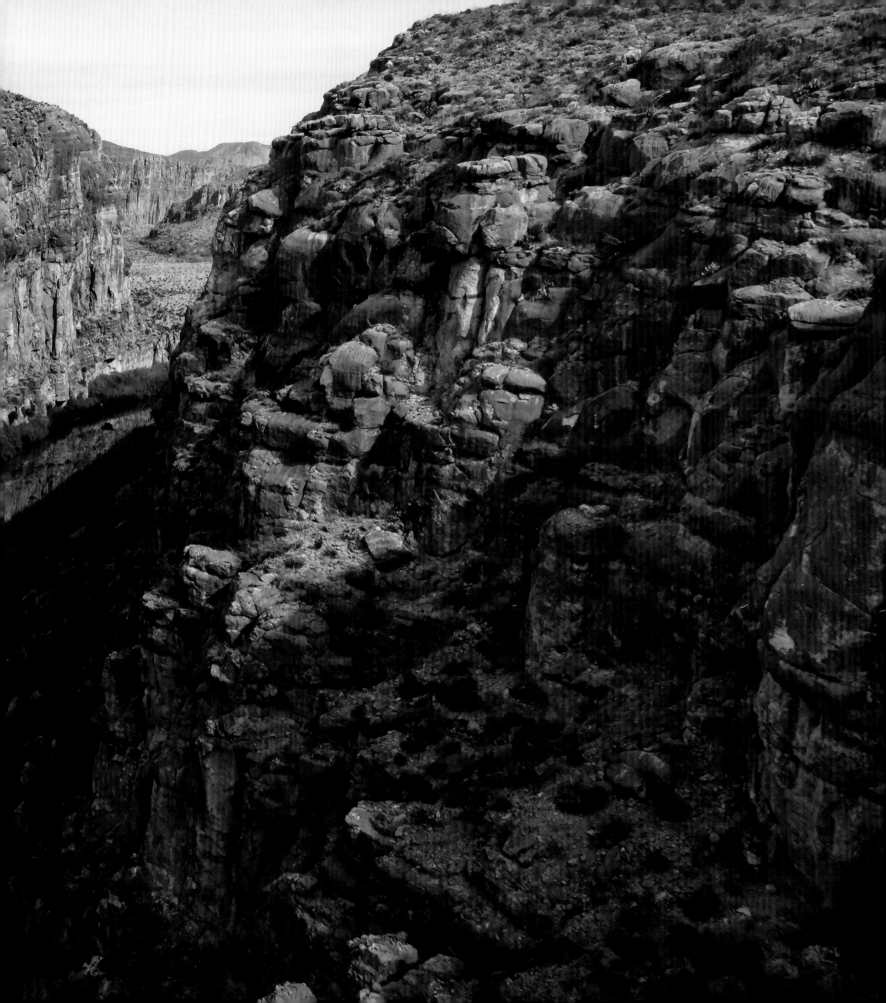

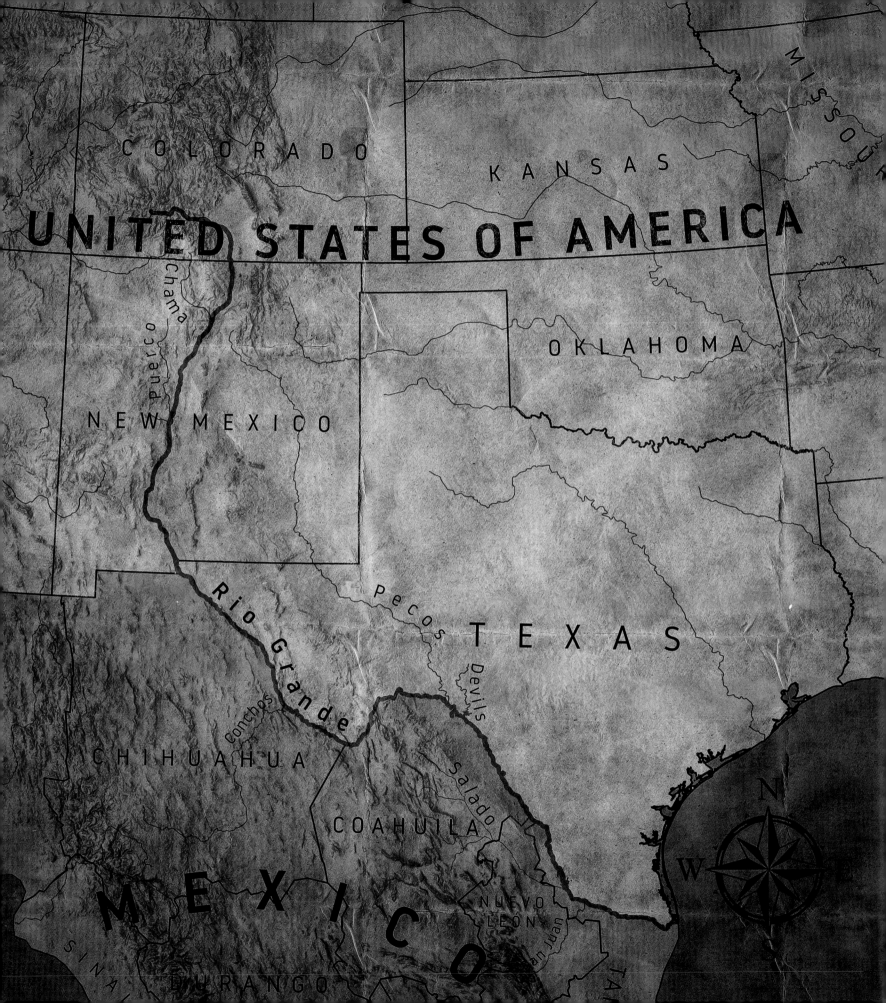

INSPIRATION

Ben Masters

The idea for *The River and the Wall* began with a set of mountain lion tracks in West Texas. My friend Bert Geary, a mountain lion researcher with the Borderlands Research Institute in Alpine, was slowly walking the bottom of Madeira Canyon, peering with an experienced eye at each patch of sand, searching for the telltale characteristics that differentiate a cat's track from a coyote's—teardrop-shaped toes and a heel pad with a flat front edge and two distinct indentations between three lobes. As we approached a side canyon, Bert excitedly pointed to the mud next to a barely flowing perennial stream. There lay a lion print, plain as day. We began tracking up the side canyon, knowing that the mountain lion could be caught in one of the snares set merely a few hundred yards away.

My adrenaline started to rush and my palms began to sweat as we followed the tracks closer to the snares. I quickly made sure my video camera was on the right settings, adjusted my exposure, and checked my audio levels. I couldn't miss this shot. We took the last bend and slowly peered around a rock in anticipation of seeing a 130-pound, pissed off kitty trying to get its foot out of a snare. No such luck. The snare was still set; the mountain lion must have jumped over it. A system of camera traps had been laid out in the area, and we quickly checked the photos to see how many and how often cats went through the

area. We poured through the photos, seeing elk, mule deer, javelina, foxes, aoudad, and, yes, an occasional mountain lion that appeared to be a young female. Bert wanted to catch her and put on a GPS tracking collar in order to learn more about this elusive animal, and I was along to film, hoping to make a video that explained some of the mystery surrounding mountain lions in West Texas. Nobody really knows how they continue to exist there.

Over the past ten years, the researchers at the Borderlands Research Institute have captured twenty-five mountain lions, fitted them with GPS and radio collars, and tracked their movements. Technology has given us our first glimpse into the secretive lives of these apex predators. We're learning what they eat, how far they roam, how often they make a kill, and how they disperse. In Texas, the biggest mystery is their sheer survival. The West Texas cats that have been collared for the study have experienced a nearly 50 percent mortality rate, almost solely due to trapping for predator control. In Texas, mountain lions can be trapped or shot 24–7–365, with no bag limits or seasons.

How does a mountain lion population continue to exist when half the animals die every year? More data needs to be collected, but there are a few hypotheses. One possibility is that the amount of data collected isn't large or thorough enough to truly represent the population as a whole. Another possibility is that there are high-surviving "pockets" of high-reproducing

females, although no existing data support this claim. Another theory is that the mountain lion population in West Texas depends upon an influx of animals from outside, notably the remote mountains south of the border in Mexico.

One month after Bert and I tracked our mountain lion in Madeira Canyon, researchers caught a three-year-old female in the same vicinity. She was tranquilized, had blood drawn for genetic tests, and was given a GPS collar. I followed the researchers who were following her and got to see where she lived, how she traversed the country, and how she dragged mule deer under big oak trees to hide them from the buzzards above. Six months after she was collared, she strayed onto a neighboring property, where she was caught in a leg-hold trap. She died from exposure—only God knows how long it took.

As we were editing the film *Lions of West Texas*, I often thought of her. She was known as TXF15, the fifteenth Texas female caught in the study. As a trained conservation biologist, I recognize that in the long run it's populations that matter, not individuals, and I make a mental effort to maintain that perspective. But I couldn't help it. As I looked through trail cam footage of her, I wondered if she had any kittens in her three short years. While editing predation statistics, I wondered if she preferred to kill and eat mule deer, javelina, feral hog, or all of the above. I wondered if she, like many mountain lions, dispersed hundreds of miles as a subadult when her mother pushed her off to be on her own. And I wondered if she came from Mexico, crossing a border that is wildly politicized by humans hell bent on walling it off, mile by mile.

When Donald J. Trump became president of the United States of America on January 20, 2017, completing the construction of a physical border wall became much more realistic all of a sudden. Trump's campaign slogan was "Make American Great Again," directly followed by "Build that Wall." "Build that Wall" was chanted by millions of people across the United States during his campaign and #buildthewall trended across social media platforms with millions of hits. There was, and still is, a lot of uncertainty as to where it would be built, what the specifications would be, and when it would go up.

Although using a border wall as a campaign promise is new, the idea of building a border wall is not. Before Trump was elected, nearly seven hundred miles of border wall had already been built along the US-Mexico border, primarily constructed during the George W. Bush administration under the Secure Fence Act. At that time, the wall was supported by many Democrats, including Barack Obama, Hillary Clinton, and Chuck Schumer. As of October 2018, most urban areas along the US-Mexico border already have a wall. What's left of the open border, for the most part, runs through some of the most beautiful and remote stretches of the country, much of it in Texas—national parks, state parks, wildlife refuges, conservation easements, national forests, federally protected rivers, and large historic ranches. Where would further construction of the wall take place? Through Santa Ana National Wildlife Refuge? Along the river road at Big Bend Ranch State Park? Above the high-water mark at Lake Amistad? On top of the 1,500-foot cliffs lining Mariscal Canyon in the wild and scenic river stretch of the Rio Grande?

After the election, I decided to stop everything I was doing, go to the border, and try to learn how a contiguous border wall would affect wildlife. For three months, I chased desert bighorn sheep, black bears, and mountain

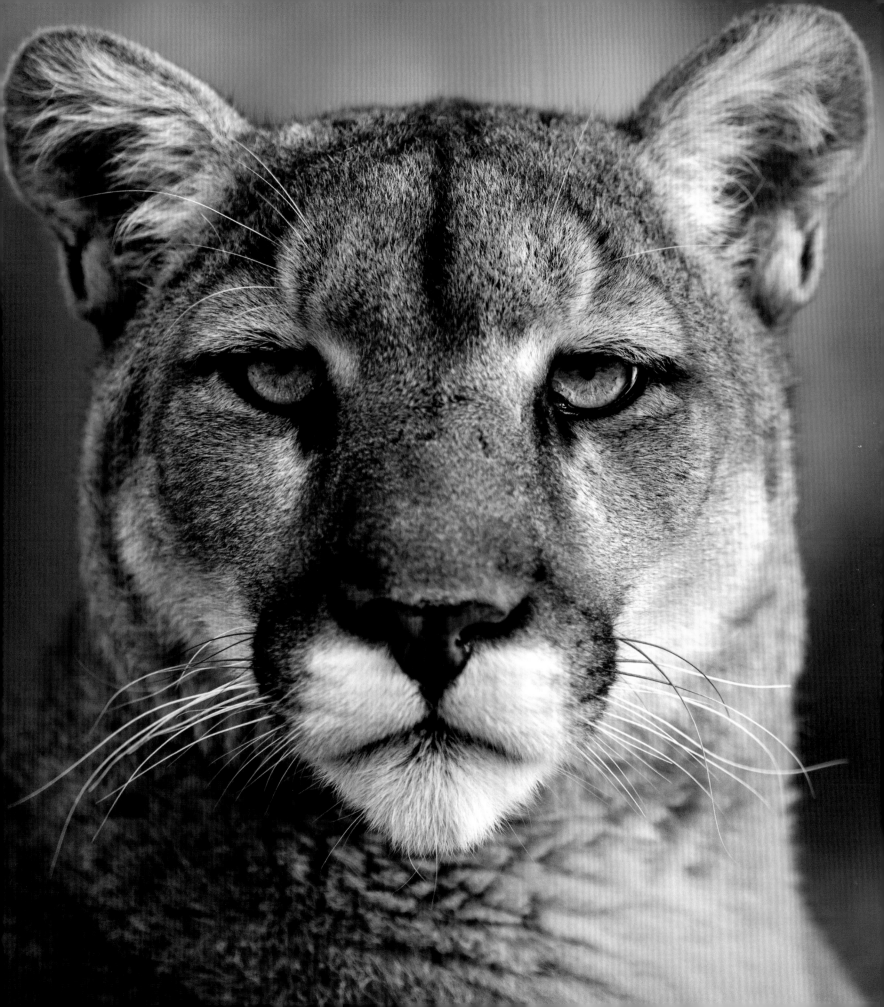

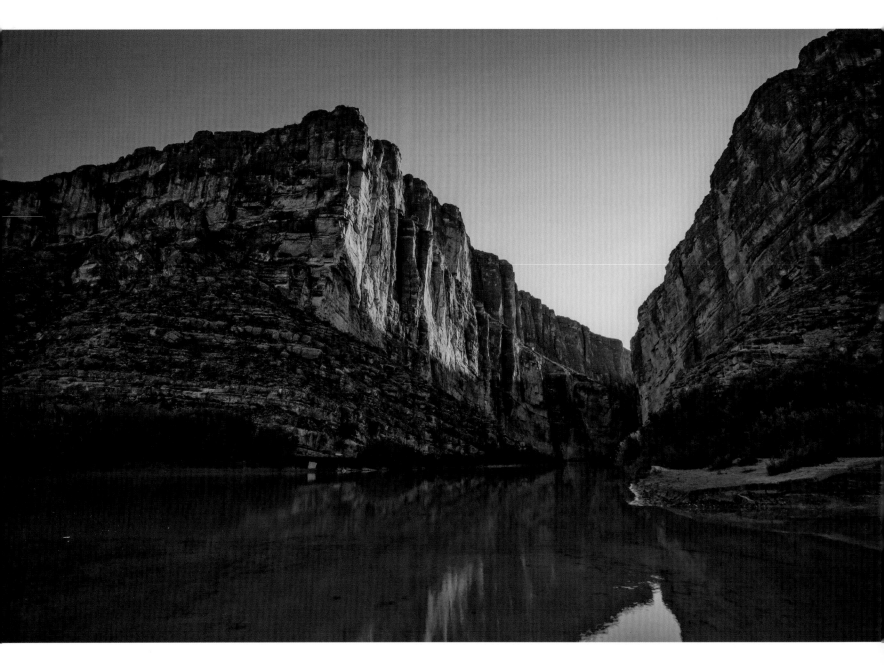

The Rio Grande runs for 1,200 miles along the junction of Texas and Mexico, forming the Texas part of the US-Mexico border. For long stretches, the terrain won't allow a physical wall to be constructed within miles of the river.

lions along the West Texas border. I carried forty pounds of camera, tripod, and lenses up steep cliffs, canoed through canyons, and spent hundreds of hours behind binoculars searching for the elusive animals that roam the Chihuahuan Desert. It was the luckiest few months of wildlife filming in my life. It seemed as if the animals wanted me to take their

pictures, to tell their stories, and to show the world how incredibly diverse, beautiful, and fragile the nation's borderlands are. A mountain lion allowed me to film her from a mere ten yards away, a black bear mother let me film her nursing her two cubs, and in the midst of an afternoon lightning storm, a half-dozen desert bighorn sheep began fighting and head-butt-

ing along the cliffs above me. I'll never forget that sound, the echo of their heads bashing together mixed with the thunder rumbling of a monsoon storm.

I learned that, for many hundreds of miles, a border wall physically cannot be built along the river. The terrain simply won't allow it, with arroyos hundreds of feet deep, canyons thousands of feet deep, and side canyons stretching dozens of miles into Texas. A border wall in that country could only be constructed in a few accessible areas, such as the river road through Big Bend Ranch State Park, or built miles inland into Texas, where the river canyon country subsides into plateaus and rolling hills. But if the United States built the wall miles away from the border, what would happen to the land between the river and the wall? Hundred of thousands of acres would be stranded in between. Would this land still belong to landowners, and would they be compensated for their loss? Would they still be able to access the river, the only reliable water source in this harsh desert environment?

At the end of the Mexican-American War, one of the primary negotiating points of the treaty of Guadalupe-Hidalgo was that the United States extend its border to the Rio Grande. The negotiators knew the economic importance of having access to the fifth longest river in North America. But if we now build a wall on the US side of the river, we would essentially be ceding back to Mexico what Americans once fought for. How does this all work?

Pondering the nuanced effects of a border wall, I drove toward the city of El Paso at the far western edge of Texas, where a portion of border wall had been built in 2007. Near the town of Socorro, I turned southwest through irrigated fields to reach the twenty-four-foot-high steel wall. The high desert climate had

been hard on it. The steel had rusted over and parts of the concrete base were worn. I drove along the wall until it ended. I parked, got out, and walked onto the Mexican side of the wall. It felt really strange, like I wasn't in the United States, wasn't in Mexico, but was somewhere in the void—the no-man's-land between the river and the wall. Looking around me, all I saw was carrizo river cane, a random cow, and a tractor. Being a filmmaker, I started looking for a good shot.

Ten minutes later, as I was setting up a slider shot along the wall, a border patrol agent rounded the bend, drove up, and stopped. He was ridiculously nice. He answered all of my questions and told me about different resources where I could learn more about the wall, border security, the deportation process, immigration, and more. I think he was really bored because he talked to me for at least twenty minutes. The longer we talked, the more he opened up. I asked him if people ever cross in the area where we were. He pointed toward the bottom of the wall to a bunch of welds meant to repair the steel after somebody cut through it with a torch. He told me about the piles of ladders they collected, the hundreds of feet of rope, and the businesses in Juarez, on the Mexican side, that sell ladders, ropes, and grappling hooks specifically designed to cross the type of border wall found in the El Paso sector. He told me that in some places the wall really makes a difference, like in cities where response time has to be within seconds or minutes in order to have a chance at apprehension. I asked him if in other places, where response time might be longer, would it really make a difference? He didn't know. Maybe.

When the border patrol agent left, I sat in the no-man's-land and took a time-lapse shot of the clouds passing through the steel bollards rising up from the concrete foundations of the

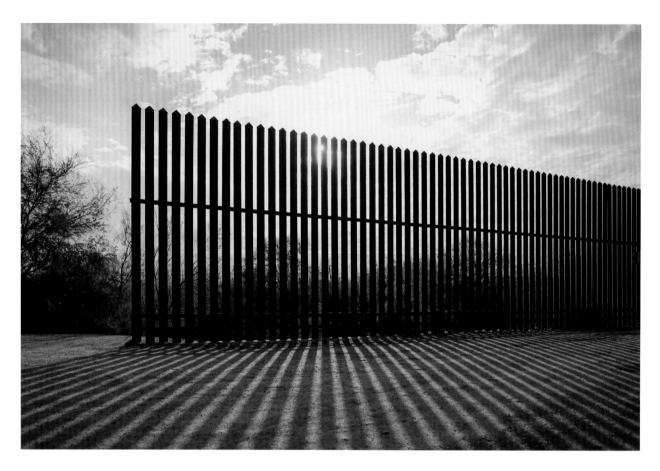

In 2006, President George W. Bush signed the Secure Fence Act, which resulted in a border "fence" being constructed along 650 miles of the US-Mexico border.

2007 model of the border wall. As time passed and clouds blew past me, curiosity got the best of me. I had to try it. I exchanged my cowboy boots for my grippy hiking boots, my wranglers for my shorts, and walked up to the wall. I put my hands around the steel bollards and leaned back. My fingers didn't slip. I put my hiking boots up against the steel bollards. They found a grip. I began to climb the wall, hesitantly at first, then quickly as I gained confidence and elevation. Moments later I was at the top, a US citizen on top of the border wall on the no-man's-land side. I didn't know whether to laugh, cry, rejoice, or get the hell out of there. I decided to take a minute, look around, and remember that moment. I'll never forget it for the rest of my life.

A million thoughts swirled through my mind as I drove away. If I could climb the wall, a twenty-nine-year-old filmmaker who historically had warmed the bench for the B-team, I imagined that a desperate individual who'd already traveled thousands of miles through untold difficulty could do it too. I called my friend Filipe DeAndrade, a fellow filmmaker at National Geographic. I knew he had been an unauthorized immigrant at one point in his life, but I didn't know how, exactly, he'd come across the border and into the United States. When he picked up the phone, I posed the question to him. He laughed. "Ha! We just flew to Cleveland!"

He flew to Cleveland. I smiled as I drove. Of course. It's cheaper, safer, faster, more reliable, and if you choose the right flight, you can even get peanuts en route. But what

happens when your visa expires? How do you get residency? Who gets citizenship? How do you get it? What is the deportation process? How does Immigration and Customs Enforcement (ICE) pick their targets? How many illegal aliens are there in the United States? Is an "illegal alien" and an undocumented immigrant the same thing? Do they pay taxes? Do they get benefits? Are they a drain or a benefit to the economy? Are employers at fault? Is the American demand for drugs the real problem with drug cartels? What is the average time it takes to get over the wall? How many undocumented immigrants cross the border on planes? Boats? By flying to Canada and coming south? How do sanctuary cities work? Should the United States deport eleven million people? Is that even realistic? Where would they go? Is further construction of the wall really going to solve anything, and if so, is it worth the cost and negative impacts?

I wanted answers to all these questions, so like every good millennial, I went to Google to learn more. I found a lot of information, most of it conflicting and much of it being spat into the interwebs without sources. I wanted to have an informed opinion about immigration and not be just another person bitching about a policy without knowing the alternatives to very real, very serious problems. I decided to dive deeper into the issues surrounding the border wall, to seek understanding, and to experience it firsthand. I wanted to see the Rio Grande and the Mexico-Texas border—all of it—with my own eyes.

I called Filipe back. In his surfer-dude-meets-Florida-birdwatcher jargon he answered the phone. "Brotato chip, what's

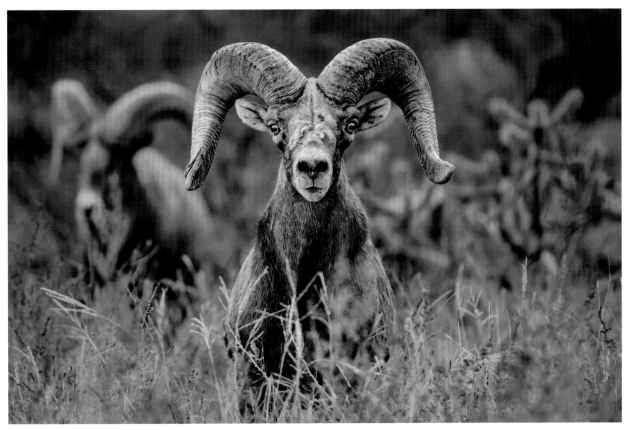

Desert bighorn sheep, which were once extirpated from Texas and have made a remarkable recovery, are one example of a species that would be impacted by a border wall.

poppin?" I pitched him my idea. "Filipe, let's have a 1,200-mile adventure, from El Paso to the Gulf of Mexico along the Rio Grande and the US-Mexico border, on my mustangs and in canoes. Along the way, we'll meet with everyone who'll talk to us about how a border wall will impact immigration, international relations, wildlife, river access, landowners, public lands, and most importantly, wild cats." (I knew I had him with the felines; he's a cat cinematographer for Nat Geo.) "Oh, baby girl, there're ocelots down there, mini-jaguars that live in trees!" he yelled. Hell yeah there are. At least for now. Filipe was in.

The next person I called was Jay Kleberg, associate director of the Texas Parks and Wildlife Foundation. I gave him my pitch. There was a long pause. "Hmmm . . . I'd have to quit my job, and I've got a newborn on the way who'll be born right before the proposed start date. Stand by, let me check with my wife, Chrissy." A few days later, Jay confirmed he was in. He said, "I could never live with myself knowing that I passed up the opportunity to potentially be one of the last people to travel the Rio Grande before it was walled off."

Once Jay and Filipe committed, I went back to filming in the Big Bend. One night in the Chisos Basin, I was sipping a barley pop waiting for the full moon to reveal itself over a mountain when a biker rolled up. He said, "Are you Ben Masters, the Aggie who rode wild mustangs from Mexico to Canada?" I replied, yes, and as I shook his hand, I noticed the sign of superior intellect and unquestionable integrity—a Texas A&M University Aggie ring. "Austin Alvarado. I'm a river guide here in Big Bend, and this is my friend Heather Mackey." After our introductions, we shared a beer and made plans to float Santa Elena Canyon in the next few days. When the moon crested the mountains, they rode off into the moonlight on their mountain bikes. I'm

more of a horseman, but I had to admit I liked their style.

Later, I met Austin and Heather at the Far Flung Outdoor Center in Terlingua, Texas, where we loaded up canoes and headed to the river. Austin surprised me by saying we were going to do a one night "boomerang" trip—paddling upstream, camping, and then paddling back downstream. The water was so low in the Rio Grande that floating a downstream stretch from a put-in to a take-out would have taken more time than we had allotted. I was shocked that there was almost no flow in the Rio Grande, one of North America's major rivers. I had no idea it got that low.

Austin explained that the Rio Grande originates in Colorado, flows through New Mexico, and by the time it reaches the Texas line, nearly all the water has been used, either by cities or for agriculture. On this trip, we had to drag our canoes through every shallow and rapid, and sometimes the river literally runs dry. The only reason water was flowing for us was because the Rio Conchos in Mexico, which runs into the Rio Grande, had brought some life back into the river.

As we paddled upriver, I got to know Heather and Austin a little better. Heather is from New York originally and was spending her summer in Big Bend studying the Yellow-billed Cuckoo, a migratory bird related to the iconic Texas roadrunner that lives along the riparian habitats of the Rio Grande. She told me that working in the rugged terrain of the Big Bend country was as difficult as the research she's done in Alaska, Wyoming, and the Galapagos. She was a world traveler and obviously a more experienced paddler than I was.

Austin was named after Austin, Texas, the city where he was born and raised. His parents started a business there after emigrating from Guatemala. Similar to myself, he worked his

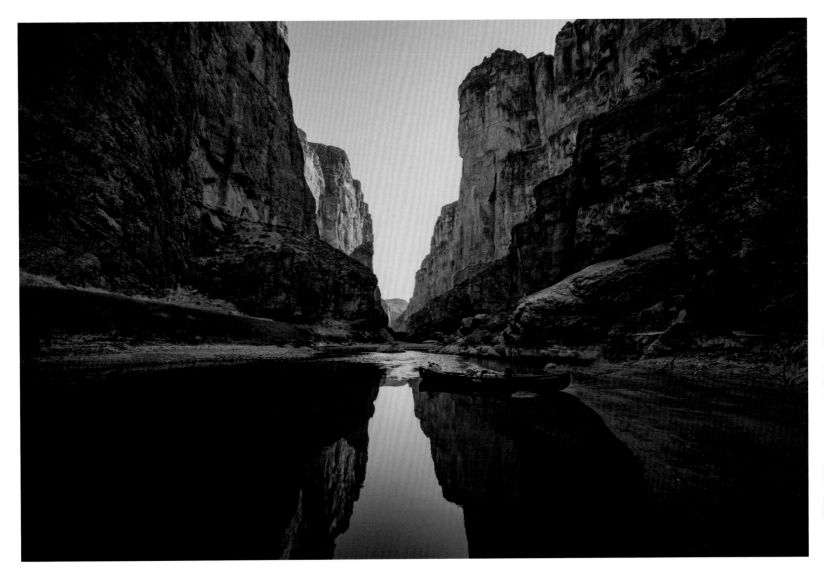

way through Texas A&M by taking oddball jobs across the world that provided a lot of adventure and opportunity. He worked on cruises, biked across Vietnam and the East Coast, and regularly went to Central America to kayak big, untouched water. He definitely knew how to use a paddle.

That night, as we camped on the Mexican bank of the Rio Grande in the depths of Santa Elena Canyon, we made a toast to the river. May it always run. May it always reach the sea. Staring up at a million stars, I told them about the plan to traverse the river along the Texas border with Filipe and Jay. I asked them if they'd be interested in coming. They replied with a resounding YES.

The landscapes along the Rio Grande rival the magnificence of the Grand Canyon.

THE TEAM

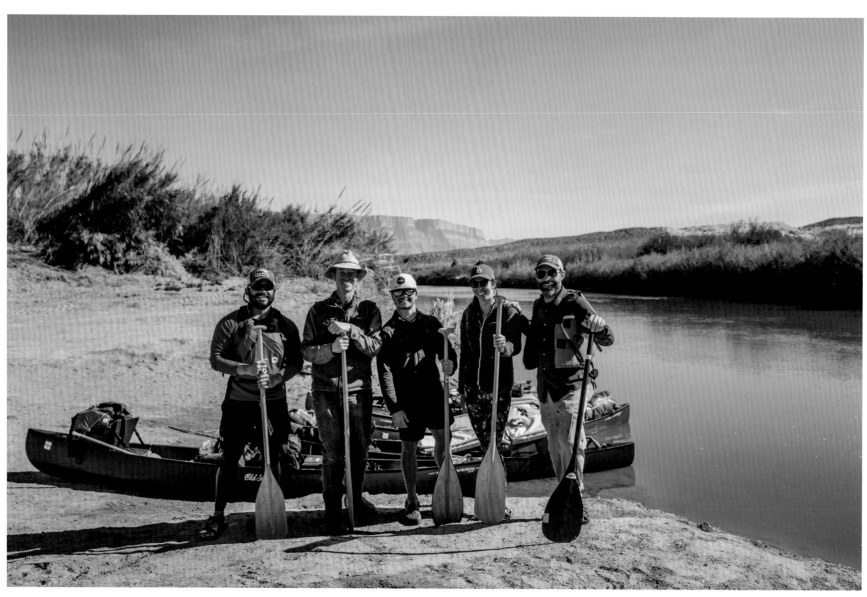

Left to right: Austin Alvarado, Ben Masters, Filipe DeAndrade, Heather Mackey, and Jay Kleberg.

Austin Alvarado

Howdy! I'm Austin from Austin, Texas. I have the privilege of being a first-generation Guatemalan American and Texan. While attending Texas A&M University, I had the opportunity to be a river guide for Far Flung Outdoor Center along the Rio Grande in Big Bend. After graduation and a bit of travel, my love for the Rio Grande brought me back. I've spent the last four years living in the Big Bend where my job and passion is to put people on the Rio so they too can fall in love with its beauty and charm. I'm fortunate to have climbed mountains on both side of the border, to have driven endless roads on both sides of the Rio Grande, and to have paddled countless miles along the Rio.

I love this border community where the Rio unites us rather than divides us. Here in the Big Bend, the Rio Grande is what it was always meant to be—a protected National Wild and Scenic River. For me, this journey and documentary is kind of similar to guiding people in person along the Rio Grande. Hopefully, the film and this book will give those who can't come to the Rio in person a chance to see and experience the beauty, majesty, and harsh terrain carved by the Rio Grande. I don't consider myself an expert in policy making or foreign matters, but if this documentary helps policy makers at least consider the magnificence of the Rio Grande then I will feel as if we have accomplished what we had set out to do. The Rio Grande will always be a river before it is a border.

Jay Kleberg

I am Jay Kleberg and currently live in Austin with my wife and three daughters. I am from South Texas, attended Williams College, and spent three years as a guide and bush pilot in the Brazilian Amazon as part of a landowner-based conservation organization. My wife, a

trained wildlife field biologist, and I spent eight years living and working in El Paso and along both sides of the US-Mexico border. We were in El Paso during the construction of eighty-eight miles of border fence as part of the 2006 Secure Fence Act.

Since then, I've earned my MBA from the University of Texas at Austin, consulted for the Grand Canyon National Park, and have dedicated my time more recently to conserving Texas' wildest places and expanding recreational access as part of the Texas Parks and Wildlife Foundation team. I am involved in this project to understand how we, as a society, have arrived at a two thousand–mile physical barrier as a policy solution to complex immigration and drug trafficking challenges. I believe that through this expedition and film we have a once-in-a-generation opportunity to tell the story of the land, water, wildlife, and people of the Texas-Mexico border at a time when the region is a part of the national conversation.

Heather Mackey

Hey, y'all! I'm Heather, and along with Donquita, I will be representing the women on this journey down the Rio. I'm originally from the Adirondacks region of upstate New York and studied ecology at Cornell University. I've spent the last several years conducting scientific research focused mainly on the conservation of birds in locations ranging from Alaska to Australia.

I discovered Texas when I started studying the impact of river restoration on birds and butterflies along the Big Bend National Park stretch of the Rio Grande. For the past two years, I've poured my blood, sweat, and tears into my research along the Rio Grande, and

along the way I have built a lasting connection to this amazing landscape and its people. For me, one of the most unique aspects of the Rio is its biological diversity. I've watched birds and butterflies glide back and forth across the Rio, unaware of the border they're crossing. I've watched coyotes paddle from one side to another, unburdened by politics. I've learned to view the river as these animals see it—not as something that divides the landscape but as the one thing that binds it all together.

For me, this expedition is about giving a voice to the plants and animals that depend on the river, so throughout the trip I'll be carefully documenting the biodiversity of the Rio Grande floodplain, possibly for the last time before further construction of the border wall.

Filipe DeAndrade

What's going on beautiful people? My name is Filipe DeAndrade and I am a wildlife filmmaker. I host a show on National Geographic

and Nat Geo WILD called "Untamed." I love what I do because I get to witness some of the most incredible wildlife stories play out all across the world.

The most satisfying aspect of my calling is telling those stories to an audience that loves animals as much as I do. I live and breathe the wild. Constantly moving and always in search of how to better communicate what's happening to our ever-changing planet—this is what fuels me. That's why when Ben Masters asked me to be a part of this journey it was a no-brainer. The opportunity to explore Texas and Mexico and share what we experienced is exciting. But more importantly, *The River and the Wall* wants to get the conversation started on how a physical border wall would impact the ecology, culture, and relationships between everyone and everything in this area.

I have an interesting perspective on this issue because my family immigrated to the United States from Brazil when I was five. We lived in hiding for quite a few years, constantly moving out of fear that we would be deported. I know it's not easy being an immigrant, but hav-

ing spent most of my life in the United States I also know that immigration reform is a real issue that needs to be addressed.

Someone also has to think about nature in all of this and how a wall would cut off the life supply to so many animals that don't recognize countries as barriers. I hope to add to this project as a naturalist, but I also hope to learn from people with opposing views. I want to meet and ask questions of people with completely different backgrounds, priorities, and opinions.

Ben Masters

I'm a filmmaker, writer, and horse packer who studied wildlife biology at Texas A&M University, where I developed a deep love for wildlife and wild places. My fascination with the Rio Grande and the borderlands began as a teenager when I worked on a South Texas ranch near the US-Mexico border. Later in life, I had the privilege of managing the wildlife and habitat on a large ranch outside of Laredo, Texas, where I frequently encountered border patrol, immigrants crossing illegally, and many of the colorful characters who live along the Rio. After I became an author and a filmmaker,

my work has largely focused on the incredible landscapes carved by the Rio Grande and the wildlife that live there. The borderlands have a magnetic appeal that I've fully embraced.

What I care about most are wildlife and wildlife habitat. People, politics, and society at large aren't nearly as interesting to me as black bear dispersals, migration corridors, or critical habitat. That said, it's impossible to separate the natural world from the human-made one. They are inextricably connected, and wildlife stories cannot be told without incorporating the human element. That's why I'm interested in the border wall.

I'll admit, if the border wall was only going to be built in cities where the habitat was already lost, then the film and this book likely wouldn't have happened. But it's not. The border wall will be built through some of the most critical habitat and remarkable landscapes in the world. In order to understand how wildlife would be impacted by a wall, we had to dive deep into all the human issues that surround its construction: water, immigration, politics, economics, imminent domain, international relations, and many other factors that complicate what some see as a simple solution.

The biological and cultural richness of the borderlands are rarely mentioned once you're more than fifty miles inland. The magnificence of the river and the nourishment it provides is barely acknowledged when people discuss border politics. To most, the Rio Grande is a boundary that divides two countries. A line on a map. A river seemingly so insignificant and expendable that millions of Americans can chant "Build that Wall" without even realizing

or considering that a wall would effectively isolate a river that we once fought a war for and that today millions of fellow Americans rely on. I genuinely hope people will look at the borderlands and at the river in a new light and go see them for themselves. It's an incredible place, and the images in this book pale to the real-life grandeur of this beautiful land.

Other Voices

Geny Alvarado is the mother of team member Austin Alvarado. She immigrated from Guatemala to the United States with her husband and son Mynor.

Katy Baldock is a photographer, writer, and associate producer of the film *The River and the Wall*.

Becky Jones grew up next to the Santa Ana National Wildlife Refuge and lives on her family farm in the Lower Rio Grande Valley.

Korey Kaczmarek, a freelance outdoor cinematographer, filmed *The River and the Wall*. His work has appeared on National Geographic and the History Channel.

Journalist **Colin McDonald** has paddled, biked, and hiked the Rio Grande and Big Bend to better understand the environmental issues there.

Hillary Pierce is an Emmy Award–winning producer. She produced the film *The River and the Wall* and coordinated the support crew for the team's journey.

THE RIVER

Colin McDonald

The Rio Grande begins its journey to the Gulf of Mexico more than two vertical miles above sea level in the San Juan Mountains of southern Colorado. Just below the snow fields of Stony Pass, the Rio Grande emerges as a trickling stream tumbling across steep fields of scree on the east side of the Continental Divide. In the summer, the white of the sparkling water is set against the rich greens and reds, yellows and pinks of the wildflowers of the alpine meadows. In the winter, it is buried under a deep blanket of snow. This is the first and last place the river runs free.

Downstream the river will become an irrigation canal, a drainage ditch, a sewer, and an international boundary as it carves a 1,900-mile-long path to the Gulf of Mexico. Along the way, it will offer some of the best fishing and paddling in the country as it winds through the scenic vistas of Colorado, New Mexico, Texas, and Mexico. It will support

The Rio Grande begins its 1,900-mile journey to the Gulf of Mexico as snowmelt near Stony Pass in southern Colorado's San Juan Mountains.

In places such as the San Luis Valley in southern Colorado, the Rio Grande is used for agriculture, watering crops that are eventually sent all over the world.

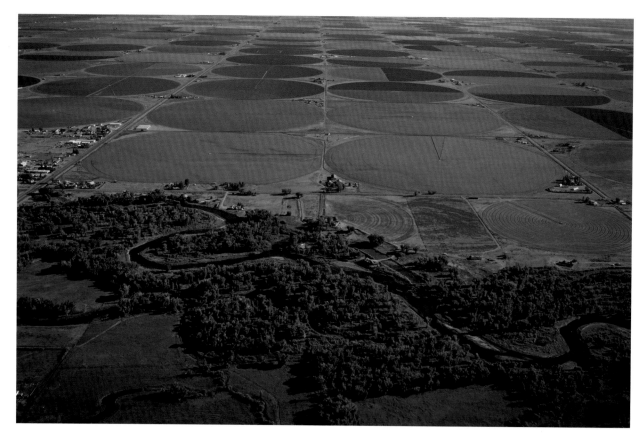

some of the most productive farmland in the United States and the best pecan orchards in the world.

Treaties and compacts will govern the use of every drop of its water. Levees and dams will regulate its path and flow. Walls, fences, and private property will determine who can have access and where.

But here where it begins, at 12,500 feet, the river is a hard-to-reach trout stream under a thin mountain sky. Only the weather and the law of gravity govern its flow. It is available to anyone who can travel the high-clearance dirt road and get by on two-thirds of the oxygen available at sea level. Any place along this river with more air and less ice is fully claimed.

Before the river travels a mere twenty miles, it will enter the Rio Grande Reservoir and assume its primary role as a tool for agricul-

ture, watering the farms in Colorado's San Luis Valley. At seven thousand feet, the San Luis Valley is a patchwork of potato, barley, alfalfa, and vegetable fields. With less than ten inches of rainfall per year, the climate of the valley floor qualifies as high mountain desert. But thanks to the Rio Grande, the aquifers in the ground below it, and the magic of center pivot irrigation, the farmers here control exactly when and how much water their crops will receive.

The barley for your Coors Light is grown here, chilled each night by the wind coming off the snow and ice of the thirteen-thousand-foot-high peaks of the Rocky Mountains that surround the valley. The seed potatoes harvested and replanted at lower elevations will feed the world. When times are good, the families working this land can buy new pickup trucks every other year. And when the irrigation

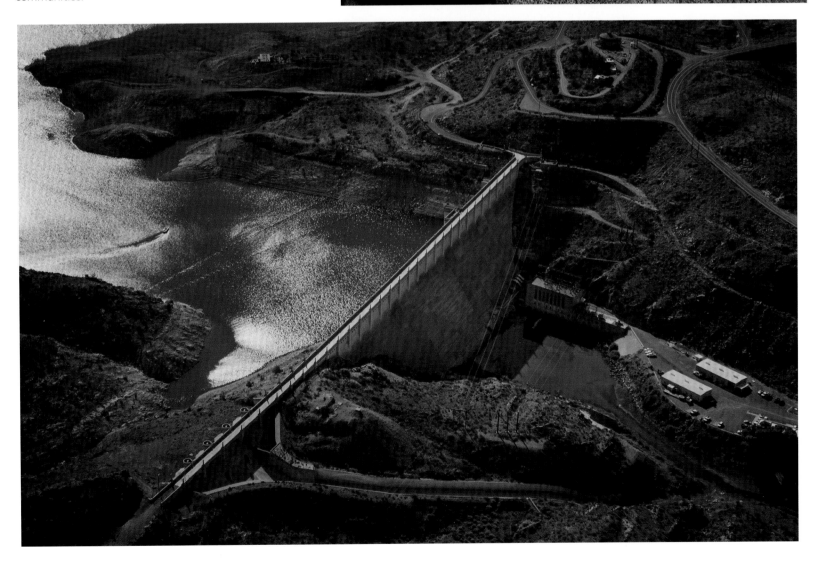

Some stretches of the Rio frequently dry up, due to dams and irrigation canals.

Since 1915, Elephant Butte Dam in New Mexico has been diverting water from the Rio Grande to farmland and communities.

The Rio Grande and the American Canal flow between El Paso and Juarez.

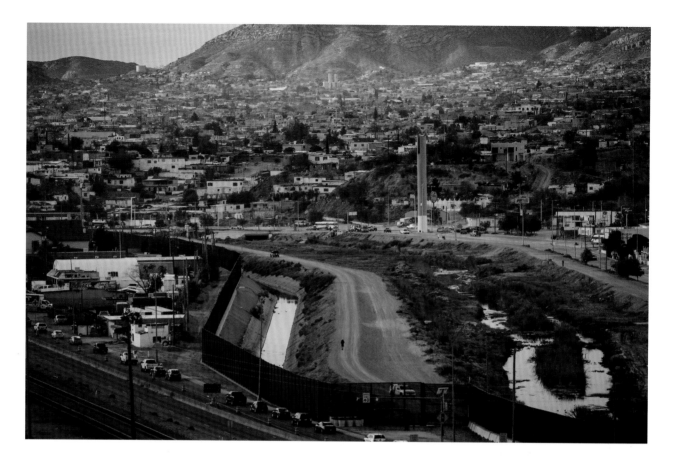

releases line up just right to keep the river flowing between the reservoir and the farms, the Rio Grande hosts some of the best trout fishing in the world.

The San Luis Valley is a remnant of an ancient lake, Lake Alamosa. When the river found a weak point in the volcanic debris blocking the southern exit some 400,000 years ago, it cut through the layers of basalt, sending a wall of water downstream. The lake drained as the river charged south and added new vigor to the ongoing work of sculpting the dramatic canyons of northern New Mexico.

This region's high, rugged landscape has been designated the Rio Grande del Norte National Monument, and the river here has been named a National Wild and Scenic River, protected from future dams and diversions.

But while the Rio Grande in northern New Mexico has been proclaimed a national treasure, the decrees, roadside plaques, and speeches do nothing to protect the flow of the river itself. The farmers of Colorado have that legal right.

Historically, the Spanish and the Pueblos worked together as communities to share the river in drought and flood alike, but Anglos adopted an English-style water law with the central tenet being "first in time, first in right." Whoever claims the water first, and has the ability to take it, can use all the water they want.

One of the first moves to secure water rights under this system is to build the biggest dam you can. The Rio Grande Dam in Colorado went up in 1914, impounding the river for the upstream farms in the San Luis Valley. Down-

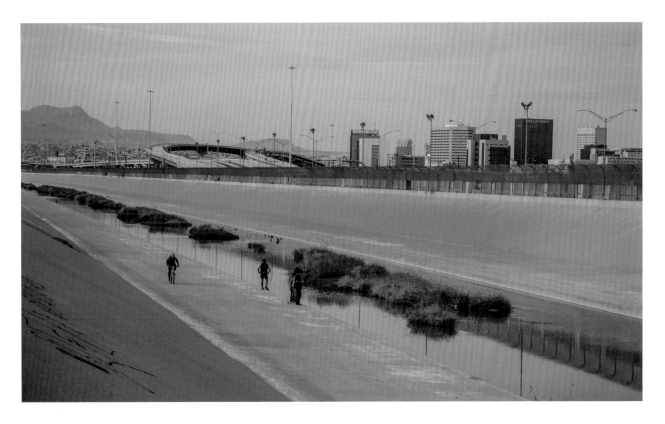

The once-mighty Rio Grande that flows between El Paso (in the United States) and Juarez (in Mexico) is now confined to a cement channel walled off on the American side.

stream, in New Mexico, farmers were already working on Elephant Butte Dam, which started to fill Elephant Butte Reservoir in 1915. With the infrastructure in place to capture the water and the demand clearly established, negotiations over water rights were not friendly. The river was already over-allocated. It took more than twenty years to hammer out an agreement and an act of Congress to complete the pact between Colorado, New Mexico, and Texas that apportioned the water in this stretch of the Rio Grande, although in 2018, more than a century after the first major dam was built, disputes over water rights continue.

What is not disputed is that all the water in the Rio Grande can be taken before it leaves the farm fields outside El Paso. The right to use every single drop has been bought, sold, traded, inherited, sued over, stolen, and fought for. While upstream farmers lucky enough to have the water rights are replacing fields of alfalfa with groves of pecan trees, more than tripling their water use, downstream of El Paso, the river stays dry.

This is the state of the river where the journey of this book begins. Outside of the irrigation season, the only reliable water entering the river channel in El Paso is the return flow from the sewage treatment plants, and even this water is diverted back to be treated and used again as drinking water.

Between the cities of El Paso and Juarez, the riverbed has been converted into an oversized, cement-lined drainage ditch. On the US bank is a thirty-foot-high fence of steel. On the Mexican side, parks and a promenade greet the river. Every morning in the United States, welders travel the border fence to look for holes cut during the night. Border patrol agents gather discarded makeshift ladders

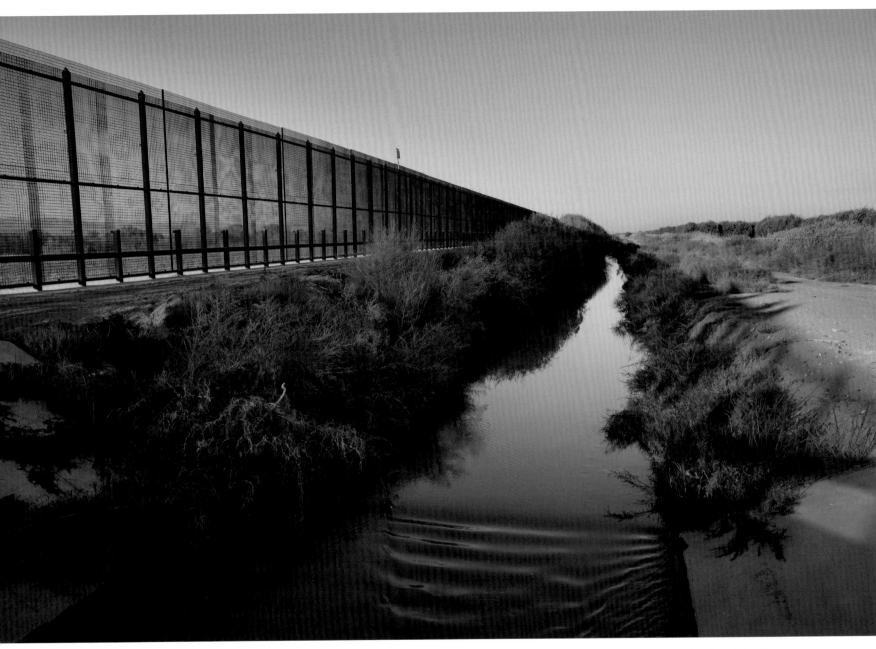

In El Paso, water from the Rio Grande is channeled into a canal system to irrigate fields downstream of the city.

and form piles of them on the north side of the barrier. Every year, people drown trying to cross the open canal of swift-flowing effluent that carries water to the treatment plant.

For the next three hundred miles, the Rio Grande, or Río Bravo as it is called in Mexico, will behave more like a dry arroyo. Its base flow is a sticky stream of water too salty for a cow

to drink, carrying more dissolved solids than seawater does. It does not have enough push to clear away its own channel, and in some places, the riverbed is impossible to see through the thick stands of invasive salt cedar that grow there, even when you are standing in it.

This valley once flooded every spring around Mother's Day and again with the sum-

mer rains; farmers planted around this natural irrigation schedule. The dusty river road is now dotted with abandoned homes, churches, and schools. A few herds of cattle and small plots of alfalfa remain. Potable water for the one or two existing communities comes in by truck or from a few small springs and wells.

By any measure, the Rio Grande here is dead. In a 2008 study, the US Army Corps of Engineers referred to this stretch of the river as the Forgotten Reach. The signs of its former glory can be seen in the high water marks left by its flows and mussel shells the size of small dinner plates that previous generations used to line their garden beds.

The river is reborn at the border communities of Presidio, Texas, and Ojinaga, Chihuahua. The Río Conchos, flowing north out of Mexico, unites with the Rio Grande and once again fills the riverbed with water. Upstream the Río Conchos is dammed repeatedly, but a portion of the river still fights its way down, and Mexico has allowed the river to flow. That flow is critical to the tourism and recreational use of the Rio Grande in Big Bend Ranch State Park and Big Bend National Park. The water may be salty from repeated use upstream in irrigation. It may carry traces of pesticides, fertilizers, and sewage. But it is wet.

Over the next one hundred fifty miles, the river tumbles through the canyons of Big Bend. Springs dilute the pollution. Sunlight and rapids reduce the bacteria. Still, it does not flood like it used to. It cannot move the sediment like it once did. The flow is dictated by the releases from dams upstream for irrigation and the need for power generation downstream. Rings of salt can be seen along the riverbanks. The natural cottonwood stands are gone, along with most of the native fish.

Usually, however, there is enough water to float a canoe. An effort to burn and spray the invasive river cane into submission and replant the native willows and cottonwoods is underway. Scientists are studying how changing the timing of water releases could benefit the river. Thousands of people on both sides of the border care passionately about the health and future of one of the most biodiverse ecosystems and dramatic landscapes in North America. On the Texas side of the river, a national park, state park, and a wildlife management area protect over one million acres adjoining the Rio Grande. Mexico protects another two million acres through federally designated Areas Naturales Protegidas.

Thanks to this protected land, native megafauna that were extirpated, such as black bear and desert bighorn sheep, are making a comeback. Sometimes they do it on their own, and sometimes with our help. Over half a million tourists visit the Big Bend area annually. They stand in awe of the canyons; they hike, look for dinosaur bones, dip their toes in the Rio Grande, and embark on river trips. Most

For three hundred miles between El Paso and Presidio, the Rio Grande regularly runs dry. This stretch of what was once a river is referred to as the Forgotten Reach.

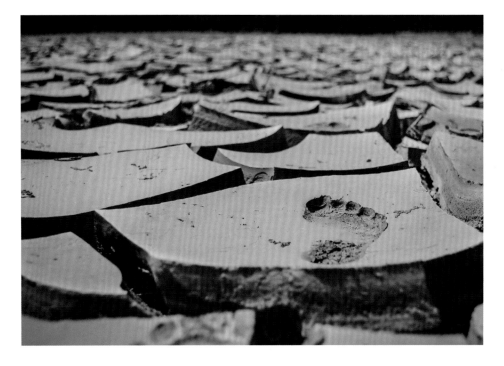

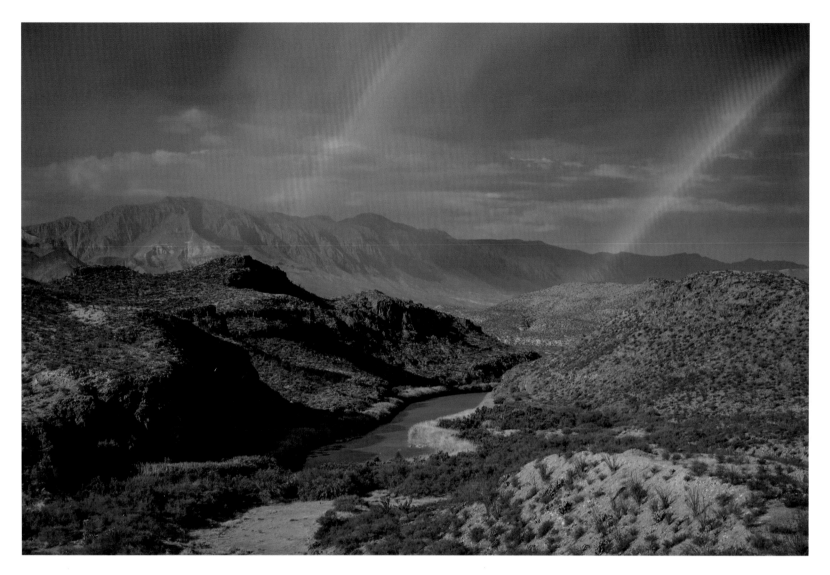

The Rio Conchos, flowing north out of Mexico, brings the Rio Grande back to life.

have no idea the river they see is a shadow of its former self.

Every so often, after a drenching downpour, it is possible to catch a glimpse of the old river. The rain triggers the blooming of the creosotes and the air becomes thick with their sweet perfume. Eventually, the land can absorb no more and the river begins to rise. The pulsing current gains the consistency of a melted chocolate milkshake as creeks and arroyos spring to life with their own contributions. The muffled booms of tumbling rocks along the riverbed can be felt on the bank. Mats of invasive cane and salt cedar ripped from the bank float on the turbulent surface. Waterfalls hundreds of feet high send mist out of the rocky cathedrals that crest the vertical cliffs above the Rio Grande. And while the floods of today are a tenth of the size they were a mere century ago, they can still rip boulders from those cliffs.

That force of nature is another reason dams were built on the river. In 1954, downstream of the canyon country of the Big Bend, a massive flood destroyed communities, livelihoods,

and lives. With international cooperation, Amistad Dam was completed in 1969. As the Amistad Reservoir filled, it drowned towns, railroad tracks, highways, and four thousand-year-old rock art painted on cave walls. But it gave bureaucracies control of the river's flow. Houses were rebuilt closer to the river. Floods are now rare and come with warnings.

The water leaves Amistad Reservoir via twin power plants, one for Mexico and one for the United States. The river is crystal clear and cold. It pours over limestone bedrock and glistens in the sun. Smallmouth bass hunt in the deep pools for baitfish swimming through the rapids, while largemouth bass hide along the vegetation to ambush their prey. As the river gathers flow from a few more springs, it rivals the beauty of the popular recreational rivers of the Texas Hill Country. But few US citizens recreate on the Rio Grande here. It has a bad reputation. Understandably, many feel uncomfortable with the constant presence of militarized border patrol trucks, boats, and helicopters. Yet, while the United States is walling its citizens away from a major river in a desert landscape, Mexico is building soccer fields and community parks along its banks.

After a few dozen miles of serene beauty below the dam, the Rio Grande is almost entirely diverted for irrigation in Maverick County. The river becomes so consistently low that the walls of invasive cane grow across the entire channel and flank both sides of the river. With a couple of good hops, it is possible to cross the entire channel without getting wet or being seen through the thick jungle of cane.

As the Chihuahuan Desert transitions to the subtropical lowlands of the Lower Rio Grande Valley, annual rainfall increases each mile closer to the Gulf of Mexico. The river

The Amistad Dam impounds the Rio Grande, Pecos River, and Devils River.

channel starts to expand. Cities and towns grow closer together. Falcon Reservoir comes and goes and the Rio Grande enters the Valley, the land of citrus and cotton. This reach of the river has the most frequent illegal crossings, the most gunboats, and the greatest bird diversity in the United States.

The Valley, as it is called in Texas, is actually not a valley at all, but the vast three hundred-mile-wide river delta of the Rio Grande. Before 95 percent of the valley was cleared for agriculture and development, a dark green forest of sabal palms rose from Tamaulipan thornscrub and flanked the river, shading its circuitous route to the sea and providing a dense blanket of vegetation over the land. It was the home of jaguars, tropical birds, and more than a third of the butterfly species recorded in North America.

Today, less than 5 percent of the sabal palm forest remains, protected in small acreages of federal and private land. With nowhere to hide, the last jaguar in the Valley was killed in 1946. Its relative, the ocelot, a smaller endangered native cat, makes fleeting and ever-decreasing appearances. The wildlife that remains depends on the slivers of forest found primarily on the banks of the Rio Grande below human made levees. It is arguably the most critical habitat in all of North America due to its importance as a stopover for bird, bat, and butterfly migrations. Soon, though, a border wall may be built along the levees, effectively isolating the remnant wild lands from the rest of the United States. Much of it will be bulldozed, sprayed, and mowed as it becomes an enforcement zone.

The use of the Rio Grande is so complete

Border patrol airboats are seen regularly along the Rio Grande from Lake Amistad all the way to the Gulf of Mexico.

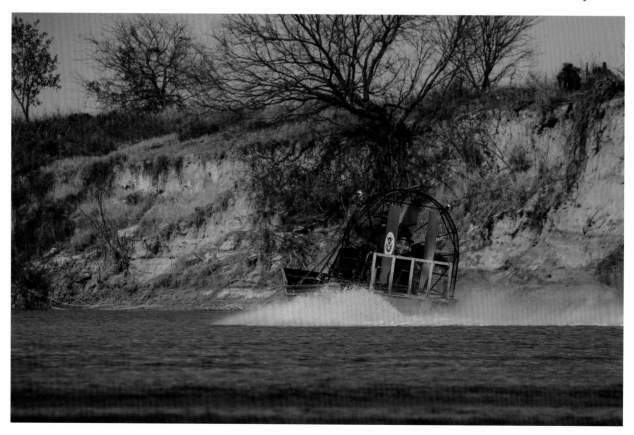

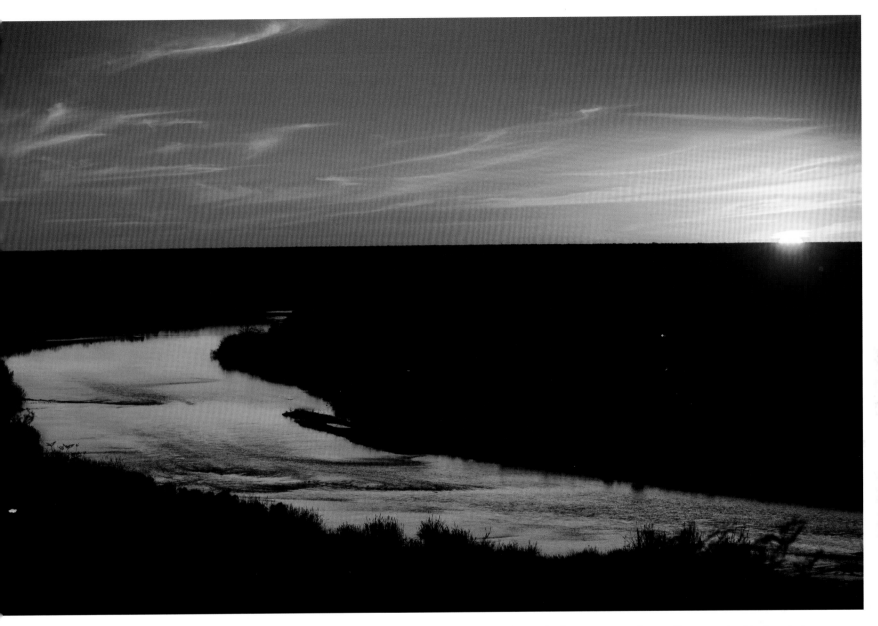

that this mighty river sometimes never even reaches the Gulf of Mexico. When the Rio Grande cannot push across the last sandbar to reach the Gulf, the US Border Patrol stations a guard on the beach. A boundary marker in the sand takes the place of the river.

The river's health reflects the values we manage it with and the priorities we pursue. We are not running out of water, we just do not have an endless supply. We have to decide what we want to do with the water we have. In Colorado, farmers are volunteering to adjust their water needs to maintain a healthier flow in the river. In New Mexico, cities are electing to pay to manage the forests that protect the Rio Grande watershed and thus their drinking water sources. In Mexico and Texas, scientists are working together to better understand how the flows of the Rio Grande can be managed to mimic nature while still providing all of the

The Rio Grande between Lake Amistad and Laredo flows along numerous large ranches.

The Lower Rio Grande Valley is a world-renowned butterfly and bird-watching destination.

water deliveries and flood protections the treaties promise.

None of this is easy. The meetings are endless. The reports are dense and confusing. Sometimes personalities clash. Lawyers and the court system are better suited to pick winners and losers than solutions. Still, people keep trying because they know we can, should, and must do better. We can store more water in the reservoirs with low evaporation rates and less water in the ones with high. We can reward farmers who irrigate crops more efficiently and grow crops that need less water. We can do the same for the owners of golf courses and suburban lawns. We can dedicate water to the river so that it will wash away the salt and refill the aquifers, thus protecting everyone's interests. We can develop our cities and towns so that they work with the river instead of constantly fighting against it. We can embrace our neighbors—the ones that live upstream, downstream, and on the opposite bank—to find long-term solutions. Or we can continue to wall ourselves off from the river and each other.

(at right) A border fence was built through much of the Lower Rio Grande Valley in 2006 and 2007.

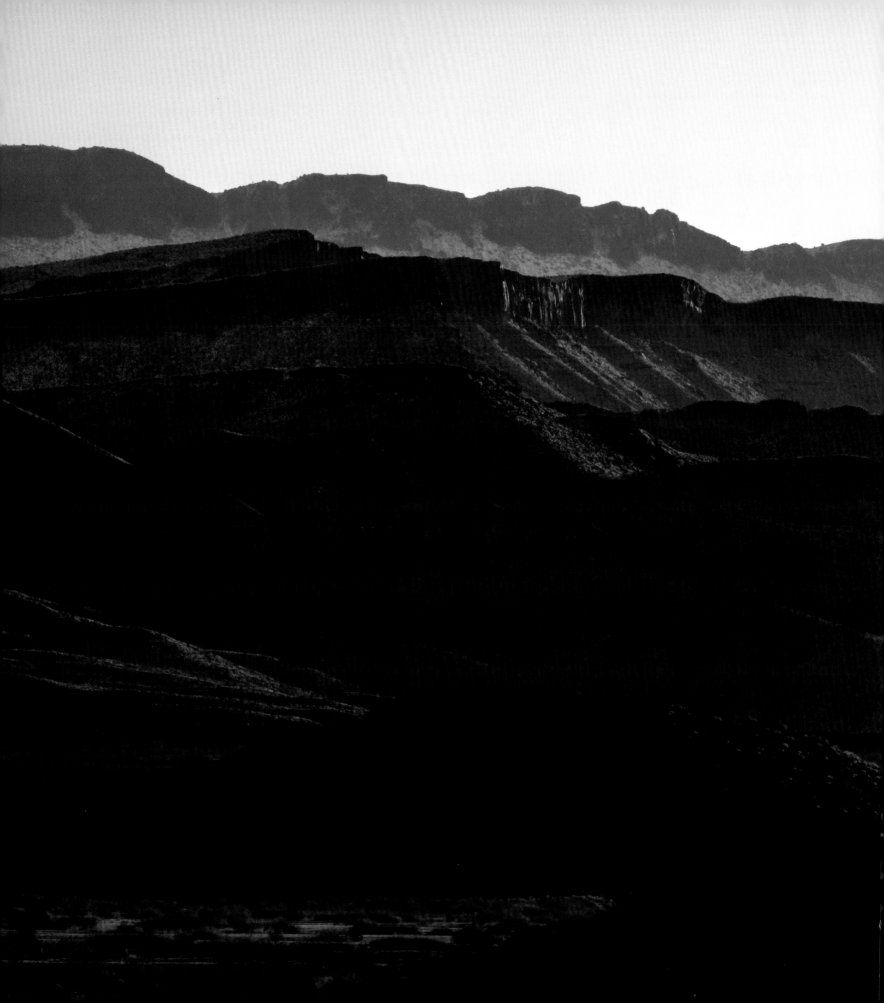

THE FORGOTTEN REACH

El Paso to Presidio

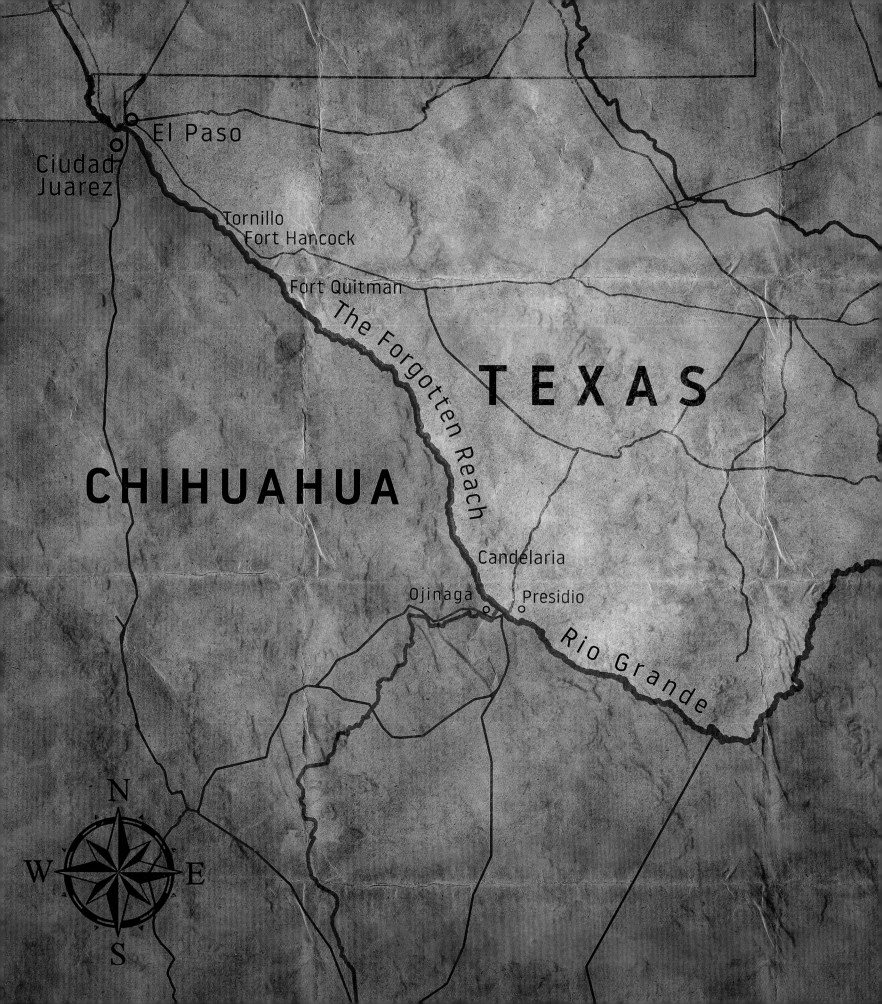

STARTING LINE TO SONIC RANCH

Jay Kleberg

The usual response when El Paso becomes a topic of discussion among friends is, "I've driven through there on my way to . . ." or an immediate drop in octave and recital of what have to be the few lyrics fans or detractors of country music can both recite, "Out in the West Texas town of El Paso." From space, the sprawling communities of El Paso and Juarez appear as if they have burst from the confines of the green Rio Grande Valley and lie deposited in the desert sands, having been squeezed between the oldest mountain range in Texas—the Franklin Mountains—to the north and the Juarez Mountains to the south.

The El Paso I know, however, has been reported to be the largest binational, bilingual workforce in the Western Hemisphere with more than 2.7 million people. It is one of the safest cities in America. It is a place my wife, Chrissy, and I called home for eight years.

Nearly a decade after leaving El Paso for Austin, Chrissy and I, along with our three girls, returned to where the western edge of Texas

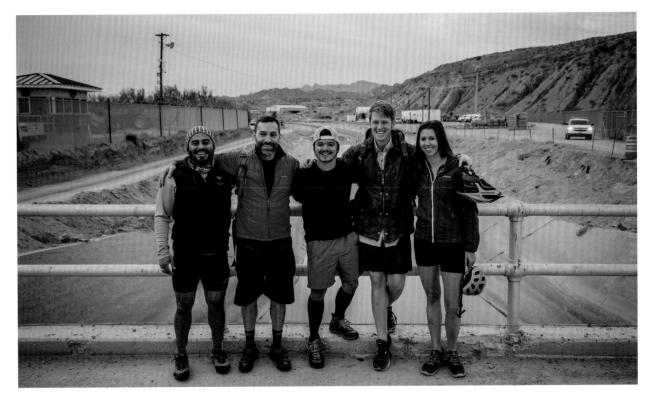

From left to right: Austin Alvarado, Jay Kleberg, Filipe DeAndrade, Ben Masters, and Heather Mackey in El Paso at the starting line of *The River and the Wall* journey.

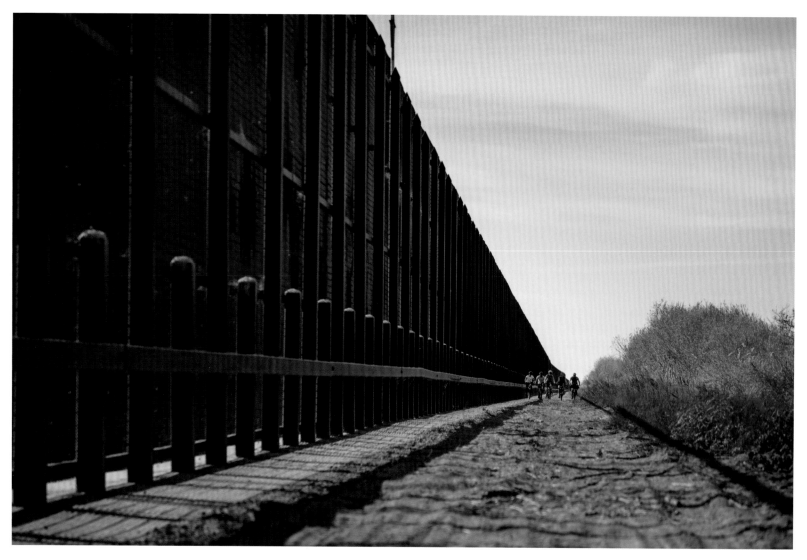

The crew biking next to the border fence that runs along the US-Mexico border near El Paso.

meets the Mexican and New Mexican borders. Chrissy and the girls came to send me and the crew off on our journey to the Gulf of Mexico. We were headed east and south along the Rio Grande to try to understand how and why a contiguous wall along the Texas-Mexico border would be built and to document the landscapes and voices of our oft-misunderstood border with Mexico.

Before our first pedal strokes toward the Gulf of Mexico, the crew, my wife, and our three daughters posed for a picture on a narrow concrete dam at the confluence of Texas, New

Mexico, and Mexico. The dam is part of the 1933 Rio Grande Rectification Project, built jointly by the United States and Mexico, which straightened and stabilized the 155-mile river boundary through El Paso and Juarez. On the other side of the bridge and river, not more than a few hundred yards away, is international marker No. 1, delineating the official international boundary between the United States and Mexico since the end of the Mexican War in 1848. Isolated by a border fence and surveilled by border patrol, the historical marker reminded us that wars were fought over the

boundary we were about to travel and that thousands of acres of public and private land could be stranded by a proposed thirty-foot wall along the entire US-Mexico border.

Before Austin, Ben, Filipe, Heather, and I set off to cover twenty-five miles to Rio Bosque Wetlands Park in El Paso, I kissed Chrissy and my daughters, aged ten, five, and five months, goodbye. Chrissy would be keeping everyone alive, including our two dogs and a rabbit, for the next few months while I slept under the stars and set out to simply move forward and absorb my surroundings every day. There is no debate in our household about who embarked on the more difficult journey—my wife deserves a medal of valor.

We pedaled along the south side of the rusted border fence, past the entrance to a one hundred-year-old tunnel discovered by border patrol just a few weeks prior. The tunnel was once used to smuggle opium and Chinese immigrants from Mexico into one of El Paso's oldest neighborhoods during the Chinese Exclusion Act era of the early 1900s. We passed by Bowie High School, ground zero for then El Paso Border Patrol Chief Silvestre Reyes' 1993 "Operation Blockade," a two-week intensive effort to prevent illegal border crossing in the El Paso sector. The operation consisted of stationing four hundred border patrol agents around the clock along the twenty-mile stretch we were traveling that day. The deterrence initiative would be the basis for the future construction of seven hundred miles of wall and proposals to seal off the entire US-Mexico border, except that future strategies would employ steel and concrete instead of agents.

Trailing behind eighteen-wheelers and cars, we crossed the Bridge of the Americas on our mountain bikes over the Rio Bravo del Norte, as the Rio Grande is known in Mexico. The river, the fifth longest in North America,

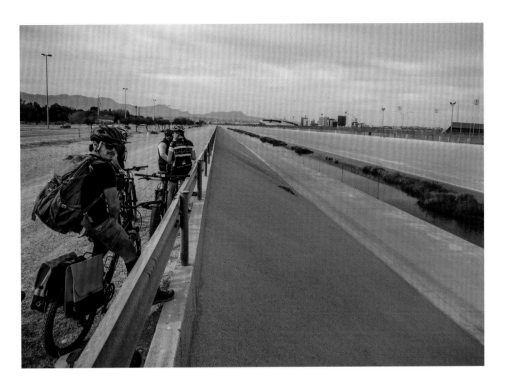

Looking from Juarez, across the channelized Rio Grande, into the United States.

has been reduced to a tiny trickle here due to dams upstream. The once-mighty river is now confined to a two hundred-foot-wide concrete channel. The "free bridge," as it's referred to locally, is one of six bridges that connects El Paso and Juarez and moves people and goods across international lines, generating 128,500 Texan jobs and contributing a minimum of $18.4 billion to the state's gross domestic product, according to Texas state comptroller Glenn Hagar. The bridge is built between two federally protected parks, spanning more than two hundred acres and both banks of river, established by the Chamizal Treaty of 1963 after a dispute between the two countries born out of the changing course of the river.

We spent some time down in the concrete river channel watching US government contract welders patch holes in the fence cut by border crossers. It appeared as if every square inch of the bottom half of that fence had been cut and rewelded at some point in its life. We spoke with a family from Juarez who, when

asked about their feelings about the fence and the proposed wall, simply said that they are not animals to be caged.

As we rode through Juarez, Filipe's bicycle broke a chain, and, while we were fixing it, two of our tires went flat. A small, innocent-looking thorn that was super abundant and impossible to avoid was just the right length to get into the tubes. We spent an hour patching everything together before riding back across the bridge to Crazy Cat Cyclery to get the right tools to fix our bikes. These mechanical difficulties were only a precursor to the challenges that lay ahead on our attempt to ride mountain bikes from El Paso to Big Bend Ranch State Park in the winter.

Bicycling through El Paso, I was flooded with memories from my time there. I came to El Paso in 2003 to work for a real estate development firm, Verde Realty, acquiring and developing industrial parks along the US-Mexico border that served the cross-border manufacturing, or maquiladora, industry. Chrissy moved from San Antonio after we got married, and in 2007 we had our first child, Sophia.

Chrissy worked for the Peregrine Fund, repopulating the deserts of West Texas and southern New Mexico with endangered Northern Aplomado Falcons, while I ran a small warehousing subsidiary in Texas and New Mexico for Verde Realty. We stored raw materials like rolled steel, automotive wire harnesses, catheter tubing, and electronics made by mostly small companies in the American Midwest for the likes of Toyota, Electrolux, Johnson and Johnson, and Cessna with large manufacturing facilities in northern Mexico. To get an idea of the scale of our partnership with Mexico, according to the Texas Department of Transportation, Texas traded approximately $176.5 billion with Mexico in 2015—more than three times what Texas traded with China, the state's second largest trading partner.

After a few years in the warehousing business, I transitioned to Verde's director of marketing and business development and visited some of those same suppliers and manufacturers in their home states of Illinois, Michigan, California, and New York, and I even traveled to India and Vietnam promoting the benefits of doing business on the US-Mexico border. In the fall of 2008, as we prepared to take the company public, the stock market crashed and Verde Realty transitioned to survival mode. The excitement of being part of a fast-growing company wore off and the allure of traveling finally lost its appeal. In an effort to try to make a difference elsewhere, Chrissy and I spent more and more time volunteering

in the community and focusing our efforts on improving the quality of life in El Paso and Juarez. During this time, a group of young El Pasoans ran for and won seats in local and state government on a unified platform to make El Paso a leading US city.

Seeing the positive changes they were making in the community, I decided to run for state representative, believing that with my understanding of cross-border commerce and a personal network that spanned the state, I could help attract more business and state funding to the city. Although I knocked on thousands of doors, I soon found out that my politics were too liberal for my slightly conservative majority district, and I lost in the primary election by a few hundred votes.

My wife and I needed a fresh start after the election, and we moved to Austin so that I could pursue my MBA at the University of Texas. Inspired by the legacy of my ancestors and my love of conservation, I began working for the Texas Parks and Wildlife Foundation, and as of May 2018, I sit as the associate director. My family has been in Texas for multiple generations and has deep ties to Mexico, the border, and international trade. A border wall built in my lifetime would serve as a blockade not only through a landscape that I love, but also through a landscape that has defined my history and who I am today. I wanted to see that landscape with my own eyes before it's changed forever.

On day one we made it out of El Paso as the sun was setting and rolled into Rio Bosque, a municipal park just beyond the industrial parks of El Paso and Juarez. The next few days, we continued down the river valley along the

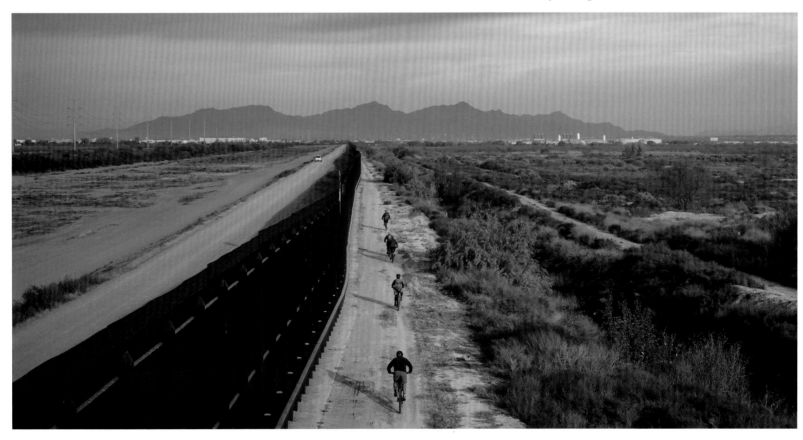

border fence through irrigated cotton fields, alfalfa, and pecan orchards with traffic from Interstate 10 always rumbling in the background.

We finished our first leg at Tony Rancich's Sonic Ranch, a 3,300-acre operating pecan orchard and world-class recording studio forty miles east of El Paso. As we learned on our room-by-room tour led by Tony, Sonic Ranch is the largest residential recording complex in the world with five studios filled with vintage equipment—guitars, amps and pedals, and microphones. When asked exactly where Tony was originally from, he responded "the world," which might be the best way to describe this place that was our home for the next few days.

Tony has molded Sonic Ranch in his own image—a transcendental, Old Mexico musical oasis on the banks of the Rio Grande. The studio is decorated with original lithographs from the European surrealist art movement of the twentieth century; a modern Texas country band in blue jeans, square-toed boots, and cowboy hats in the studio mastering their soon-to-be-greatest hit; and a Portland-based experimental trio in skinny jeans and Chuck Taylors staring at the night sky for inspiration.

Maybe someday Tony will add to his tour narrative that a group of documentary filmmakers and adventurers passed through here once, regional migrants in search of understanding and, much like Tony's musical guests, on our own quest to generate and record a piece of cinematic art by blending place, culture, and time.

The border fence ended near Ft. Hancock, and we wouldn't see it again for more than five hundred miles.

THE CONGRESSMEN

Ben Masters

I n and around El Paso, there is already a border "fence." Built during the George W. Bush administration as part of the Secure Fence Act of 2006, it is about twenty-two feet high, made of steel mesh too tight to get your fingers through, and supported by steel columns filled with concrete. While legally called a "fence," I consider it a border wall. If your neighbor built a twenty-two-foot-high steel and concrete structure between your house and their house that you couldn't see through, that was really difficult to climb without a ladder, and that had enforcement roads on either side of it, you wouldn't call it a fence. You'd call it a wall. A big, imposing, intimidating wall. At least you would think it was big and intimidating for a while, until the novelty wore off. For me, it took only a few miles of riding bicycles along the wall before the intimidation factor faded and it became a big chunk of steel and concrete blocking us from the Rio Grande.

In 2006, then-Senators Barack Obama and Hillary Clinton both supported building 650 miles of the border "fence." At that point in history, the pain and fear of 9/11 was fresh, and the "fence" construction was widely accepted because it was pitched as a counterterrorism measure. (Never mind the inconvenient fact that the 9/11 terrorists flew in or were born in the United States.) Fast forward ten years to the Clinton-Trump presidential campaign, and the border wall became something else entirely. It became a symbol.

To some, the border wall became an icon of hate, racism, and isolationism. To others, the border wall symbolized the desire to halt millions of people entering the United States illegally and to prioritize American citizens over citizens of other countries. Rarely in the debates and rhetoric surrounding the border wall do people scratch beyond the surface to ask, what does the wall actually do? Seeking that information, we reached out to Representative Will Hurd (Republican TX-23) and Representative Beto O'Rourke (Democrat TX-16), whose combined districts cover nearly half of the US-Mexico border.

The steel border fence in El Paso was constructed during the George W. Bush presidency.

Will Hurd met us at a stretch of the existing border wall near Tornillo, Texas, about twenty-five miles from El Paso. He showed up by himself in a rental car, wearing slacks and a button-down shirt like he was showing up for a congressional meeting. In contrast, we were in bike clothes, covered in mud, and smelled like pit sweat and stinky shoes. It didn't matter. Hurd spotted Austin's Aggie ring, and once it was established that he, Austin, and I all went to Texas A&M University, the finest of educational institutions, we got along great.

Hurd, a Republican, represents Texas' 23rd district, which stretches east to west from San Antonio to El Paso and north to south from the Texas-New Mexico line to the Rio Grande below Big Bend. His district is enormous, all or part of twenty-nine counties butting up against 820 miles of border—nearly half of the entire US-Mexico boundary. He sits on the Homeland Security Committee, spent nine years undercover in the CIA, and chairs a subcommittee on information technology for the House Committee on Oversight and Government Reform. To put it mildly, border security, immigration, counterterrorism, and drug trafficking are huge issues for him. Personality wise, he's the type of guy who drops everything to ride bicycles along the US-Mexico border with people he doesn't know and goes on record on very controversial topics for a documentary and book over which he has zero creative control. I liked him from the get-go.

Will got out of his stuffy congressional representative clothes, threw on a bike outfit, and began pedaling with us down the border wall road. On our right was the border wall, or "fence," with the nearly dried up Rio Grande about 250 yards beyond. To our left was a marshy irrigation canal carrying river water to the pecan orchards we passed. It was a beautiful day, and the shade from the border wall kept us cool and sunburn free. As we rode, I asked Will a few questions, and here's a smattering of that conversation:

Can you describe your district and how terrain affects border security?

My district runs from the fringes of El Paso east to Eagle Pass, and every mile of those eight hundred-plus miles is different. One of the things I've been frustrated with when it comes to border security is that we try to have a one-size-fits-all solution. You can't, because every mile is different. In some places you have 1,500-foot canyons, in other places Chihuahuan Desert where you can see for over one hundred miles, and in others there's thick brush with little visibility. Some areas are sparsely populated; other areas have millions of people. People need to realize that when you talk about the border, you're talking about something that's two thousand miles long, and you can't have a homogenous perspective of it.

How has the 650 miles of "fence" that was built in 2006 under the Secure Fence Act impacted, either positively or negatively, your district and your constituents?

In some places, where there's urban-to-urban contact, a fence makes sense because border patrol can measure their response time in seconds to minutes. That is where the majority of the fencing from the Secure Fence Act was put in. But you have to be able to see through it. We have to remember that the adversaries are responding. It's move, countermove. But I will say this, building a wall from sea to shining sea is the most expensive and least effective way to do border security. In some areas, where border patrol's response time is measured in hours to days, a wall is not a physical barrier. Building a wall in the desert, on Lake Amistad, or in Santa Elena Canyon in Big Bend, it's just

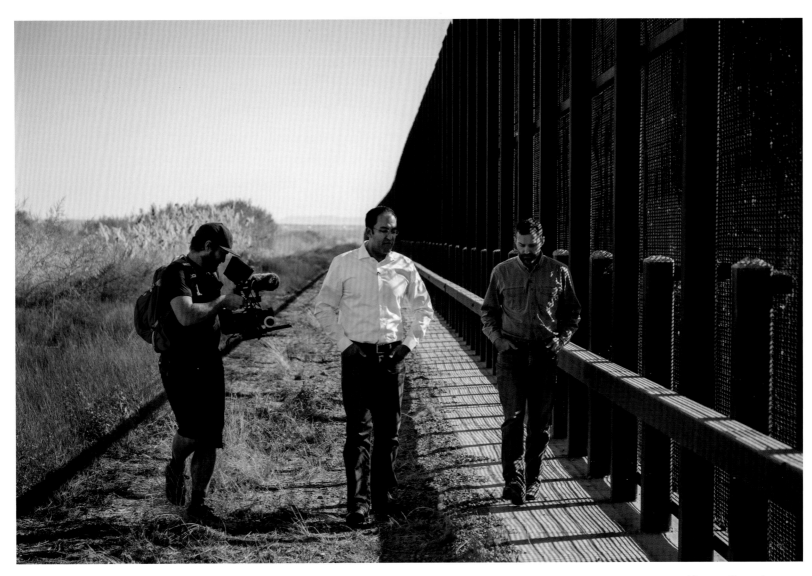

crazy. Using technology to change with the ebb and flow of the realities on the ground is not only a much better use of hard-earned taxpayer dollars but also a more efficient way to achieve operational control of the border.

Explain "operational control of the border."
 We should be able to know who and what is coming back and forth across our border. Nobody disagrees with that. Can we do that right now? No. We can't do it on our southern or our northern border. It's a complicated

problem and folks want to gravitate to simple solutions. But you can't have a simple solution to a complicated problem. A complicated problem requires a complicated solution. I believe we need to utilize technology along all two thousand miles of the border, to use the best test tactics for different terrain and variables, to enforce the laws we have, and to fix our broken immigration system to match the labor demands and needs here in the United States of America.

Republican Will Hurd represents Texas' 23rd congressional district, which includes 820 miles along the US-Mexico border.

Representative Hurd rode with us for a day and had to carry his bike through a marsh.

What kind of technology are you talking about?

Right now we have the sensor technology—radar, lidar (which uses light instead of sound), and cameras that can see at night and for long distances—to detect the difference between a person and a jackrabbit crossing the border. When that sensor goes off, we have the technology to use a blimp or drone to identify and track whatever the threat is. That way the men and women on border patrol aren't going in blind to do what only they can do: interdiction, stopping it. We have this technology today, but it is not the type of technology we're giving our men and women in the border patrol to do their job of keeping us safe and securing our border. It's also a fraction of the cost, approximately half a million dollars per mile for the smart wall versus $24.5 million per mile for an actual physical border wall that people can climb over or dig under.

How determined are the human and drug traffickers?

Our adversaries have resources, they're smart, and they don't have to abide by laws. The *narcotraficantes* in northern Mexico are making roughly—and this is a conservative number—$50 billion annually from the United States of America. That is almost as much money as the budget for the entire intelligence community in the United States. To make that much money, they aren't bringing it across in backpacks alone; they're bringing it in in significant weights, and that is occurring at our ports of entry. Investing more resources and technology in the ports of entry would yield higher results. I spend most of my time, energy, and effort chasing bad guys, but it's also about supply and demand. If we [the United States] weren't spending billions annually on illegal drugs, if our citizens

weren't employing people here illegally, then we simply wouldn't have the supply.

After fifteen miles of bike riding, Representative Hurd had to leave in order to make it to a meeting on time. But there was a problem. We were riding along an irrigation canal road, and Will couldn't get to the other side where a vehicle could reach him. We didn't know how much farther it would be before we came to a bridge that crossed the canal, so we just decided to hoist the bikes over our heads and trudge ten yards through the swampy, head-high overgrowth and across the irrigation canal to the road on the other side. Not going to lie, I laughed pretty hard watching a congressional representative wade through a swamp!

A few months after our meeting and interview with Representative Hurd, Representative Beto O'Rourke agreed to talk to us as well. Beto, a Democrat, represents the 16th district of Texas, which includes El Paso and some of its suburbs. At the time of the interview and this writing, Beto was running for US Senate. Jay, Hillary, and I flew to El Paso to interview him while we took a stroll along the border wall in El Paso. The following is a selection of the dialogue we had that day:

Tell me about your family's history and connection to El Paso and the border.

I was born and raised in El Paso and am a fourth generation El Pasoan. El Paso, along with Juarez, which is located across the Rio Grande in Mexico, is one of the largest binational commu-

Democrat Beto O'Rourke represents Texas' 16th congressional district, which includes El Paso and some of its suburbs.

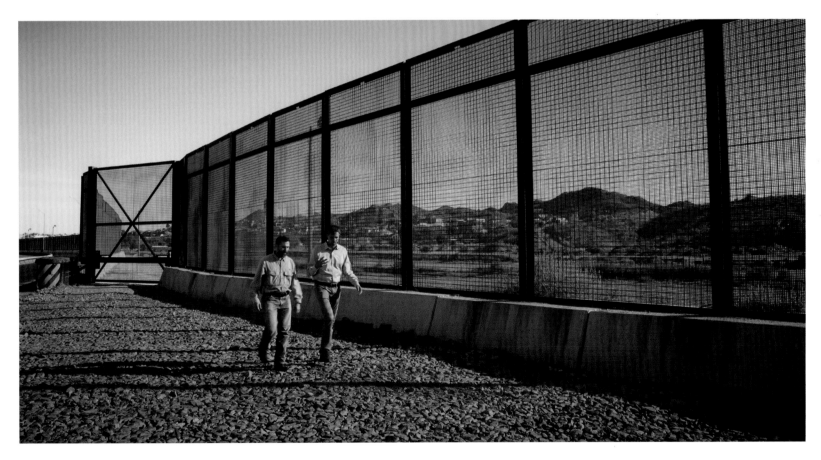

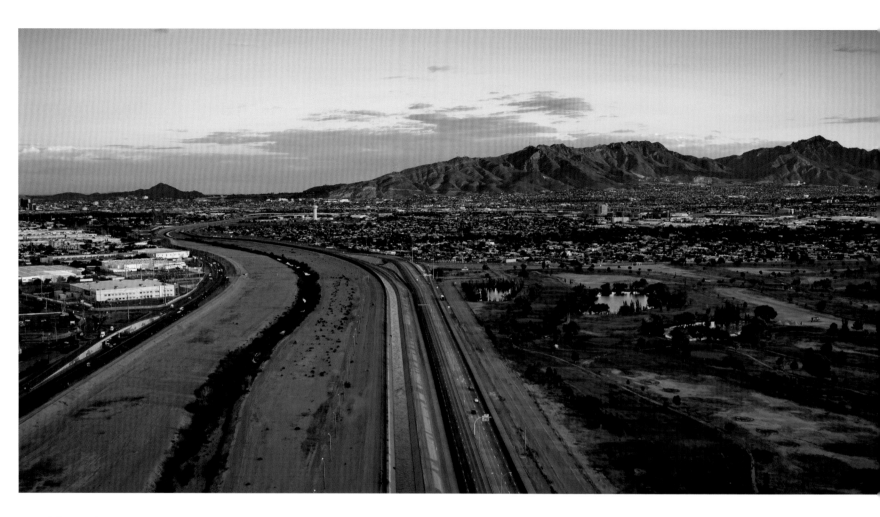

From left to right: Juarez, the Rio Grande, the border wall, the American Canal that carries most of the Rio Grande's water, and El Paso.

nities in this hemisphere. Between the two cities, there are over three million people who live here, who speak two languages, and who share this remote landscape, hours removed from any other large urban area in either Mexico or the United States. There's something really amazing about this place; it's an international community with a lot of misconceptions about it.

How safe is it here on the border with Juarez?

El Paso for the last twenty years has either been the safest, the second safest, or the third safest city in America, which is really remarkable because that is at complete odds with the rhetoric about the border. It's supposed to be this dangerous, lawless place where Mexicans

are coming to get us, or sell us drugs, or commit crimes, or take our benefits, or whatever they're dreamed up to do next. Importantly, El Paso was one of the safest cities in America before there was a wall here and it was one of the safest cities after there was a wall here. In other words, I don't think that the wall has made us any more, or less, safe. It didn't really have much of a security impact at all. My wife and I are raising our kids here; my son Henry walks to school at Vilas Elementary, a stone's throw away from the US-Mexico border and Juarez. If I thought this community was dangerous, I wouldn't be here.

When did the border "fence" or wall go up in El Paso?

There's always been some kind of fence as long as I've been alive; at one time it was just a chain link fence. Today there are steel bars and a far more physically imposing wall slash fence. That was built after the 2006 Secure Fencing Act when I was on the El Paso City Council. We actually sued the federal government along with the water control district because the Secure Fence Act waived all safeguards and processes to protect local stakeholders. We were literally about to lose all access to the Rio Grande and the ability to manage the most important resource we have here in the Chihuahuan Desert: water. The wall created anxiety for our community and it was a hit to our pride, our sense of what we were. All of a sudden we were dangerous and needed to be walled off even when El Paso was at that point in time the safest city in America. And yet that wall went up, is still going up, and they just added another section of it last year. For me, and for many in El Paso, it is a source of embarrassment.

What are some of the effects of the current border "fence?"

I think the border wall has pushed people who are trying to cross to more remote and desolate stretches of the border. As total northbound crossing attempts have decreased, the migrant deaths have stayed relatively the same. You could argue that the wall is guaranteeing additional suffering because people are still going to be drawn to be with their families, still going to be drawn to the work being created in this country that isn't filled by people who are born in this country. For me, the answer isn't going to be walls or fences or physical barriers. It will be ensuring that our immigration laws match our reality, what our true needs are in this country, and that our actions reflect the values defined by the best traditions of Texas

and this country. When I talk to people who study border security, their conclusion on the wall is that it's had a negligible effect on safety, that the flow of migration to the United States is really a function of our economy, the function of economies in the Americas and this hemisphere, and a function of the kind of violence and brutality, civil wars, and death that you find in Central America and that you have found off and on in Mexico.

Speaking of violence, can you describe the magnitude of the illicit drug trade?

The United States represents about 5 percent of the globe's population and is 25 percent of the globe's illegal drug market. The drugs that we consume in this country have to come from somewhere and have to be transported through some place. That's Mexico. It's gotten so bad that kids in Juarez are willing to kill or die for the chance to cross heroin, cocaine, meth, opioids, and even marijuana into the United States.

I think we have to, as a country, look at this problem in the mirror and think about the demand for and the consumption of illegal drugs in the United States. Because the United States is the world's largest illegal drug market, because so many of those illegal drugs come from Mexico, and because so much of the cash that is produced in those sales travels back to Mexico, along with the guns that are used for so many of the murders and crimes in Mexico, Mexico would like nothing more than for us to get a handle on our consumption of illegal drugs in this country. The billions of dollars in cash that get sent back to Mexico allow those cartels and criminal organizations to purchase entire police departments, to kill, to torture, to maim, to kidnap, and often with complete impunity.

A tiny percentage of murders in Mexico

are solved, and at the height of the drug war in 2009, 2010, and 2011, Juarez was the deadliest city on the face of the planet. That has a lot to do with what is going on in the United States. There's almost no ability for Mexico to fully build its institutions—its judiciary, its police, its press—if we continue to be this kind of draw for illegal drugs.

What is going on in Honduras, El Salvador, and Guatemala? What is life down there like and why are these people coming to the United States?

Over the past few years, more Mexican nationals are going south from the United States to Mexico than are going north from Mexico into the United States. Today, those who are being apprehended at the southern border are often from Central America, where some countries are having a really hard time establishing the fundamental pillars of a successful, civil society—court systems, police forces, democracies that really work and represent the people. We are part of the problem there.

The US drug demand is being transited through Central America, and we have a long and troubled history in that part of the world. The United States fully participated in wars in Central America, and we have supported the overthrow of democratically elected governments. We helped create some of the conditions that lead people to make the difficult decision to leave their community, their family, their country and come here to the United States of America. We can address the problem as they arrive at our border with a wall, which won't do anything, or we can learn from our history and our mistakes and help those governments and people by having more sensible policies in this country.

I think the United States has an oppor-

tunity to help stabilize many of these countries by engaging with them economically to facilitate the growth of smaller businesses. We should also engage with them diplomatically, culturally, and politically to help bring opportunity and prosperity to those countries and communities. Give more people more reasons to stay where they are and make something in their home country to sell here in one of the world's largest markets.

How does negative rhetoric about Mexico and Central America impact trade and relations?

When people in Mexico hear our president denigrate their country, vilify Mexicans, refer to Mexican immigrants as rapists and criminals, and promise to build a two thousand-mile wall that Mexicans will pay for, the Mexican people remind themselves that they have other potential partners around the globe. Mexico today has more free trade agreements than any other country. They are being courted by China and other countries of the Pacific, and they are deepening trade relations with others at our expense.

When we import from Mexico, about 40 percent of that content originated in the United States. When we import from Mexico, we win. Those factories in Juarez are using components that were built in Michigan, in Indiana, or in Ohio, shipped to El Paso, crossed over into Juarez, assembled in maquiladoras, and brought back to this country. Our economies are inextricably connected, and you couldn't pull them apart if you wanted to without destroying the US economy, certainly without destroying the Texas economy.

The rhetoric right now in this country that is so negative about Mexico will come at a cost to our country. The sooner we get a handle on this and the sooner Mexico realizes that we are their partner and they are our top foreign

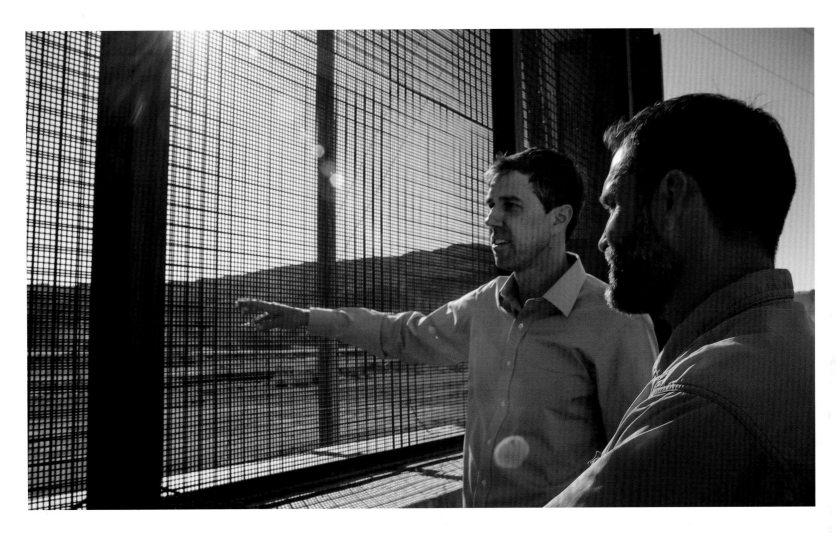

policy priority, the sooner we can grow our own economy, create more jobs there, and make the most out of this relationship.

I found it fascinating that the closer you get to the border, the wider the scope of the problems of the border becomes. The demand for drugs and labor exists in all fifty states, in both urban and rural areas, and across all socioeconomic demographics. The reality is that complex, multilayered problems require complex, multilayered solutions. By introducing bipartisan immigration and border security legislation, Representatives Hurd and O'Rourke are hoping to gain support for such solutions and find common ground amid the deep division surrounding these issues.

Representative O'Rourke talked with our team about life in El Paso and the challenges of immigration policy.

THE FORGOTTEN REACH

Ben Masters

The Forgotten Reach of the Rio Grande is a mysterious part of the Texas border and arguably the least visited place in the state. Unlike the Big Bend region, no national park, state park, or designated National Wild and Scenic River draws in adventurers or tourists. The river isn't big enough to paddle, there is essentially no road to drive on, and the land is almost entirely privately owned, primarily by folks living in cities hundreds of miles away who only visit a few times a year. No oil or gas, no wind farms. The hunting isn't that good, and you can run only one cow for every hundred acres or so. No industry, very few resources, and virtually no people. When the sun goes down, you can look dozens of miles into Mexico, dozens of miles into the United States, and not see a single light. It's like stepping back in time. The Forgotten Reach makes Big Bend

The Forgotten Reach stretch of the Rio Grande is often dry or a series of boggy pools. When we traveled through, runoff from the rain and snow filled the river so that it flowed again.

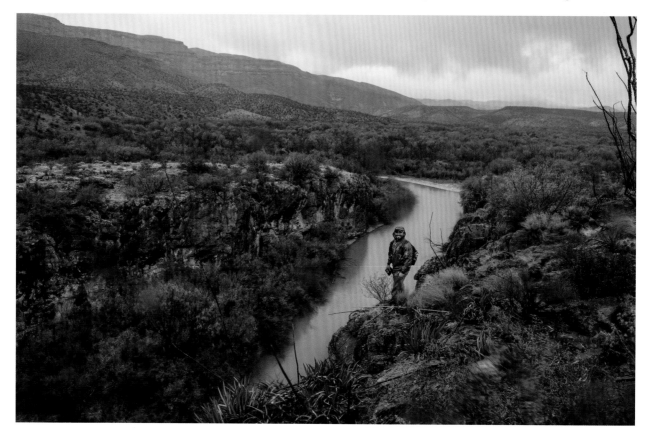

National Park seem like a booming metropolis. But what it lacks in people, it makes up for in solitude and intrigue.

Depending on who you ask, the Forgotten Reach starts either near El Paso, where the Rio Grande is sucked dry, or somewhere near Fort Quitman, where paved roads turn to dirt behind locked gates. The Forgotten Reach ends either at Candelaria, where a paved road once again runs along the Rio Grande, or in Presidio, where the Rio Conchos flows north out of Mexico to refill the Rio Grande. I consider the Forgotten Reach the stretch of land between Fort Quitman and Candelaria, forgotten by tourists, politicians, photographers, and the river itself.

A hundred years ago, flowing through the Forgotten Reach, the Rio Grande would have crested at 50,000-plus cubic feet of water per second during spring runoff. Nowadays, the river here runs completely dry except during local showers. The river valley floor, once lined with forests of cottonwoods, is now choked with an invasive species called salt cedar, or tamarisk. On the US side, the Quitman, Eagle, Van Horn, Sierra Vieja, and Chinati mountain ranges rise up from the Chihuahuan Desert. On the Mexican side, the Sierra la Amargosa, Sierra San José del Prisco, Sierra los Pilares, Sierra la Esperanza, and Sierra el Pegüis mountain ranges mirror the mountains in Texas. In between them, the Rio Grande meanders through a vast valley with shockingly little development. The Forgotten Reach doesn't have the notability, or the deep canyons, of the parks to the east, but the landscapes are equally as magnificent. The country is beautifully desolate and reminded me of the parallel mountain ranges in the Great Basin of the American West.

The logistics for traveling the Forgotten Reach were the most complicated of the entire trip. Because it is entirely private land, we had to get permissions for access, something that can be difficult to do. Bicycle-riding filmmakers from Austin aren't always welcome in the circles of West Texas ranchers. But when we explained what we were up to, we got permission from every single ranch. The overwhelming sentiment from the ranchers and landowners we talked to is that a border wall through the Forgotten Reach is the craziest, most ineffective waste of taxpayer dollars ever. If hundreds of miles of sheer cliffs, cactus, and rocky terrain won't stop somebody, a twenty-foot wall won't either.

Highway 192 runs along the Rio Grande to Fort Quitman before the pavement swings north away from the river, over Quitman Pass to Interstate 10. At Fort Quitman, the pavement on the river road ends and the dirt begins.

The dirt roads were pretty easy riding in the beginning, but as each mile passed, they became more hilly and less maintained. Big arroyos descending from the Quitman Mountains ran into the Rio Grande, and our dirt road along the river became a roller coaster of ups and downs with each drainage. The downhills were great. The uphills, well, it was like riding uphill through loose gravel. A sandy creek lay at the bottom of each arroyo, which killed any speed gathered from the downhill.

The hardest part of riding that damn bike was that I couldn't keep up with my traveling partners. It was all I could do to pedal up those hills, and as soon as I'd get to the top, I'd find Filipe cracking a joke, Heather looking at a bird, Jay eating Sour Patch Kids, and Austin pondering what the Rio looked like before there were dams. I'd struggle up to the top of the hill with sweat pouring off my face, legs trembling, groin throbbing, and lungs heaving. Before I could catch my breath, they would take off again to the top of the next hill and wait for me. I felt like the weighted end of a rusty slinky. It was

the first time in my life I couldn't keep up with everybody else, and I hated it. No matter how fast I pedaled, how much I cussed, or how hard I tried, I just couldn't keep up with them. My mind split between cursing Jay Kleberg for his bicycle love affair and daydreaming about my good horse loping across the desert.

Our first night in the Forgotten Reach was at Indian Hot Springs Ranch, where we met Terrye, the ranch manager and our host, at the gate after dark. That is, everybody else met Terrye. I caught up to the crew after the introductions and rode their dust down to the headquarters.

But as we were making our way to the ranch, I started to see crazy things. It was pitch black with a tapestry of stars above—no moon, just my headlamp on the road ahead. Then lights started flickering in the distance. Red lights, green lights, orange lights, blue lights. I tried to shake my head and clear my vision. I thought I was going crazy, as if bike riding in the sun had stolen my mind along with my energy.

The lights remained. Disco lights. Colored disco lights. As I got closer, I started making out structures. The ranch headquarters looked like an old-school Western movie set that had hired a hippie on LSD for grip and lighting. Adding to the crazy ambience, big thermal features poured steam and strange odors into the cold night air.

Terrye stepped out of a jeep to give us a tour. She was wearing camouflage coveralls and snake boots with a pistol holstered to the outside for easy access. Terrye lives by herself forty miles from pavement and twenty yards from the Rio Grande and the Mexico border.

Indian Hot Springs Ranch, located in the middle of nowhere, West Texas, has one hundred-degree hot springs that are known for their healing powers.

Her only neighbors are across the river. Border patrol response time out here is measured in hours or days.

The historic ranch is known for its healing hot springs that have attracted people for millennia. Terrye showed us pictures of mountain lions, exclaimed how badly she wanted to kill one, and then told us how stupid we were to take bicycles through the Forgotten Reach. I agreed wholeheartedly. She pulled out some maps and proceeded to show us where a few big canyons entered the Rio Grande and were way too steep and rugged to build a road through—or a wall. The only way to negotiate the canyons would be to ride north, away from the river. She said it was great horse country but awful for bicycles. Again, I had to wholeheartedly agree.

Terrye then showed us the hot springs. Somebody decades ago had built a roofless rock building around the main hot spring. Some brilliant person later put in disco lights. We hopped in and sat in the one hundred-degree water, allowing the healing waters to soak into tired legs and chafed buttocks. The disco lights bounced off the walls, and the roofless building revealed a brilliant Milky Way above. It was one of the coolest experiences of my life.

The next morning, we hopped on our bikes, pressed sore butts to hard seats, and started pedaling. Because of the steep canyons, we had to divert to a barely used two-track road and ride about ten miles away from the river. We climbed about one thousand feet on that road before coming to a pass that dropped down into Red Light Draw, a massive drainage that runs into the Rio Grande from the east side of the Quitman Mountains, the west side of the Eagle Mountains, and the flatter country farther north by Sierra Blanca. Paralleling Red

Terrye Wellborn Shirley, the manager of Indian Hot Springs Ranch, greeted us with Texas hospitality.

Light Draw was a caliche road that offered fairly easy riding through a magnificently vast landscape.

As we rode, the wind started to swirl, temperatures dropped, and a cold stinging rain began to fall. When we reached the end of the caliche road at dusk, we broke camp and quickly crawled into our tents as the rain increased.

We woke up to a soggy mess. While I made coffee, Jay rode his bike about one hundred yards to see how the conditions fared. When he returned, he and his bike were completely covered in mud. He could barely pedal. The mud was a brown, gumbo, superglue, concrete concoction that stuck to the tires and wouldn't let go. As the wheels spun, the mud got all over the forks, the gears, the pedals, the shocks, the chains, the shoes, everywhere. Every twenty yards we had to stop, pull all the mud off our tires, ride another twenty yards, stop, pull all the mud off our tires, and repeat. The bikes were unreliable, soulless, unusable, muddy dead weights dragging us down and preventing further progress. Rather than fight it, we made

the decision to throw the bikes onto the camera crew's vehicles and take off on foot. A choice for the best, and not just because I hate bikes.

The next fifteen miles followed the confluence of the Eagle Mountains and the Rio Grande. There were no roads or established trails, and we would have had to ride the bikes along the river bottom or on cow trails where possible and carry the bikes where it wasn't possible. We decided to give this stretch of the Rio the handle of "the Forsaken Stretch of the Forgotten Reach." We were going to hike through it while camera operators John Aldrich and Alex Winker drove about 250 miles around the Eagle Mountains to the other side of the Forsaken Stretch.

As we started to walk, the rain picked up.

The temperature was about thirty-five degrees Fahrenheit, and we were soaking wet. We walked at a brisk pace to get the blood flowing and to keep our fingers and toes alive. A lonely two-track road took us from camp to the river, where it disappeared into the cane and salt cedar. Fortunately, a cow trail gave us a path to walk, paralleling the river through the canyons and arroyos. At a handful of spots, we had to sidehill through the cactus and boulders, but we thought we were doing well—until I checked the GPS. In five hours of walking, we had covered only six miles. We needed to get ten to fifteen miles behind us before nightfall. Almost on cue after looking at the GPS, the rain began to fall even harder and was gradually turning to sleet.

With frozen feet and mud-covered boots, we trudged through myriad cacti, loose rocks, and mesquite mottes roughly paralleling the river. Wherever our pants and jackets were ripped, the cold rain managed to find the openings. But we were doing okay until a big rock face jutted out of the Eagle Mountains and forced us into the river. We had three options: swim across the river in thirty-five-degree temps and travel on the Mexican side, swim down the river around the rock face to reach the other side of the canyon, or attempt to climb the canyon wall to look for a route above the sheer rock face. We decided on option three, climbing up in the hopes of finding a small path that would get us past the vertical rock face. Climbing was hard. The canyon walls were slick from the rain, our shoes were soaked, and our hands were cold. We slowly climbed 150 feet or so in elevation where we got lucky and found a game trail, which we followed until we were past the vertical rock face. After an exhilarating butt scoot down a scree field, we managed to get back to the Rio Grande.

The cliffs slowly gave way to steep, gravelly

hills with the occasional cow trail cutting through them. Between the hills were arroyos hundreds of yards wide choked with a tangle of mesquite and catclaw. We were tired, cold, and already had dozens of tears in our clothes, so rather than trying to find alternate routes, we put our backs into the brush, leaned into the thorns, and did squats through the tangles until we got to the other side. It was miserable. I couldn't imagine traveling like that for days or weeks on end like so many immigrants do. That country rips a person to shreds. A mesquite thorn stuck in your foot could mean the difference between life and death. I thought about how many people were doing the same thing we were—cursing the rain, the catclaw, the loose footing—and wondering how far they had yet to travel. Their stakes were much higher than ours, and unlike us they didn't have an SOS beacon in case something truly drastic occurred.

Although the travel was harsh, I couldn't help but stop occasionally and admire the beauty of the surroundings. Austin, who knew the Big Bend better than any of us, was trying to soak in all the sights and store them in his long-term memory bank. Very few people see the Forgotten Reach, and almost nobody travels the Forsaken Stretch. There wasn't a fence or a footprint, and the only signs of life were a few hardy aoudad sheep and a mountain lion track.

Eventually, we emerged out of the Forsaken Stretch and found a two-track dirt road. We were freezing, in really bad shape, and decided to run to warm up. Slipping and sliding through the mud, we hit a jog for about five miles before we saw a white F-150 coming our way fishtailing through the drenched road. It was Alex, our camera operator. He greeted us with candy and coffee, some of the best of my life. He told us about a ranch house another five miles up the road that had a truck parked

outside of it. As we talked, the wind increased and sleet started to accumulate on our clothes. We asked him to drive to the ranch house and see if we could find shelter for the night.

We jogged the next five miles in silence with our heads held low trying to deflect the sharp wind and sleet from our faces. It was dark by the time we reached the ranch house, and three men, who were there hunting mule deer, greeted us. They recognized me from the documentary film *Unbranded*, which I had made a few years prior, and offered us whiskey and a warm house, which we heartily accepted. Once we were settled in, they told a hilarious story about Alex.

Alex Winker, who is twenty-two and fresh out of film school, is as good of a production assistant and assistant editor as you could ask for. He reads blogs on codecs, loves to talk about the nerdier facets of the film industry, and geeks out over color correction. He's the type of guy who, after watching an awesome action movie, talks about how amazing the sound design was and wonders what type of stabilizing aftereffects were utilized by the post-production team. He has long hair, with a braid coming out of the side of his head, and looks like the person who sits in a dark editing room, slowly tweaking away, to get the perfect color profile, which he does. He's brilliant at what he does, but knocking on the door of an unknown ranch house in the middle of a blizzard, at dusk, fifty miles from pavement, and on the US-Mexico border was a little out of his element.

Bam Bam Bam! Alex hit the door. A big, bearded, military-looking man with a pistol slowly cracked open the door and growled out to Alex to state who he was and what he wanted. Alex froze. "Ummm, I'm a guy. A guy named Alex?" I can only imagine what they were thinking. Alex must have been an incredibly lost millennial filmmaker or some

Traveling across the terrain in the Forgotten Reach on foot was considerably more difficult than climbing the border wall near El Paso.

super bad dude. After a few tense moments of awkward stare off, Alex explained what he was doing, dropped the name *Unbranded*, and the military-looking man (who was in the Marines, thank you for your service, by the way) said, "Wait, I've seen that movie, the one where they ride horses from Mexico to Canada?" "Yeah, that movie. We're doing another movie on the

border, and everybody will be here shortly."

Over whiskey and a hot plate of food, we cracked jokes with our new friends and scoffed at the howling wind and sleet outside. They told us about how earlier that day, while they were hunting, they stumbled on a backpack full of marijuana bricks. They were understandably nervous after the encounter and assumed the

worst when Alex knocked on the door. We kind of joked about how we were glad it was Alex who knocked on the door, an innocent looking white kid, rather than Austin or Filipe, who are brown and were covered in mud. It wasn't that funny.

The next morning I managed to get a call out to Hillary, our producer, to fill her in on everything that had happened. She was relieved to find out we were okay. She also gave us some grave news. The border patrol had found fifteen unauthorized immigrants a mere twenty miles to the north of us standing next to a road trying to flag someone down. One of the members in their party had frozen to death, and the others were delirious from the cold. I couldn't help but feel a small common bond with them, traveling through the same landscape in the same elements. I had a taste of what it was like to walk through that miserable weather. I couldn't imagine spending the night in it.

No one knows how many immigrants die in the desert every year. The International Organization for Migration (IOM) recorded 415 deaths along the US-Mexico border in 2017, a number based mostly on reports from US Border Patrol. The leading known cause of death is drowning in the Rio Grande followed by dehydration and exposure. But most of the bodies are too decomposed to offer any clue to the cause. Not even the gender of many of the remains can be identified. Between the buzzards, the coyotes, and the elements, bodies don't last long and the desert has a way of erasing things.

The IOM believes the body count is low because it only includes bodies that are found and doesn't account for the thousands of people who disappear every year somewhere between the homes they left and their destination somewhere north of the border.

With heavy hearts and tired legs, we unloaded the muddy bikes from Alex's truck and began pedaling again. We were on the Chispa-Candelaria road, a county-"maintained" dirt road that traveled through private ranches along the river. We had to stop every few hundred yards to unclog the mud from the tires, but we made faster time than we had walking. Around midday, the clouds lifted enough to reveal a winter wonderland. For as far as we could see, the surrounding mountain ranges were covered in snow. It looked like Colorado. The Rio Grande, swollen from the recent snow and rain, flowed through a mesquite riparian area flanked by hills of ocotillo and Spanish daggers and crowned by snow-white cathedrals in every direction.

Today, there are no towns on the American side of the Forgotten Reach, but the community of Porvenir is still a dot on the map, the site of a horrific massacre in 1918. As the two-decades-old revolution in Mexico was ending, Pancho Villa was on the run in northern Mexico. United States' relations with Mexico had grown tense, especially after Villa raided the border town of Columbus, New Mexico, where a full-on battle with the US Army ensued. A year earlier, a manifesto called the Plan de San Diego had appeared calling for an uprising against the Anglos who had settled on the land acquired by the United States in the Treaty of Guadalupe Hidalgo. The border country was a dangerous place, and the Texas Rangers were sent in to stop the raids and secure the boundary.

On December 25, 1917, a group of Mexican raiders, either Villistas or Carrancistas, crossed the Rio Grande into the United States and raided the Brite Ranch, a cattle operation between the Rio and Marfa. Two people were shot, one was hanged, and the general store was robbed. The raiders quickly rode across the river south into Mexico to escape. The Texas Rangers went after them.

Mud covered the gears and then froze, turning our bicycles into deadweights.

The details are conflicting, but what we do know is that on January 26, 1918, despite having no evidence that the villagers of Porvenir were involved in the Brite Ranch raid, Company B of the Texas Rangers entered and searched their homes. Two weapons were confiscated, and three men were arrested and detained at the Rangers' camp. They were released the next day. The following day, January 28, ten Rangers, along with eight US Army cavalrymen and four white ranchers, reentered the village at dawn, took everyone out of their homes, and separated fifteen men and boys. They then led the men and boys onto a nearby hill where they were shot and killed. The bodies were left on the hillside. It was a horrendous massacre with lasting consequences.

Following the massacre, the 140 remaining villagers in Porvenir packed their belongings and moved across the river to Pilares, Mexico, where the deceased were buried. The US Army then razed the village, and the incident wasn't reported to Ranger command until a month later. The Texas Rangers reported that they were ambushed and that the villagers had stolen property from the Brite Ranch. The US Cavalry claimed that they didn't take part in the massacre. To this day no one knows exactly what transpired.

As we traveled the Forgotten Reach near Porvenir, we encountered a cemetery with about fifty graves, many unmarked. We had no idea who the people were who lay in the graves or where they came from.

As the day progressed, snow and ice turned into even sloppier mud. In the mucky flats at the bottoms of arroyos, we had to carry our bikes for hundreds of yards—an easy feat on a normal day, but a more difficult task when the bikes were also carrying fifty pounds of mud. We managed to pedal and trudge twenty-five miles before breaking camp on a hill overlooking the Rio and the valley of the Forgotten Reach. While we prepped dinner, Jay and Heather took on the finger-freezing task of taking the bicycles to a snowmelt stream to clear the mud and ice off the chains and tires as much as possible. That night, the stars came out in force, and the temperature plummeted to the low teens. It didn't matter, we were exhausted and went to sleep.

We were up before dawn the next day determined to ride as far as we could while the ground was still frozen. It worked. For a mile we pedaled hard over the icy mud, finally making good time. Then Filipe got a flat. Then I got a flat. Then the sun came up and everything started melting. By the time we got the bikes working again, the mud was thawing and beginning to accumulate on our tires and wheels. After two miles, the bikes once again

became muddy, soulless, dead-weight hunks of metal hindering our forward progress. Camera operators John and Alex were ahead of us, setting up for a shot, so we slung the muddy bikes over our shoulders and once again backpacked through the mud. It's a problem when a bicycle is riding you.

After a mile of humping bikes through the mud, we caught up to Alex and John in their truck. They were hopelessly stuck in the mud. The truck was in so deep we had to clear the mud away from the doors before they would open. After about an hour of shoveling, I managed to drive the truck out of the muddy patch and onto rockier ground, for the moment. The ice continued to melt, and we had worthless bikes, a useless truck, and no idea how long it would take to begin forward motion again. We were also running behind schedule and had to get to both Big Bend Ranch State Park and the national park to use the camping permits we had reserved. We decided to leave the bikes with the truck and begin walking again. It was another twenty miles to pavement, and we hoped we would get there before it was too dark to see. Alex and John would wait in the truck until midnight to let the mud freeze over again and then drive out of the Forgotten Reach in the middle of the night on a tiny, icy, two-track road.

We enjoyed the hike to pavement. By this time we had our traveling legs under us and weren't carrying large packs, and it felt great leaving the bicycles behind. The miles seemed to fly by under a beautiful sunny day, and at

dark, we reached pavement in the little border town of Candelaria, marking the end of the Forgotten Reach. It was a beautiful sight. We were thoroughly exhausted but gratified that we had reached a major milestone. Alex and John drove through the icy night to reach us, and by morning everyone was safe.

We left the difficulty of the Forgotten Reach and rode seventy miles on pavement to Presidio, where the Rio Conchos flows from Mexico into the Rio Grande and refills it with water. In Presidio we would also ditch our bikes for the next month and take to horses, my much preferred method of travel.

Our camera crew got hopelessly stuck in the muck.

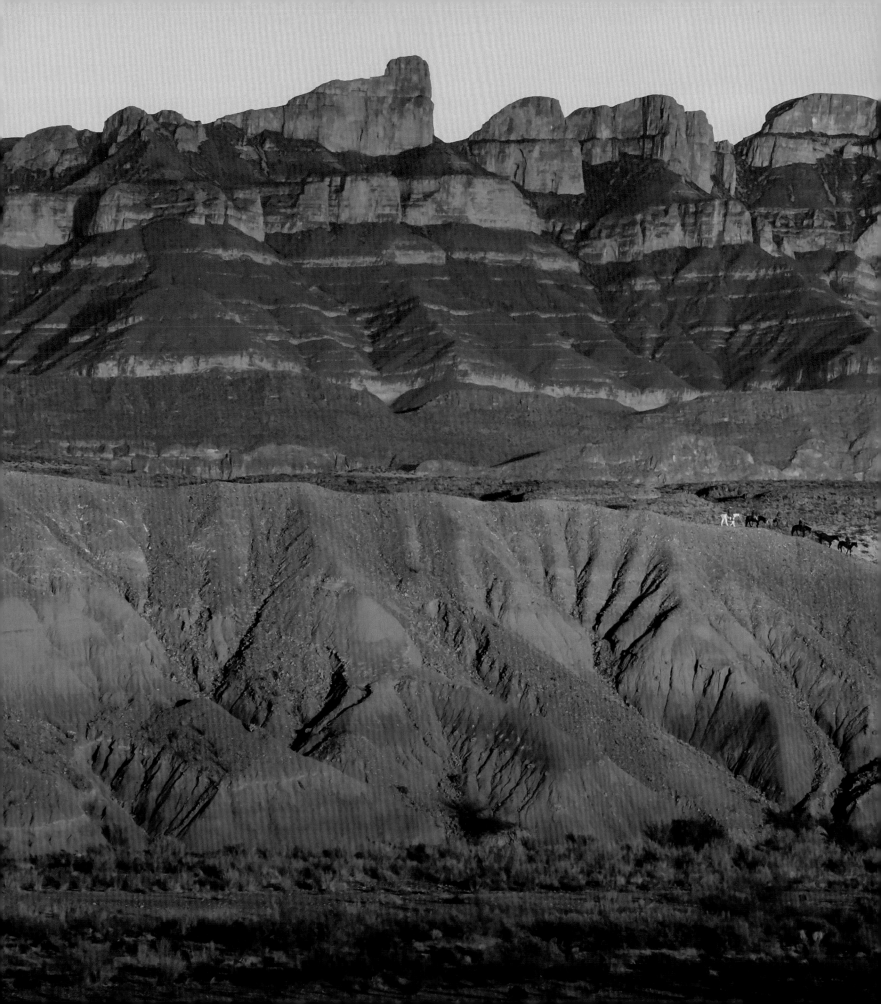

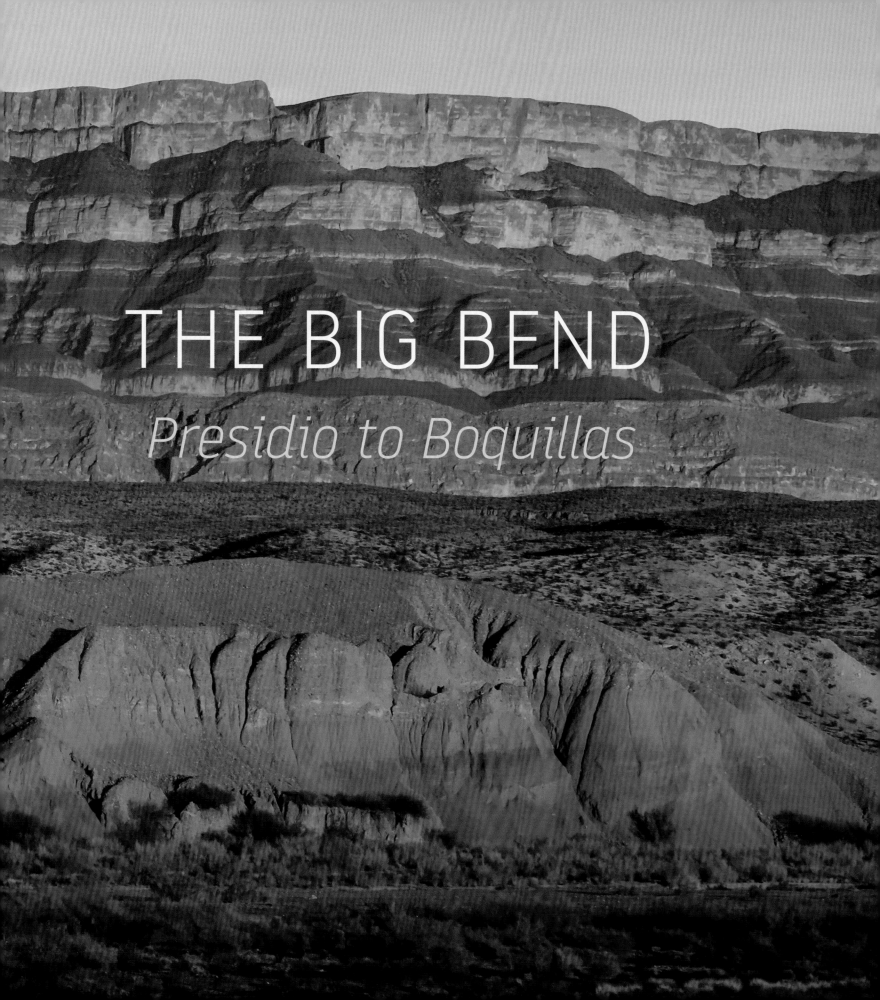

THE BIG BEND

Presidio to Boquillas

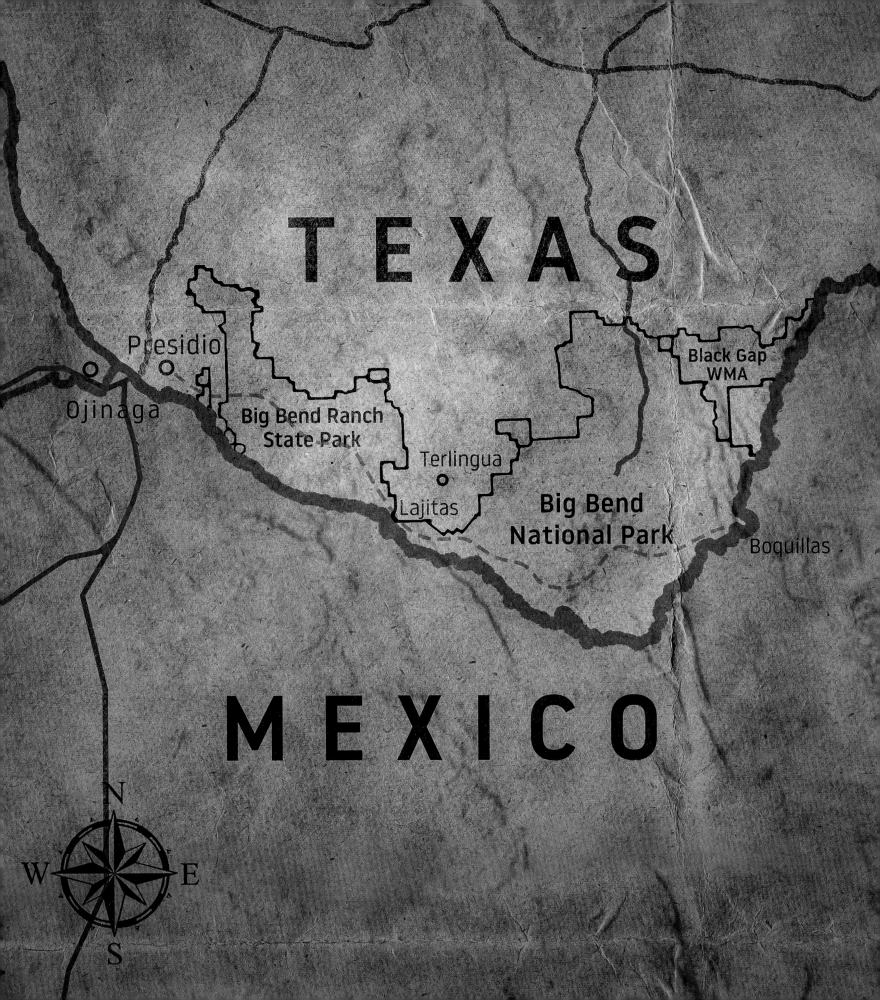

THE MUSTANGS

Ben Masters

I didn't grow up with horses, but I did my best to make up for lost time. At nineteen, I got a job shoveling manure on a dude ranch in Colorado. Not the most prestigious job, but one that gave me access to horses and the opportunity to ride in Rocky Mountain National Park. Hundreds of miles of trails surrounded the ranch, and I tried hard to ride every single one of them. We raced along narrow trails through pine forests, galloped the flat stretches, trotted the switchbacks, and summited peaks to soak in the views. I fell in love with both the partnership that can develop with a good horse and with the public lands that seemed to stretch on forever.

Coming from Texas, where a mere 5 percent of the state is public land, it felt exhilarating to be in a landscape devoid of fences, roads, and power lines. Freedom to roam is a beautiful thing. While most of Texas is fenced up, split apart, and locked behind gates, there is one glaring exception—the contiguous 1.2 million acres of public land found in Big Bend Ranch State Park, Big Bend National Park, and Black Gap Wildlife Management Area. I've dreamed of doing a horse ride through this unique part of Texas since I first saw it on a map.

In 2010, I had the life-changing experience of riding the Continental Divide Trail two thousand miles through New Mexico, Colorado, Wyoming, and Montana. We had a really tight budget for the trip and couldn't afford to buy many horses, so we decided to adopt and train a couple of untouched mustangs from the Bureau of Land Management (BLM). Roaming wild on public lands in the West, these horses had been gathered by the government to help control their populations. Because of their tough upbringing, they were perfectly suited for a long, cross-country journey, and they ended up outperforming the domestic horses we also used on that trip. They had no hoof problems, kept their weight on, and were incredibly sure footed through the rugged terrain of the Rocky Mountains.

That five-month ride completely changed my twenty-year-old outlook on life. It gave me a tremendous appreciation for nature, for public lands, and for the people who have fought to keep these landscapes intact over the past century. A sophomore at Texas A&M University at the time, I decided to transfer from the Mays Business School to the wildlife and fisheries sciences department and have been exploring, filming, and trying to understand the natural world ever since. That journey, with mustangs we had purchased for $125 each, also opened my eyes to a terribly tragic, misunderstood, and complex issue in the American West: wild horse management.

When the Spanish arrived in the "new" world in the sixteenth century, they brought with them the modern-day horse. Over the following centuries, some of those horses escaped, were set free, or were let loose to breed. As a result, feral horses thrived in North

America, and their populations boomed across the Great Plains and Texas. (Populations of feral cattle, donkeys, and pigs were also established.) The horse changed the lifestyles of many Native American societies, and it became an inextricable symbol of the American West. Over time, the feral Spanish horses mixed with other breeds—stock horses used to pull plows, thoroughbreds favored by the cavalry, ranch horses, and even Russian horses from Alaska. Through generations of natural selection, the *mesteños,* or mustangs, became amazingly self-sufficient, resilient, and tough.

As the West was settled, vast herds of free-roaming horses were rounded up and used for saddle stock and consumption. Only in the most remote and desolate parts of the country did the last remnant herds escape the mustangers. In 1971, after a hard-fought, decades-long campaign, horse lover Velma Johnston (a.k.a. Wild Horse Annie) managed to push through the US House and Senate the Wild and Free-Roaming Horses and Burros Act, which was unanimously passed. The act gave federal protection to the remaining wild horses and burros. But the legislation was not without controversy.

Shortly after the act became law, land managers, ranchers, and wildlife organizations became concerned about the growing number of protected wild horses and their impact on the natural habitat the horses, livestock, and wildlife all depended on. The Bureau of Land Management, the federal entity that primarily manages the animals, responded by creating Herd Management Areas that would ideally only contain what wildlife managers call the Appropriate Management Level of horses. Once the population of horses exceeded that number, the excess horses would then be gathered, transferred to holding facilities across the United States, and put up for adoption.

Unfortunately, adoption numbers haven't kept up with the number of horses that have been removed from the range to keep the populations in check. As holding pens filled up, lawsuits from animal rights organizations were filed against the BLM to prevent the excess horses from being euthanized or sold at auction. As a result, tens of thousands of mustangs are stockpiled in holding pens and leased pastures. The federal government spends more than fifty million taxpayer dollars annually to feed and house these horses. Living in feedlot style pens and crowded pastures, the horses don't have a semblance of their former "wild" life as they await for an adopter who rarely comes. It is a heart-wrenching situation with no easy solution.

Inspired by how awesome the mustangs were on that 2010 ride, I wanted to find a way to inform more people about the plight of the mustangs, and to help get more horses adopted. I approached a few friends at Texas A&M University about doing another journey, this time using only mustangs, and filming the entire process with the hope of inspiring people to adopt wild horses. In 2013, Tom Glover, Ben Thamer, Jonny Fitzsimons, and I adopted sixteen mustangs from the BLM, trained them with some professional guidance, and rode three thousand miles from Mexico to Canada through the most backcountry route on public lands possible. The experience was incredible. My friend Phill Baribeau directed the filming of the journey, and we created the documentary and book *Unbranded,* which turned out considerably better than any of us could have dreamed. Through *Unbranded,* we were able to get hundreds of mustangs adopted, and we raised more than $100,000 dollars for the Mustang Heritage Foundation's adoption programs, something I'm very proud of. You should adopt one, too.

Unfortunately, we weren't able to get all of the many thousands of horses in the holding pens adopted through *Unbranded,* and the magnitude of the crisis has continued to grow. As of March 1, 2017, more than 72,000 wild horses and burros ranged in an area meant for only 26,700. After the 2017 and 2018 foal crops, there are likely now more than 90,000 wild horses and burros in the same space, more than three times the Appropriate Management Level. In addition to these estimates, hundreds of thousands of additional wild horses and burros live on reservation lands and on public lands not officially designated for them. Wildlife biologists and rangeland scientists are seeing severe ecological impacts from an overabundance of horses across millions of acres of public lands in the American West. The Bureau of Land Management can't research and implement alternative methods to reduce their numbers because they spend the entire wild horses and burros budget on feeding the nearly 50,000 animals that are in holding facilities.

I've been involved in and studied this issue in both an official and unofficial capacity, and as it is a truly tragic situation, I wish more people would adopt a mustang because they can be phenomenal riding horses.

A huge perk from the *Unbranded* experience is that I now have seven really awesome mustangs that have quite literally traveled across the country with me. I can't describe how fulfilling it is to adopt a wild horse out of the holding pens, watch it progress through training, and see it become a super reliable teammate, so trustworthy I can ride with my three-year-old nephew. My best riding horse, Violet, was so scared when he was adopted that

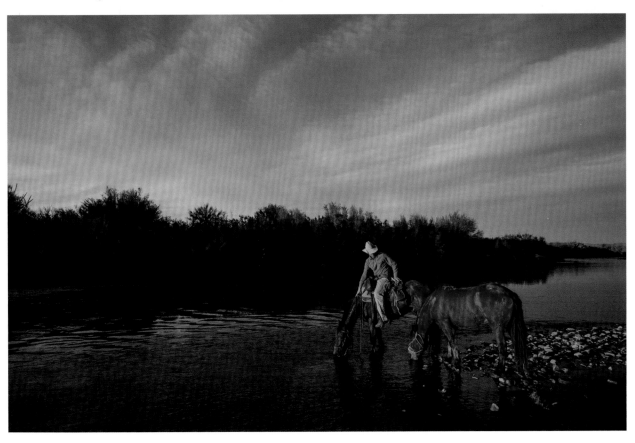

A five-month horseback riding journey in 2010 made me a dedicated mustang adopter (here are Violet and Stumbles) and public lands advocate.

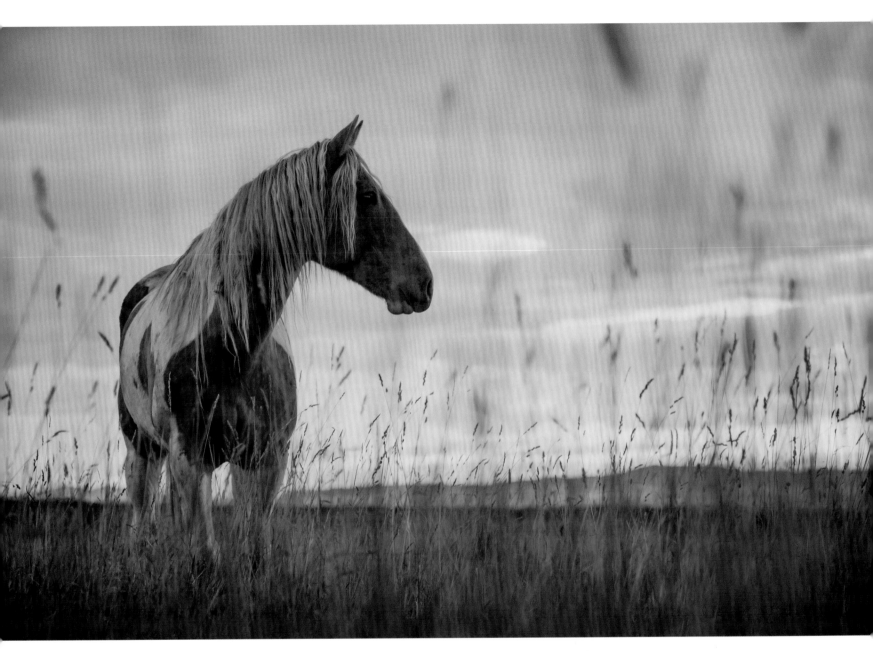

After being introduced to
North America by Spanish
explorers, mustangs like
Luke became an iconic sym-
bol of the American West.

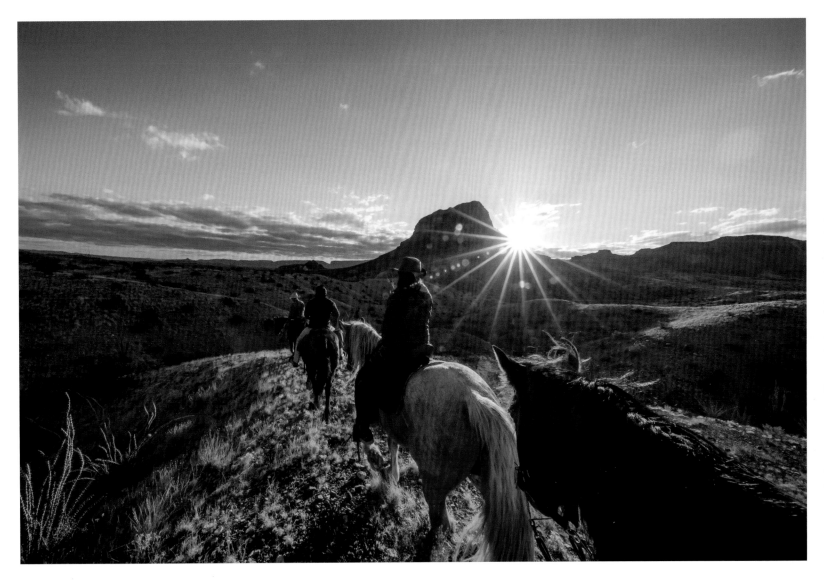

we considered getting rid of him as a possible lost cause. He's now the best mountain trail horse I've ever been on and might ever be on. I'm incredibly proud of each one of my horses, and they're all very different. They spend their winters in Texas and their summers in Montana, where they work as therapy horses for a backcountry veterans program called Heroes and Horses.

It's a good thing my mustangs have thousands of miles of riding experience because Filipe, Austin, and Heather had none—our trip along the Rio Grande was their first time to ride. Normally, I wouldn't subject a new rider to riding twenty miles a day for two weeks straight, but I trusted my horses would take good care of them.

We brought in some extra help for the horse portion of *The River and the Wall* trip because Big Bend Ranch State Park and Big Bend National Park have regulations that make riding horses really difficult. Although there are hundreds of feral horses, donkeys, and cows that regularly overgraze the landscapes along

Filipe, Austin, and Heather had no prior riding experience, but thankfully my mustangs did.

the Rio Grande, private parties are not allowed to let their horses take a single bite. Logistically, we needed hay, water, and outside support every single night during the ride through Big Bend in order to keep our horses well fed, strong, and fit.

I tried to match the horses' personalities with those of the riders. Because Jay was the most experienced rider, I gave him Luke, my wife Katie's palomino paint Wyoming mustang, who is responsive, reliable, and always cognizant of his appearance. Luke really loves Sour Patch Kids—also perfect for Jay. I matched Heather up with Dinosaur, my go-getter, red roan mustang from Utah, who can be mischievously curious and is always on the lookout. Dinosaur snacks constantly and is fascinated by birds, which reminded me of Heather. Austin got paired up with Tuff, my short, stocky, blue roan Spanish mustang, who plows through the brush and is as good of a teammate as you could ask for. Tuff always carries more weight than everybody else and loves a cold Lone Star barley pop in the afternoon, just like Austin. Filipe, our smallest team member with the biggest personality, got teamed up

with C-Star, the smallest mustang with the biggest personality. Together, they competed for the attention and love of Donquita, the adopted *Unbranded* burro who joined us for the journey.

For backup horses to carry gear and a camera operator, we brought Ford Mustang, a bug-eyed, quick-stepping, lanky Nevada bay, and Stumbles, a sure-footed, stocky Nevada bay who doesn't live up to his name. I rode my Nevada bay gelding, Violet, named in honor of the mother of a princess in Bahrain who helped support the making of *Unbranded*. Five of the mustangs were mine, whereas C-Star and Stumbles belong to Tom Glover and were his *Unbranded* horses. Combined, we became a crew of seven adopted mustangs, a Brazilian immigrant, three Texans, a Yankee, a mobile camera unit, and a donkey.

Stumbles, Dinosaur, Tuff, Luke, C-Star, and Violet proved themselves steady and reliable during our trek through the Big Bend.

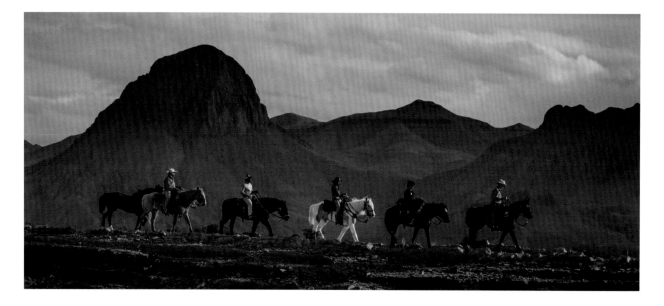

LEARNING TO RIDE

Heather Mackey

Before my journey down the Rio, I could count the number of times I had ridden a horse on one hand. Each of these experiences basically went the same way. I got a five-minute introduction to horseback riding from a guide and got on the horse. Each horse followed in line behind the leader, and my horse completely ignored all of my attempts to command it. This was the extent of my expertise in horsemanship when I traveled to Austin to meet the rest of the crew a few months before the expedition. During this visit, I met Ben's horses and we went for a short ride on the premises. Ben selected Luke, a trustworthy and dependable horse by his account, for me to ride.

We got off to a good start. Luke was a smooth ride, and he followed Ben's horse Violet so I had little need to direct him. However, things started to go south when Ben dismounted to open a gate into the neighboring pasture. Violet began evaluating the merits of walking over the cattle guard, forcing Ben to dash over to attend to him. He released the gate, which, without the support of a lock, clanked loudly to the ground. Startled, Luke sped off toward the barn while I clung desperately to the saddle horn. My sneakers slipped through the stirrups and my legs slammed erratically against Luke's sides. I remember realizing just how high I was off the ground and wondering nervously about the consequences

of falling off a horse. To my relief, when Luke arrived back at the barn I was still in the saddle. Ben quickly followed, calm and composed as always. While I struggled to pull my sneakers back through the stirrups, he warned that had I fallen off like that, I would have been dragged and likely trampled to death. This was my first real lesson in horseback riding—you are on a living creature with a mind of its own, so take it seriously.

Fast forward a few months, and we are in Big Bend Ranch State Park, about to meet the horses and our mascot, Donquita. I've traded my sneakers for cowboy boots and my spandex for jeans, but I still don't know any more about horseback riding.

When the trailer pulled in with the horses, I instantly felt transported to the Wild West. We immediately began lessons in proper horsemanship. I quickly picked up the technical aspects but missed some of the finer points about proper communication with my horse. On our first day of riding, we had twenty miles to cover before we reached camp, and it was already well past noon.

Before long, Ben identified a potential shortcut up a drainage that would save us at least five miles, and, hell, these were off-road mustangs we were riding. I was on Dinosaur, a sweet and dependable horse, with a disheveled head of dreadlocks. Unlike Luke, Dinosaur was not a smooth ride. Riding Dinosaur was like driving an old car with a tired transmission that

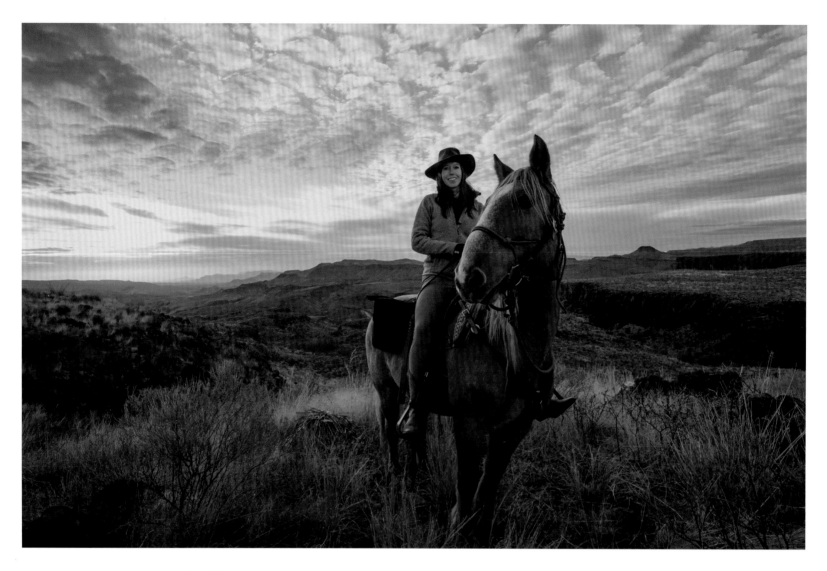

With minimal horse riding experience prior to *The River and the Wall*, I eventually got the hang of things, learning to appreciate horseback riding and the bond I formed with Dinosaur.

lurches between gears. When Dinosaur wanted to jump a stream, he recoiled his hind legs and then lurched forward. When he transitioned from a trot to a gallop, he skipped right into high gear. I swear if the name Stumbles hadn't already been taken by one of the other horses, that would have perfectly suited Dinosaur. I became even more acquainted with his traits when our drainage shortcut turned into a rugged canyon.

As the canyon walls closed in, we were faced with a decision: either turn back to the road or carry our horses up the canyon walls.

Sadly, unlike bicycles and canoes, you can't carry a horse. We turned back, having added an extra five miles to our day.

To make up time, Ben decided to trot the horses for a while. Jay helpfully gave us an overview of the appropriate riding techniques to use while trotting. I settled on "posting" primarily because it gave me moments of relief from sitting on the saddle. This basically looked like me bumping along on Dinosaur's back while clinging to the saddle horn. After a few minutes of Austin, Filipe, and me struggling with the trot, and many vocal complaints from

Filipe about losing the ability to have children, we switched to a gallop. I have no idea how long we galloped, but it felt like at least a half hour, the entirety of which I was wholly focused on not falling off Dinosaur. Day turned to night and we still had nearly ten miles to go. Somewhere in the blur of darkness and brilliant stars, Austin asked if walking next to the horse was an option. I cannot remember a time I was more grateful to walk on my own two feet.

Dinosaur is more than akin to an old car, though—he's steadfast and tough. Most of the time it was hard to imagine Dinosaur as a wild horse because of his affectionate nature, love of nose scratches, and generally calm demeanor around people. Yet there were times, like when we pushed through spiny ocotillo, or when he munched down on a bundle of cholla cactus, that I'd remember this was a gnarly mustang I was dealing with.

Once I began to wear bike shorts under my jeans and to learn to move with Dinosaur, I could appreciate the glory of traveling by horseback. Our second foray off the beaten

While Dinosaur was affectionate, he was also tough as nails and effortlessly handled the cacti and rocky terrain we traveled through.

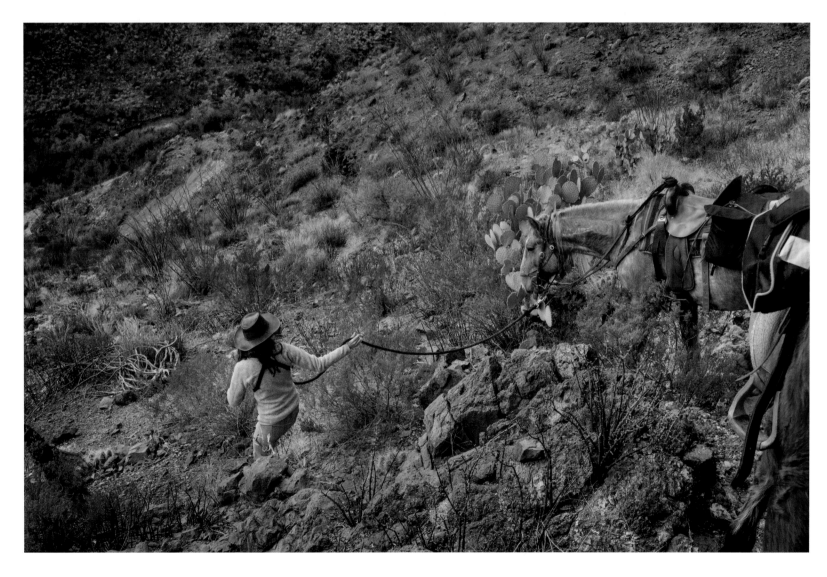

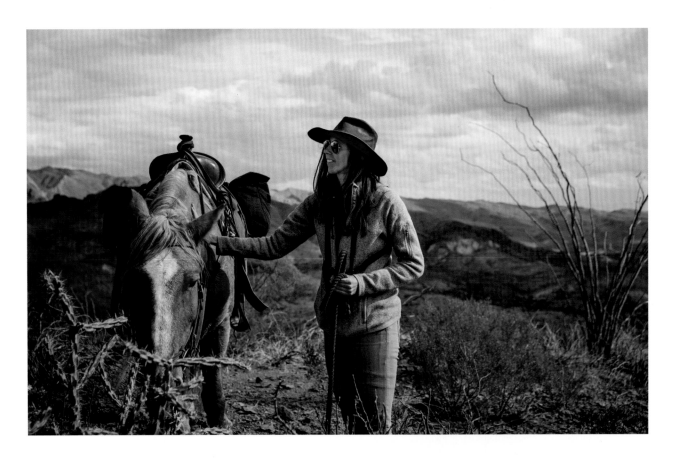

path went far better than our first as we cut a path from the Chorro Vista campsite to the eastern extent of Big Bend Ranch State Park. From our starting point, we could easily see sixty miles in every direction, including the Chisos Mountains emerging six thousand feet out of the floor of the Chihuahuan Desert. We began traveling down the plateau from Chorro Vista to the wide gravel bottom of Fresno Creek. The freedom of gliding over the landscape, high above the prickly-pear cactus and mesquite shrubs, was exhilarating. We reveled in looking across a vast landscape with no scars of human civilization and seeing a distant butte, knowing we'd soon reach it. Once again the image of the untamed, lawless West came to mind, and I felt the rush of discovering something new and unknown around each bend.

When the horseback riding portion of the journey began, I was counting down the days until I could use my own legs again and regain feeling in my butt. But as the journey progressed, I found I was reluctant to leave the horses behind. On the final day of our ride, we traversed a knife-edge ridge, nose to tail, as the sun dipped behind the Chisos Mountains and lit the Sierra del Carmens in brilliant hues of pink and gold. The ground was loose gravel and there were precipitous drops on either side, yet the tranquility of the moment overwhelmed any fear, and we rode triumphantly along the ridgeline.

I don't think I'll trade my bike for a horse just yet, even one as spirited as Dinosaur, but I also won't soon forget the feeling of riding atop that ridge or galloping across the open desert, my body in rhythm with my horse.

ME AND C-STAR

Filipe DeAndrade

Horses are spiritual beings. I find them to be gorgeous, powerful, and mindful creatures that command my attention in a way no human can. Growing up, I often fantasized about a life off the grid with nothing more than shelter, a woman, and a horse. But even with a lifelong affinity for horses, I had never actually been on one. The opportunity just never came up for me to ride a horse. Illegal immigrants living in Cleveland, Ohio, don't get ponies for Christmas—they don't even get Christmas. So when Ben Masters asked me if I wanted to join the team, I believe my first question was, "Can I ride a horse?"

I'll never forget the day a trailer showed up full of the most incredible ponies I ever did lay my browns on. It was the day I had most looked

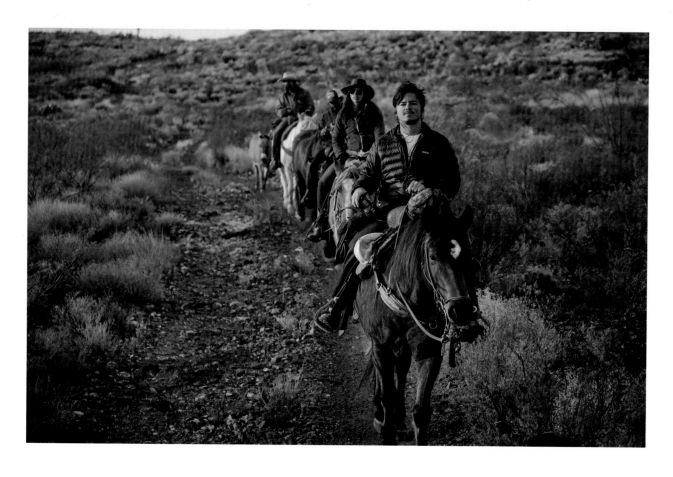

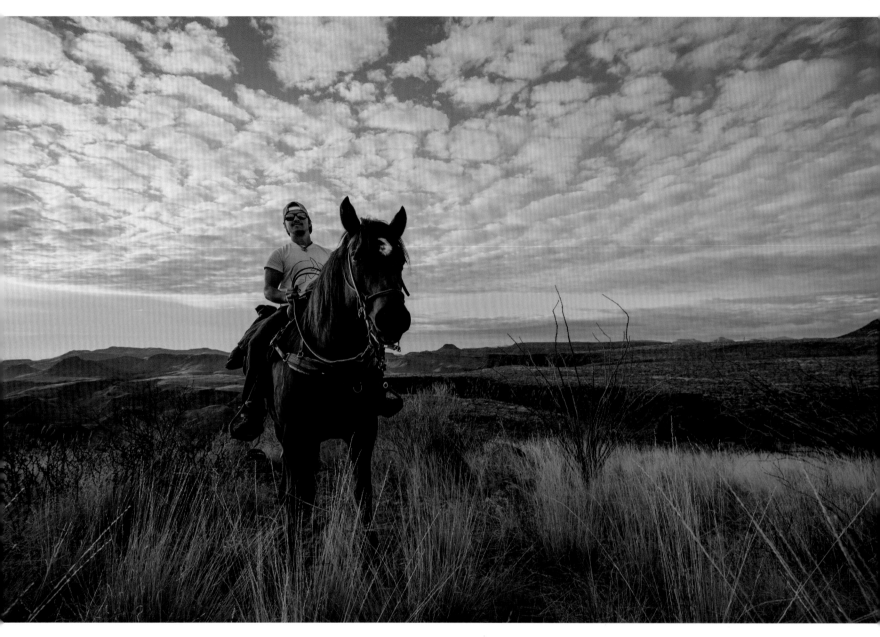

Fil and his mustang, C-Star.

forward to on the trail. But I had to calm my nerves. Horses have an uncanny ability to pick up on human energy.

Before I first draped myself over a perfect creature named C-Star, I wanted to get to know him. I let C-Star smell me. I talked to him, gave him some snacks, and assured him that I could be trusted. This allowed me to get to know C-Star and temper my own excitement before

going for a ride. Also, it's what I was told to do, so I listened to those with more knowledge of horses than I had.

When I finally did go for my first ride, it felt natural. C-Star is a great horse to learn with because he's experienced and fair. He takes what you give him, and with plenty of adventures under his saddle, nothing seems to faze him. I love that horse. Being

around accomplished horse people, I was able to learn quickly and keep up with the rest of the team. It also helped that Heather and Austin were learning how to ride as well.

After mile one, I felt great. The song "Cowboy's Lament" was replaying over and over in my head as I morphed into my new identity as a Brazilian conservation cowboy. By mile ten, I was lamenting something else. My testicles were killing me. Why did no one on the team warn me? The pain was simply unbearable. And we rode twenty-five miles in just the first day! Twenty-five miles bouncing on a hard leather saddle. I couldn't keep myself from complaining about the pain, nor did I try. I let the team know about every ten minutes in the most creative and colorful language possible what it was like. It got so bad that we began having physical demonstrations of how to prevent groin pains while riding. We would stop and talk it over. Jay and Ben showed me how to position myself to make sure I was riding C-Star correctly, but I just couldn't get it. The pain and the complaining carried on for the next six days.

But eventually I did figure out how to ride C-Star, and the last four days on that horse were four of the greatest days of my life. I consider myself hooked and fully intend on having horses in the future. Maybe I'll revisit that fantasy: shelter, a woman, and a horse named C-Star.

Donquita, the adopted *Unbranded* burro, joined us for the journey in Big Bend.

DESERT BIGHORN SHEEP

Ben Masters

On December 10, the day after we finished the first leg of the trip, bike riding through Big Bend, we decided to take a day off, charge batteries, and analyze logistics. Taking advantage of the break, Jay and I borrowed one of the camera crew's trucks and drove to meet some friends about one hundred miles northeast of Presidio at Elephant Mountain Wildlife Management Area (WMA). They were capturing desert bighorn sheep in a healthy population to be translocated to Black Gap Wildlife Management Area on the Rio Grande, where they would help replenish a struggling herd. I wanted to see it and I wanted to film it. That these sheep still exist in Texas is mind-boggling.

During the latter half of the 1800s and into the 1900s, much of the charismatic wildlife in the United States was nearly driven to extinction. The number of American bison plummeted from thirty million to mere thousands. White-tailed deer were extirpated from much of their range. Wild turkeys were greatly reduced, elk killed out of the plains, and an all-out government-funded war waged against bears, wolves, and mountain lions. Like so many other species, North American native bighorn sheep populations also plummeted, disappearing from much of their historic habitat. It wasn't until conservation visionaries such as Theodore Roosevelt, George Bird Grinnell,

and Gifford Pinchot became influential, both politically and socially, that wildlife laws were passed prohibiting market hunting, regulating individual hunting, and setting the stage for our native wildlife to begin a comeback.

And come back it has. Bison, once in the mere thousands, now number over a half a million. There are more white-tailed deer now than there likely have ever been. Turkey, elk, pronghorn, and mule deer have all bounced back from near depletion in the late 1800s. I believe that as a society we should be proud of the successful restoration of some of our wildlife species over the past century, but we should not take it for granted. Habitat recovery, research, and rewilding efforts in the United States have just begun.

Biologists believe that five hundred years ago, prior to European contact, desert bighorn sheep would have been found in about eighteen mountain ranges in what is now West Texas and along the rocky canyons of the Rio Grande. By the late 1800s, desert bighorn were nearly wiped out of Texas by a variety of factors—primarily market hunting, sustenance hunting, disease transmitted from domestic sheep and goats, and competition with domestic livestock. A few small populations of desert bighorn managed to survive into the 1900s, but by midcentury, they were whittled down to mere individuals. Eventually, they were extirpated from much of their historic range,

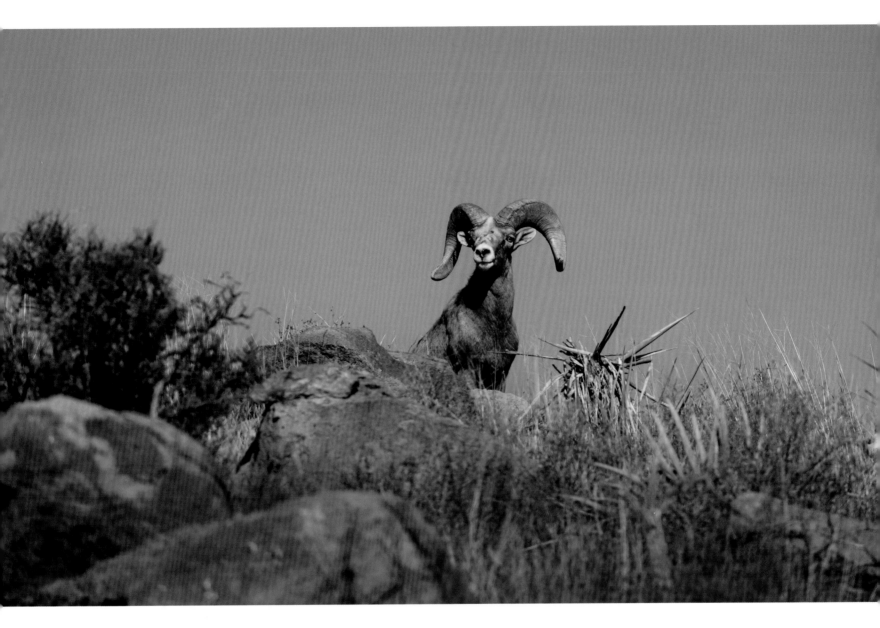

meaning they became locally extinct. For the first time in millennia, the native desert bighorn sheep, an iconic species that symbolizes the rugged nature of West Texas, was gone.

Then a group of ranchers, hunters, wildlife enthusiasts, and desert sheep supporters rallied together and began making plans to bring the species back into West Texas. The first reintroduction efforts occurred in the early 1970s, when sheep from Nevada, Utah, and Arizona

were released into a brood facility in the Sierra Diablo Mountains. In 1982, the Texas Bighorn Society was founded and began fundraising and lobbying to further the reintroduction efforts.

In 1985, inspired by the program, rancher C. G. Johnson donated the Elephant Mountain Ranch to the Texas Parks and Wildlife Department as a management area for the restoration of desert bighorn sheep. Twenty desert bighorn from the Sierra Diablo Wildlife Management

In the mid-1900s, conservationists came together to bring this iconic species back to the state. In a remarkable recovery, the population of desert bighorn sheep has gone from zero to over two thousand in the past fifty years.

Area were released onto Elephant Mountain. They took off. The habitat, size, and environment of Elephant Mountain was wonderfully conducive to desert bighorn sheep. The population grew quickly and has become the source of animals for other reintroductions.

Over the past forty years, the desert sheep population in Texas has gone from zero to more than two thousand. Half of the historic mountain ranges in West Texas once again have desert bighorn roaming their rocky cliffs. But success hasn't come without difficulty or controversy. Debates over predator management, invasion of the exotic aoudad sheep, and even competition by feral donkeys have been waged in meetings, the press, and the courts during the program's lifetime. No doubt mistakes have been made along the way, but I for one am grateful for the extreme efforts that has been poured into bringing back these mountain warriors to the cactus-strewn cliffs of West Texas.

When Jay and I pulled into Elephant Mountain at daybreak, there was still snow on the ground from the same storm that made our travel through the Forgotten Reach a cold, muddy mess. Two helicopters were firing up their engines, and three dozen people stood at the processing tables—volunteers from Texas Bighorn Society, Texas Parks and Wildlife employees, students at Sul Ross University out of Alpine studying at the Borderlands Research Institute, and a group of volunteers from the organization Stewards of the Wild.

Somehow I managed to talk my way onto a helicopter to film the sunrise over snow-clad Elephant Mountain and to get a bird's-eye view of the desert sheep capture. We took the door off the helicopter, and I bundled up and strapped in tight. Hanging halfway out of the chopper and holding a $50,000 camera with a death grip, I was off into the frigid morning air. My adrenaline started pumping as the chopper gained altitude and revealed a rising sun that cast a magical glow onto the winter wonderland of Elephant Mountain and the snow-clad peaks beyond. The beauty of the light pouring across the mountains made it extremely difficult to concentrate on filming.

After a few scenic shots, chatter over the radio told us the other helicopter had spotted a group of desert bighorn. We peeled out of pretty picture mode and flew to chase the action. Coming over a rise, we saw the other helicopter working a group of ten or so sheep that had no idea what was going on and were trying their best to run away. Their acrobatics running across the mountainside away from the helicopter were a sight to behold. The sure-footedness of desert bighorn is simply breathtaking. They can traverse a near vertical cliff effortlessly; one misplaced footstep would lead to a nasty fall and near certain death. The helicopter pilots knew this and pushed the desert sheep into flatter terrain. Once the helicopters had the sheep positioned in a safe area, a gunner in the backseat leaned out of the helicopter, drew a bead on the sheep, and pulled the trigger. An eight-foot diameter net flung out and landed on top of a very frightened ewe. The helicopter quickly landed and a different person, called the mugger, hopped out. I yelled to the helicopter pilot to let me down with the mugger, which he did.

Jumping out of the helicopter, camera in hand, I quickly ran over to the mugger. The ewe was fighting the net and bleating like, well, a terrified wild sheep caught up in a net. The mugger quickly put a blindfold around the sheep's head to keep her calm and sedated her for her own safety. He hobbled her feet and gently placed her into a sling specially designed to carry animals. He made a call to the helicopter pilot, who hovered over us and dropped a rope. The mugger clasped a carabiner onto the

rope, attached it to the sheep, now in the sling, and signaled for the helicopter to take off. I will never forget the odd feeling and sight of that blindfolded sheep in a blaze orange bag flying through the air back to the headquarters. Not wanting to miss the action, I hopped in the next helicopter to film the rest of the effort.

The helicopter slowly flew into headquarters and lowered the sheep down as gently as possible. Once it was safely on the ground, the rope was released and the helicopter flew back for more animals. The ground crew, which consisted of about thirty people who were Texas Parks and Wildlife employees, students, and volunteers grabbed the sheep that were brought in, took them out of their orange flight bags, and carried them to a table, where they stayed hobbled and blindfolded. As smoothly and quietly as possible, veterinarians and biologists worked to collect data. Blood was drawn for lab testing, temperatures checked for health monitoring, ear tags were applied,

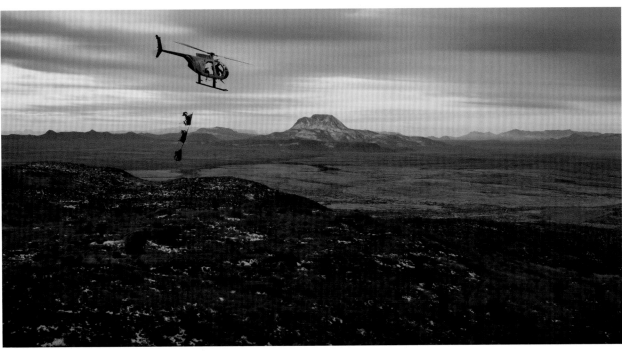

and some individuals were given GPS collars so that researchers could track and analyze additional data after release. The desert sheep were then quickly moved onto a trailer, where their hobbles and facemasks were removed immediately before loading. I can only imagine what was going through those sheeps' minds. Reintroduction efforts for us are a straight up alien abduction to them!

When the trailer was full, the sheep were quickly transported four hours southeast to Black Gap Wildlife Management Area, 100,000 acres of state-owned public land ranch on the

Jay and I participated in a translocation of desert bighorns to Black Gap WMA.

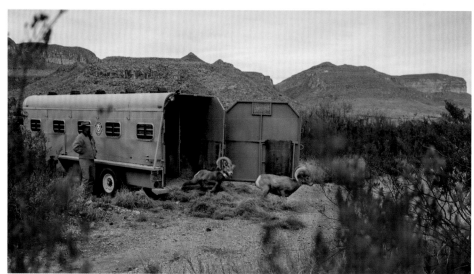

eastern boundary of Big Bend National Park. Black Gap includes twenty-five miles of the Rio Grande and holds some of the most striking scenery in the state. Its Chihuahuan Desert habitat supports black bear, mule deer, and an incredible array of both flora and fauna. Thanks to the reintroduction initiative, desert bighorn sheep once again roam the cliffs.

Upon arrival at Black Gap, the trailer gates were swung open and the sheep stepped into their new home. After a few timid steps, they took off into the desert. It was a hopeful moment. The released sheep could stay in Black Gap, they could cross the river to supplement the populations in Mexico, or they could move west into Big Bend National Park. Though there were many unknowns about what would happen, and a lot of habitat to recolonize, the dramatic cliffs that rise out of the depths of the Rio Grande are most spectacular when crowned with desert bighorn.

In two days, more than eighty sheep were successfully captured in Elephant Mountain WMA and transferred to Black Gap WMA in one of the largest and most successful translocation efforts of the desert bighorn. With luck, the population will grow and expand into surrounding areas. The GPS trackers will allow researchers to better understand habitat use, travel corridors, and dispersals and will give scientists insight into better management for desert bighorn sheep.

South of the Rio Grande, in Mexico, three large tracts, called Areas Naturales Protegidas, border the river. Combined, these protected areas in Mexico contain over two million acres of historic habitat for desert bighorn to reclaim. Mexican officials and conservation groups are working hand in hand with US biologists to restore these areas as an ecosystem united by the Rio Grande rather than divided by it. CEMEX, a Mexican concrete company, has

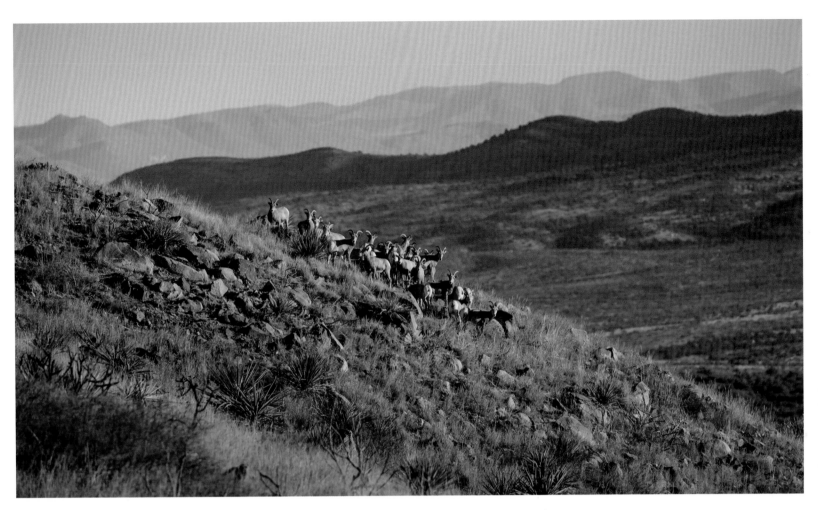

acquired vast tracts of land in the Sierra del Carmens mountains immediately south of and across the Rio Grande from Black Gap WMA. The company has been instrumental in helping establish desert bighorn sheep on the Mexican side of the Rio.

It takes cooperation, money, time, and luck to successfully bring a species back. It's also easy to take this success for granted. A month after we witnessed the desert bighorn capture and release, we were canoeing through Black Gap WMA. Taking a bend in the river downstream of Heath Canyon, we encountered a group of a dozen bighorn sheep. Looking

through binoculars, I could see the ear tags. They were the same sheep we had filmed being released a mere month prior! They had just finished drinking from the river and were standing on a hillside watching us canoe past. For me, it was one of the most emotional moments of the journey. I had had a glimpse of the hard work and dedication that was required to put those sheep on the mountain. I'm truly thankful for the dedication of all the organizations, volunteers, landowners, and agencies who have helped create a world shared by wildlife as magnificent as the stately desert bighorn.

THE DRAW OF THE BIG BEND

Austin Alvarado

first saw the Big Bend as a teenager while on a Troop 5 Boy Scout trip. While I can't recall the details very well, I clearly remember the feeling of awe when we reached the South Rim. The hills rolled away from the mountains like waves breaking onto the desert floor. As the desert reached deep into the badlands, mountains unexpectedly burst in the air, filling the sky with islands. This stunning beauty was enough to fill anyone with disbelief, but the feeling did not come entirely from what I was seeing. It was a result of thinking that people like me shouldn't get to experience things like this.

Going to wild places was for people with

more money and time than I would ever have. It was a benefit of being "well-off," and somehow I had fooled my way to Big Bend. The outdoors seemed foreign to me, seemed more "American" than I actually was. It wasn't that people were ever anything less that welcoming; it was more about my feeling of not belonging. Being the child of Guatemalan immigrants in a Boy Scout troop filled with mostly Anglo middle-class families caused me to remember constantly that I was different. People in the troop were kind, generous, and thoughtful, but I couldn't shake off the discomfort of not belonging. On the Big Bend trip, I was completely out of my element, and I couldn't comprehend what had led me to this special place on Earth, the South Rim. As an awkward, shy, and confused kid, all I could do was smile politely and admire the spectacular view.

Fast-forward to my college days when outdoorsman Greg Henington came to speak to one of my recreation, park, and tourism sciences classes at Texas A&M University about the challenges and rewards of conducting business in a national park. At the end of his presentation, he mentioned he was the owner of Far Flung Outdoor Center, the leading outfitter in Big Bend. I remembered how beautiful the area was when I had gone as a Boy Scout, and I figured there would never be a more appropriate time in life to spend recreating outside than in college. I spoke to him about the possibility of completing my required internship in the

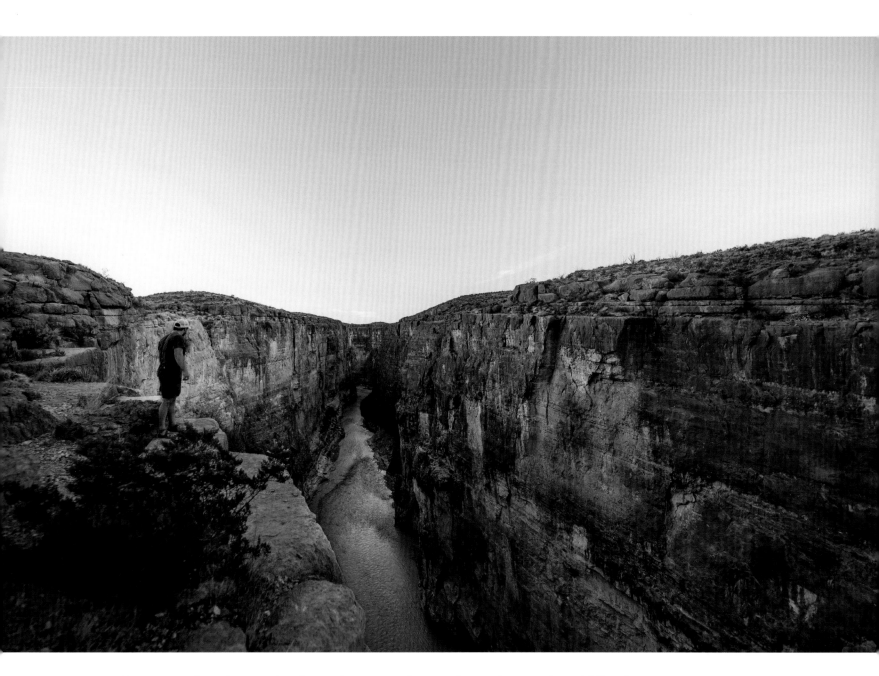

Big Bend. He agreed, and a couple of months later I found myself guiding tourists along the Rio Grande.

I spent most of my free time that summer exploring the area on my own. Solitude became part of the adventure, and vulnerability was my companion. What I found was that being alone in the Big Bend forces people to expose themselves to themselves. In the middle of summer in the Chihuahuan Desert, most people take care of their daily activities in the early mornings or later in the evenings. The rest of the day is spent trying to find what little shade there is. I learned to accept the discomfort as normal, and it was in this discomfort that I learned a lot about myself. It's easy to admire Big Bend

Peering into the depths of Santa Elena Canyon, one of the many canyons I've guided river trips through.

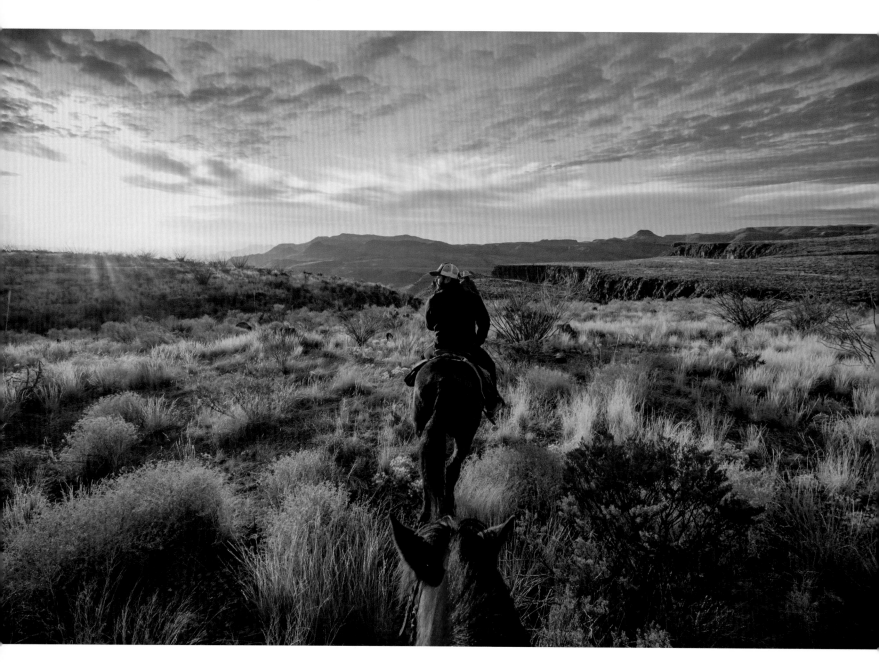

Getting to ride through the Big Bend on horseback was incredible. I'm grateful to have had the experience of seeing the landscape from a different perspective, all while connecting with Tuff.

from afar. The sheer size is enough to make you stop and appreciate it. But to truly get the most out of this place, you have to be willing to get past being uncomfortable and adapt to its harsh terrain. This is when the Big Bend shares its real treasures. When I began finding all these treasures, I started to realize the sense of ownership I felt for Big Bend. It is probably

something everyone living in Big Bend shares. Though we all took different paths to get here, we understand the effort that was needed to stay. I started finding community—unknowingly and gradually creating a sense of home.

The majority of my time was split between two places that summer, the Chisos Mountains and the Rio Grande. The Chisos Mountains are

the heart of the Big Bend, but the Rio Grande is the lifeline. In its resilience it has survived drought, misappropriations, and political misconduct. Through all these difficulties it still manages to sustain life in the Big Bend, along the way creating some of the most pristine landscapes in the state of Texas. People who have not seen them firsthand may know of the river's canyons, but seldom do they understand their scale. Enormous walls line miles of the Rio Grande and extend into the desert beyond, creating sets of ribbons that stitch the whole of the Big Bend together.

Rivers are often regarded as metaphors for life, and the Rio Grande is no exception. It fluctuates from extreme to extreme, drought to flood, but never loses its pulse. It continues flowing, and when one channel disappears it creates another. In the river's stubbornness to continue flowing and its adaptability to changeable conditions I find the resemblance to my life. I have attempted to separate my upbringing as a child of illegal immigrants from my status as an American, which is not to say I am ashamed of my past, but that it shouldn't be the deciding factor of my merit: judge me on my stubbornness and my adaptability. The Rio does not discriminate. It is truly a great equal-izer and humbles any ego. It does not matter where someone comes from, how much money someone has, or what their status on this planet is. The only thing that matters is respect for the river.

With everything the Big Bend and the Rio Grande have given me, I want to try to learn as much as I can about them. Part of what really captures my imagination is the region's human history. Seeing this rugged and beautiful land on horseback, as so many explorers did way back when, had been a goal of mine for a while. As we got closer to the Big Bend on our expedition, where we would leave the bikes for horses, my eagerness grew. I was excited to see the place I knew so well from a new perspective. When the time finally came, it was unlike anything I had experienced. I'll admit I had a steep learning curve, but even as an inexperienced rider it was hard not to feel cool on a horse, especially a horse on top of a mountain. To ride through what seemed like endless miles on an animal you have connected with was an incredible feeling, and letting the horses open up and find their stride as we galloped through the vast desert was like something out of a movie.

BLACK BEARS

Ben Masters

The first black bears I ever saw in Texas were in the Chisos Basin in Big Bend National Park. There were two of them. They were making more black bears. I really wanted to look at the bears because they are super rare in Texas, but I felt like a huge creep staring at them engage in courtship behavior through my binoculars. To make it worse, I started chasing them with my camera to get the action in high definition and slow motion with a 600mm lens.

I was shooting a short film for National Geographic about the different species of wildlife that would be impacted by a border wall. Black bears would definitely be one of them, and that's why I was there, to document their miraculous existence and their inspirational recovery, a recovery that definitely depended on reproduction, a behavior I always feel bashful about filming.

The romantic bears were around six hundred yards away when I first saw them. I parked the car, grabbed my forty pounds worth of camera, lens, and tripod, and started hiking in pursuit. Fifteen minutes later, drenched in sweat early on a summer morning, I peeked

While black bears historically were found throughout most of Texas, a variety of factors contributed to their extirpation by the mid-1900s.

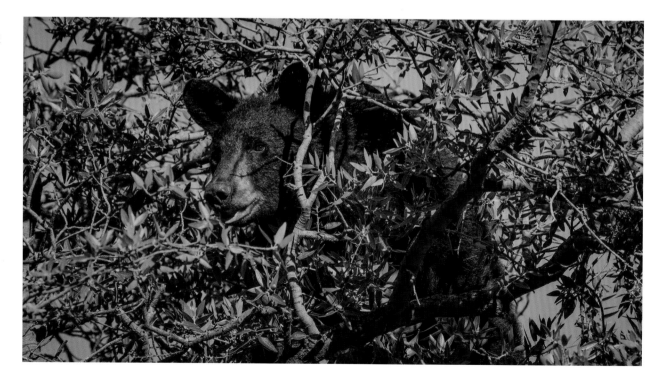

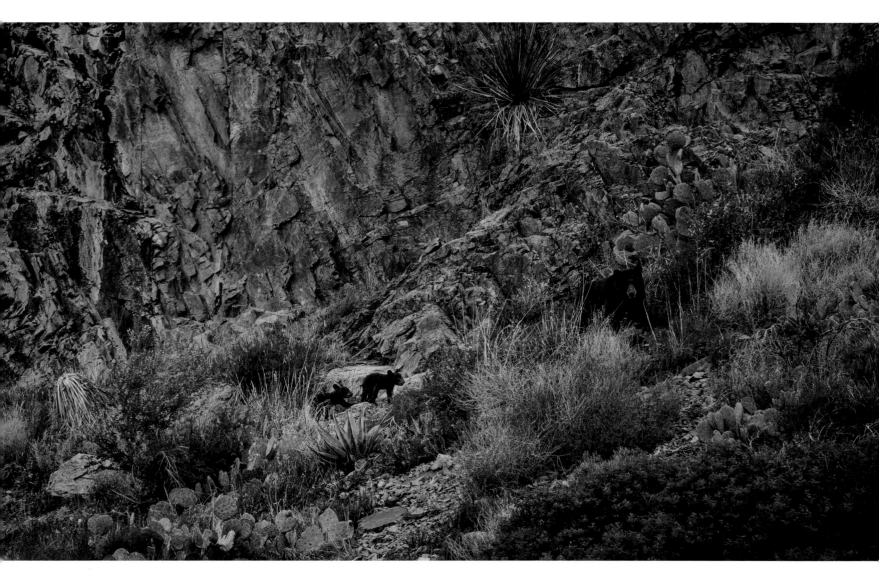

over a ridge where I at last spotted them. They were still hanging out together, turning over rocks, lounging on boulders, and climbing oak trees. I set up my tripod and filmed them until the light was gone. It was a profound experience and a truly remarkable encounter. Large mammals, or megafauna, once eradicated rarely reclaim their lost habitat without the help of humans, but these bears were a shining exception.

Black bears historically existed throughout most of Texas. Grizzly bears were here too, the

last of which was killed in 1899 in the Davis Mountains, north of Big Bend. Habitat loss, persecution from ranchers, trapping, poison, and unregulated hunting led to their demise. Nobody knows exactly when black bears were extirpated from Texas, but sightings and reports consistently declined into the 1900s. By 1944, the year Big Bend National Park was established, they were virtually gone. Populations continued to exist south of the border, in the high Sierra del Carmens and Sierra del Burros in Mexico, and a wandering male bear occasion-

Hope for the future of Texas black bears returned in the '80s when a female black bear crossed over from Mexico and had cubs in Big Bend National Park.

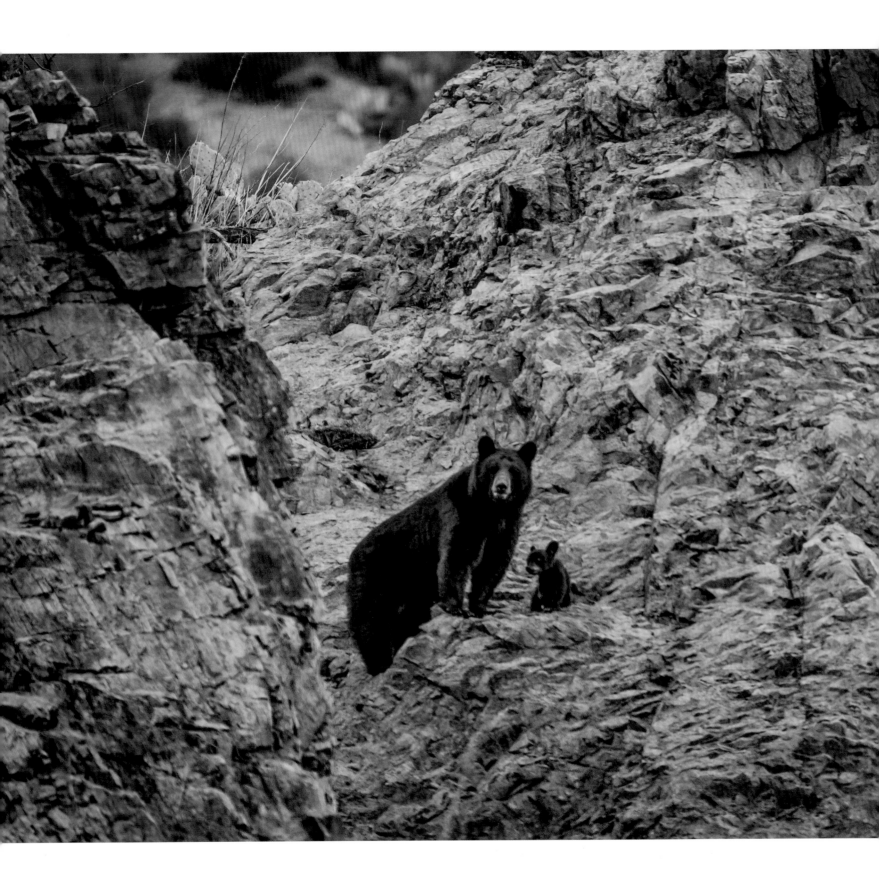

ally crossed the border, but a viable population did not exist. That all changed in 1988.

Sometime in the 1980s, a female black bear came out of the mountains in Mexico, crossed the Rio Grande, and entered the Chisos mountain range in Big Bend National Park. It's unknown whether she was pregnant when she began her trek or whether she encountered a male who had also made his way into the Chisos. What is known is that a picture of her and three cubs surfaced in 1988, providing documentation that breeding bears were back. Over the following decades, the bear population slowly increased to the point where, during my three weeks of searching for and filming bears in Big Bend, I saw a bear every single day except one. The population is thriving in the Chisos Mountains, and they are beginning to spread into other mountain ranges in Texas. They are commonly spotted in Big Bend Ranch State Park and Black Gap Wildlife Management Area and have been caught on trail cameras as far north as the Davis Mountains. Bears have been observed in the river canyon country around Del Rio, and sightings have been verified as far north as Kerrville in the Texas Hill Country. In addition to the expanding population in West Texas, black bear sightings in East Texas have been on the rise as well, due to dispersing bears from Louisiana and Arkansas.

According to Louis Harveson, the director of the Borderlands Research Institute and professor of wildlife management at Sul Ross State University, a border wall in West Texas would greatly reduce the chances of black bears recolonizing their former habitat in West Texas. Assuming the wall would be built somewhere close to the Rio Grande, which is a big assumption due to the huge geographic challenges, the black bear population on the north side of the wall would be isolated from the source popu-

lation in Mexico. While nobody knows exactly how many bears would be isolated north of the wall, if it is built, it's highly possible that the population wouldn't be large enough to sustain itself and continue to grow, ending the likelihood that bears would return permanently to West Texas.

Two months after we completed *The River and the Wall* trip, my wife, Katie, and I took a float trip down the Lower Canyons of the Rio Grande between the little towns of La Linda and Dryden. Toward the end of the trip, just where San Francisco Canyon runs into the Rio Grande, we heard the cane snapping next to the river where we were paddling. We kept quiet, wondering what it was. A few moments later, a large black bear stepped out of the river cane and onto the water's edge. It was a mere seven to ten yards away. It stopped in its tracks, looked at us for a second, and then bolted back into the cane. We paddled across to the other bank to get a better angle on the adjacent hillside. A few minutes later, the bear came into view, walking up the opposite hill, a mother bear, and following close behind her were two cubs. They were large cubs, born the year before. We stared in awe. That desert country was good enough habitat for the mother not only to make a living but also to give birth to two cubs and manage to keep them alive for fifteen months.

I often wonder where those cubs will go in their lives. Will they live in the steep terrain of the lower canyons? Go south into Mexico? Or will they head north, perhaps to start a new population along the Pecos River, the Devils River, or even in the Hill Country? The important thing is that we give them a chance to go without a physical barrier to stop their progress. I wish them the best.

(at left) Black bear populations are now thriving in the Chisos Mountains and spreading into other parts of Texas. Construction of a physical barrier at the border would significantly hinder their chances of establishing a healthy population in Texas.

THE YELLOW-BILLED CUCKOO

Heather Mackey

It had been five months since I had seen River Road West in Big Bend National Park, but when I arrived there in December, it felt like I had been there just the other day. Up until now, everything on our journey down the Rio had been new to me, but this road was different. I knew every bend and pothole of this road. I had spent the past two summers racing against sunrise on River Road West, dodging badgers, nighthawks, and the occasional mountain lion in a white F-150 pickup. Just as the sky beyond the Sierra del Carmens began to light up, I'd pull off along the side of the road and scamper off into the mesquite. Somewhere between eight and ten hours later I'd emerge, red-faced and mildly disoriented, back at the truck. During this time the temperature had gone from 85 to 115 degrees, and I had conducted ten bird and butterfly surveys, covering about ten miles in the process. If I was lucky, I may have heard a cuckoo or two. And if luck was truly in my favor, I may have even seen one.

As part of my graduate research, I spent two years studying the habits of an enigmatic species of bird called the Yellow-billed Cuckoo. Named for the color of its lower mandible, the Yellow-billed Cuckoo breeds throughout North America and migrates as far south as Argentina in the winter. Cuckoos closely track food resources, appearing in areas with recent insect outbreaks and consuming massive quantities of cicadas, tent caterpillars, and gypsy moths. During these times of abundant food resources, they may lay their eggs in other birds' nests, allowing another species to foster their young. Cuckoos have one of the shortest nesting cycles among any bird species. From the time they lay an egg to a chick leaving the nest can be as little as seventeen days. The nesting cycle of most bird species is more than twice this length. A relative of the Greater Roadrunner, they also share the habit of evicting nestlings that don't develop quickly enough. When the nest is threatened by a predator, one parent will stay by the nest while the other will perform an intimidation display, spreading their wings and flicking their tail from a visible perch. Besides these distraction displays, cuckoos are rather inconspicuous. They perch motionless, waiting to attack their prey, and their long, slender wings render them silent in flight. Many of these traits make the cuckoos a challenging study species but at the same time all the more fascinating.

In 2014, the species was officially classified into two distinct populations, with the western subspecies listed as federally threatened by the United States Fish and Wildlife Service (USFWS). The range of the western subspecies contracted by over 90 percent during the last century as its preferred habitat was converted to agricultural lands and urban areas, and water was diverted away from its riparian breeding grounds. The eastern subspecies is also declining, but it still has healthy populations throughout the deciduous forests of the eastern United States and is not considered to be in immediate peril.

After spending two summers in Big Bend National Park studying the Yellow-billed Cuckoo, I felt a comfortable familiarity returning to the area.

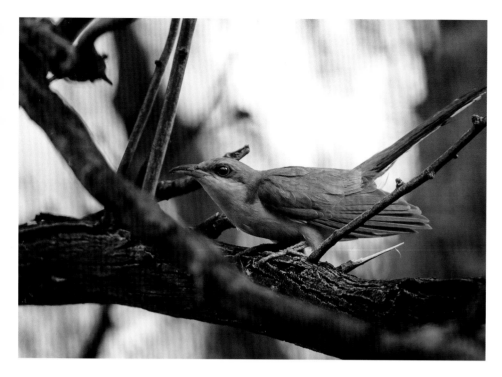

There are two subspecies of the Yellow-billed Cuckoo in the United States, and their populations officially diverge right in the middle of Big Bend National Park.

Cuckoos were the reason I spent so many mornings skulking around the Rio Grande floodplain, having my clothing and skin torn by catclaw acacia and crawling through doghair willow thickets until I was brought to tears. Now I was back on this familiar road, on the back of a horse no less. The landscape was the same, but the river had changed and the birds were different. With the heat of summer long behind us, we'd awake to cool mornings, the river and bosks blanketed in fog. A few of the songs emanating from the forest were familiar voices from my summers in the park, but most were birds I knew from up north that, like winter Texans, had migrated south for the season. The forests had lost much of their summer color, the Summer Tanagers and Painted Buntings had left, and the Yellow-billed Cuckoo was conspicuously absent. My inner biologist was struck by how little I truly understood about the place I had spent two years studying and by how important it seemed to be out in the field, observing species in their natural state.

Like the Rio Grande itself, there is much we have yet to learn about the cuckoo. My fellow graduate student Julie Coffey and I found that there were Yellow-billed Cuckoos throughout the Big Bend stretch of the Rio Grande. They were clearly nesting there and seemed to prefer the honey mesquite bosks, the closest thing they could find to mature forest in the floodplain. However, these findings only seemed to prompt more questions. One question that I kept coming back to was how habitat on both sides of the Rio Grande might affect cuckoos. Is it important to have large patches of old growth forest on both the US and Mexican sides of the river? Or, are scattered, small patches enough to support cuckoos? Hopefully, future research will provide us with answers to these questions.

Interestingly enough, the border that splits the two populations cuts right through the heart of Big Bend National Park, at Mariscal Canyon on the Rio Grande. There is a high level of uncertainty surrounding this somewhat arbitrary dividing line, but according to the USFWS listing, this is the spot where the two populations officially diverge. My research wasn't so much to determine which population Big Bend's cuckoos belong to, which can only be done with gene sequencing, but to figure out whether there was an established breeding group in the park and, if so, which habitats they were using. Cuckoos are known to nest in cottonwood and willow forest, which have become increasingly scarce on this stretch of the Rio Grande. Settlers cleared these riparian forests years ago for fencing and building materials. In Big Bend, most of the Rio Grande floodplain is now dominated by thick bosks of honey mesquite, a hardy species that could only be called a tree in the desert.

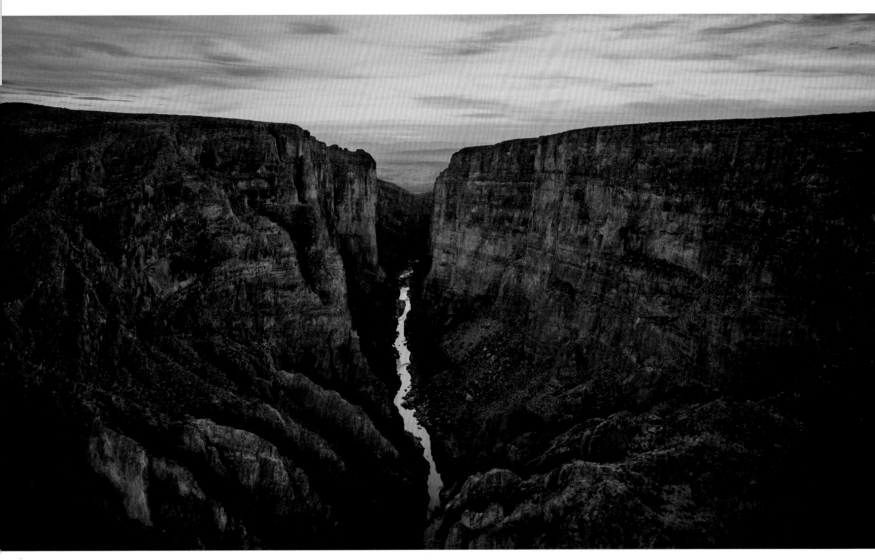

In 2014 the western subpopulation of the Yellow-billed
Cuckoo was listed as threatened under the Endangered
Species Act due to steep declines over the past fifty years.
Under this decision, Mariscal Canyon in Big Bend National
Park was identified as the dividing line between the east-
ern and western populations.

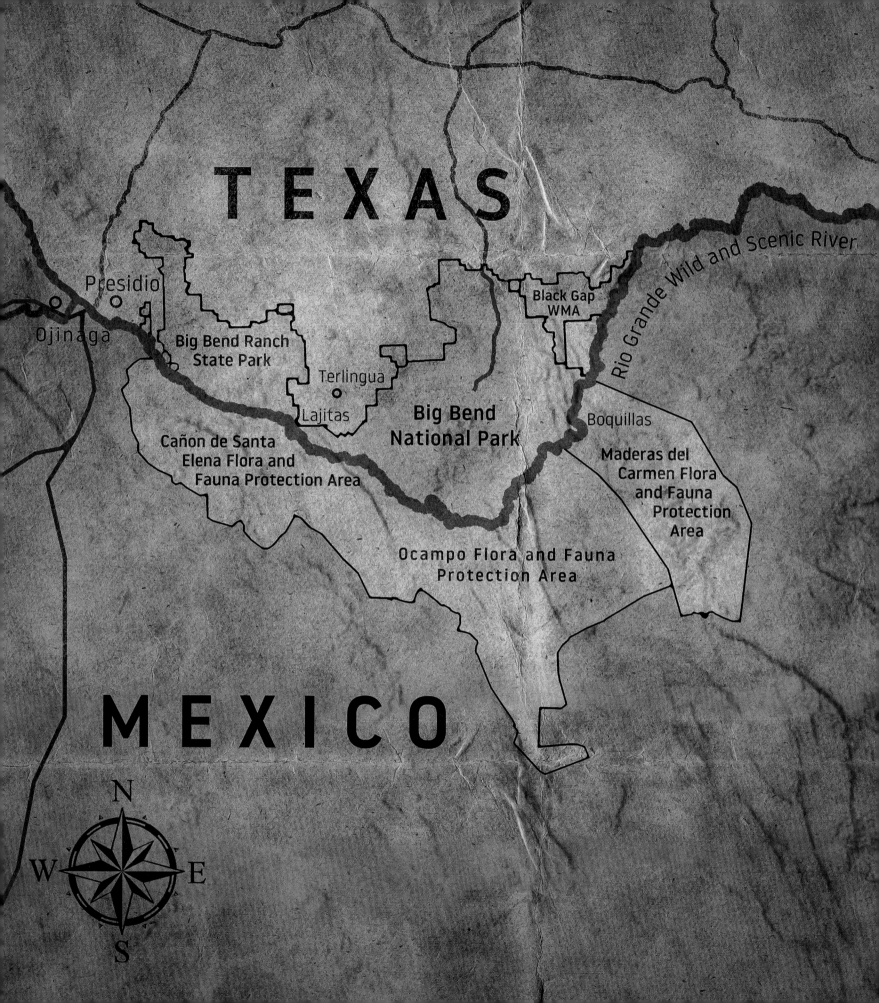

THE INTERNATIONAL PARK IDEA

Jay Kleberg

t's difficult to comprehend what a binational park designation would mean, not just to the black bear, mountain lion, and desert bighorn in this vast, remote wilderness but to the world. The Big Bend is some of the most rugged and breathtaking terrain in North America. Limestone shelves four stories thick rise seven thousand feet from the desert floor, towering above the oak and pine forests of the Sierra del Carmens that stretch into Texas and southeast into Mexico. From the shadow of El Pico, the Rio Grande meanders through desert shrubland and 1,200-foot canyon walls. At three million acres, it would be larger than Yellowstone and one of the greatest conservation and international relations victories of the twenty-first century. The idea isn't new, it's merely one that has been biding its time.

By looking at the maps provided by the National Park Service, it's difficult to differentiate which mountain range or deep canyon belongs in the United States or Mexico. Even in the mobile trailer that houses Mexican customs in Boquillas del Carmen, Coahuila, Mexico, the maps taped to the wood paneled walls show both sides of the Big Bend in the Rio Grande as one block of more than three million acres of wilderness. Upon further inspection, the river not only provides a reference point for the dividing line between nations, but it also serves as a symbol of a shared resource and an idea for an international park that is eighty-four years old.

Big Bend National Park is Texas' first national park, established in 1944 by Congress. Texas took its time setting land aside for federal protection, trailing America and the world's first national park, Yellowstone, by more than seventy years. As part of the negotiation to enter the union, Texas retained its public lands, and even today, the federal government owns less than two percent of the state. Big Bend National Park was a gift—a piece of North America's largest and most diverse desert ecosystem—from the people of the Lone Star State to the nation.

Four months after signing the bill to establish Big Bend National Park, Pres. Franklin D. Roosevelt wrote a letter to His Excellency General Manuel Avila Camacho, president of the United Mexican States. Roosevelt states, "I do not believe that this undertaking in the Big Bend will be complete until the entire park area in this region on both sides of the Rio Grande forms one great international park."

The idea of an international park between the United States and Mexico was not without precedent. In 1932, in response to World War I, Waterton Lakes National Park in Alberta, Canada, was combined with Glacier National Park in Montana to form the world's first international peace park. Waterton-Glacier's Goat Haunt Port of Entry enables backpackers to hike continuously from one country into the other with the same customs and immigration procedures found at Big Bend's Boquillas Port of Entry. Waterton and Glacier National Parks

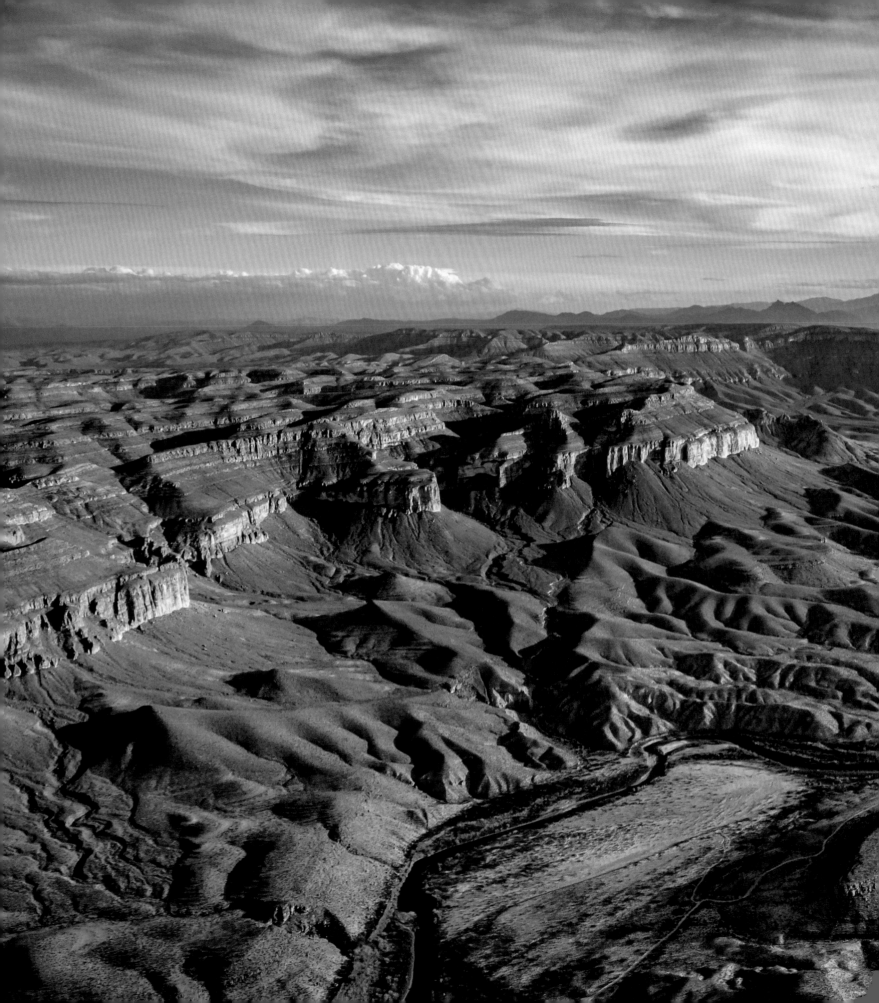

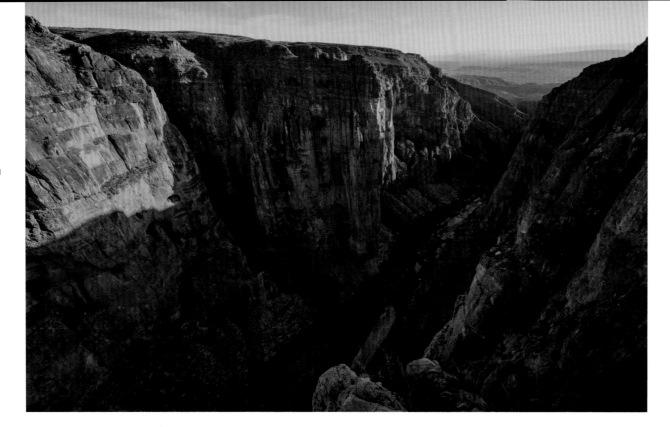

Protected areas on both sides of the Rio hold promise for the creation of an international park on the Texas-Mexico border, an idea first proposed by President Franklin Roosevelt.

work together on many issues, but they retain political, administrative, and financial independence from one another.

Tangible progress on the international park along the banks of the Rio Grande slowed through the 1980s. It wasn't until 1994 that the pace picked back up. Mexico established the Cañon de Santa Elena and Maderas del Carmen Flora and Fauna Protected Areas in Chihuahua and Coahuila, and again in 2009 they designated the Ocampo Protected Area. Mexico's efforts helped solidify a contiguous set of conserved landscapes on both sides of the border that also include the wild and scenic river stretches of Rio Grande, the Rio Bravo del Norte National Monument, Big Bend Ranch State Park, and Black Gap Wildlife Management Area.

In 2011, the United States and Mexico agreed to a binational conservation initiative and working plan to continue coordination in the protection and preservation of the Big Bend/Rio Bravo region. Since then, national and regional stakeholders, which include more than thirty government, nongovernmental

organizations, and private stakeholders from the United States, have established the Desert Landscape Cooperative and the Big Bend Conservation Cooperative to collaborate on transboundary conservation efforts with Mexico's federal environmental authorities.

In 2015, US Secretary of the Interior Sally Jewell joined Mexican Environment and Natural Resources Secretary Juan José Guerra Abud, US Ambassador to Mexico Anthony Wayne, US Rep. Will Hurd, and other local leaders to celebrate the two-year anniversary of the Boquillas Port of Entry (which was reopened after closing in 2001) and the ongoing binational conservation initiatives in the region. At the ceremony, Secretary Guerra reiterated Mexico's commitment to collaborate across international boundaries and added, "The Big Bend Rio Bravo Conservation Initiative is a model envisioned by our presidents; it is a dream shared by many past generations, and a legacy for present and future ones. In sum, it is an example of the best our governments and people can pursue through cooperation and joint work."

While our two nations have made progress to coordinate conservation efforts, the dream of an international park still holds its challenges. Communal properties, known as *ejidos*, and private landholdings lie within the protected areas in Mexico and would require access permission. While the Big Bend region historically sees the lowest rates of illegal cross-border traffic on the US-Mexico border, border security concerns remain at the top of US administration priorities. Some question if an official park designation would benefit those living in *ejidos* who live in or have limited access to areas conducive to ecotourism.

Rick Lobello, long-time advocate of the international park idea and chair of the Greater Big Bend Coalition, believes that even if an international park did not significantly alter land and water management practices already in place, the designation of what might be the largest binational park in the world could be a beacon for tourism and a gesture of solidarity with our southern neighbor. He argues that combining an international park designation with well-orchestrated voluntary access agreements could increase the amount of tourists and tourism revenue flowing into the region. Greater economic activity would drive more stable economies on both sides of the border and lead to greater border security. Rick worries that a wall slicing through the middle of a wilderness area twice the size of Yellowstone National Park would make it hard to live up to Roosevelt's original vision and would destroy more than eighty years of collaborative conservation efforts between two nations.

In 1932, just a few years into his tenure on the Texas Game, Fish, and Oyster Commission, the predecessor to the Texas Parks and Wildlife Department, my great-great-great uncle Caesar Kleberg visited the Big Bend region. Desert bighorn and black bear populations were on a precipitous decline that would see them extirpated by the time Big Bend National Park was established just over ten years later. Soon after the trip, the district game warden wrote Caesar a letter expressing his gratitude and appreciation. Quoted in the book *Caesar Kleberg and the King Ranch* by Duane Leach, it read, "Mr. Kleberg your interest in my country has been one of the most encouraging things that has happened in seven years of struggle on my part. Knowing that you realize the possibilities of this district from a game and recreation view has given me new life, and I am going to carry on here with new vigor and look forward to the proper assistance being forthcoming—on your visit you immediately saw that the country would never support but a small population but would support a great wildlife population, that it would never be farming country but to a certain extent remain wilderness."

Whether we like it or not, humans are now the steward of the natural environment. In a world where progress has lured the overwhelming majority of us to cities, and, in a state where less than 3 percent of open space is accessible for outdoor recreation, we are forced to consciously decide the fate of our natural environment. In the case of this great wilderness on the Texas-Mexico border, our predecessors have laid the foundation for not only an entire ecosystem to flourish, but for entire generations of people from within our borders and beyond to find inspiration in the symbolism, power, and grandeur of an international park. I will not simply imagine but will work to realize the dream of one day hiking for days across hundreds of miles of trails from the Chisos Mountains into the heart of the Maderas del Carmen. Some may argue that the conservation efforts in place are enough. I would argue that those efforts are just the beginning.

THE
RIVER CANYON
COUNTRY

Boquillas to Laredo

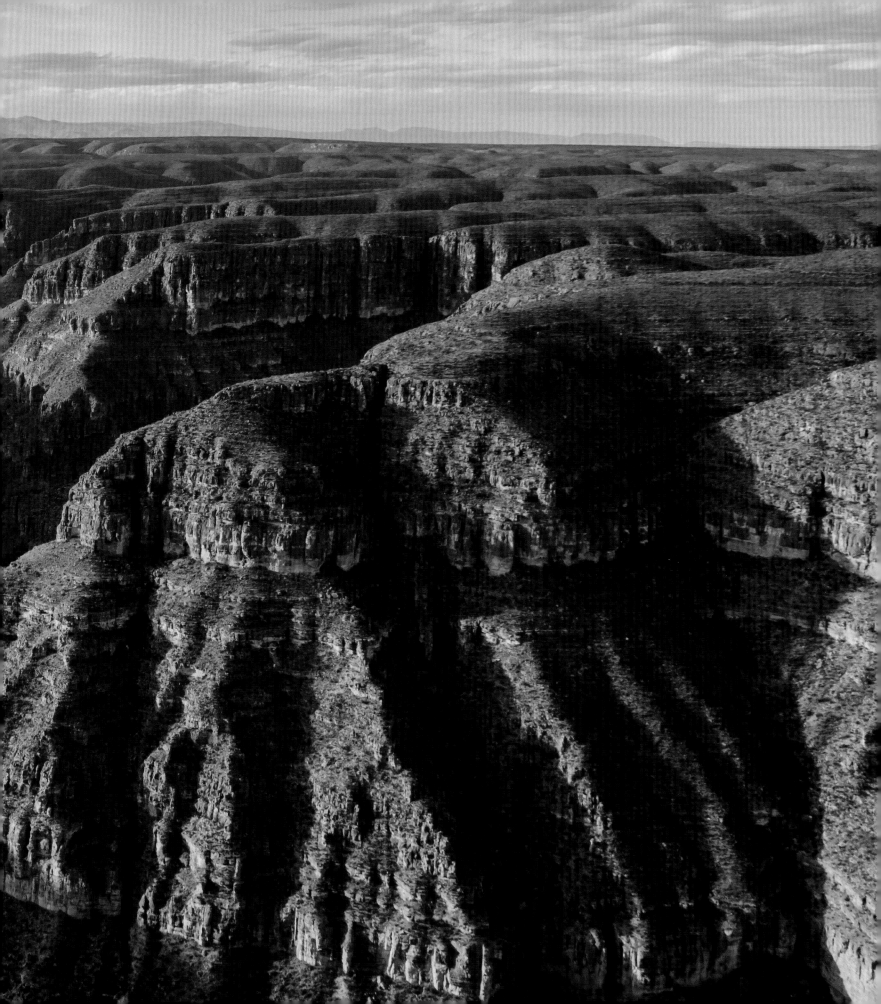

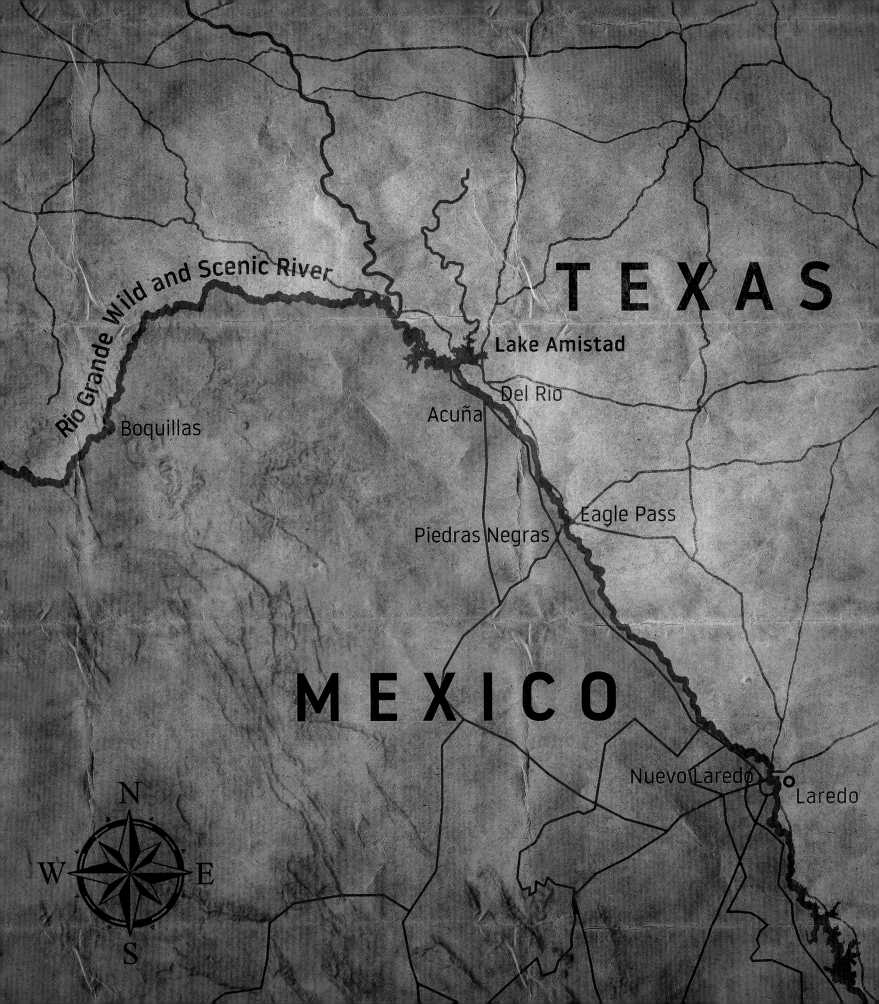

BOQUILLAS

Heather Mackey

first glimpsed the little village of Boquillas, Mexico, after ducking under a metal gate. I was walking briskly down a weathered dirt road toward a modern government building. Its gleaming, angular architecture offering a stark contrast to the thirsty brown hills at its back. I circled the building, jumping every time its air conditioning roared to life. Striding down to the Rio, I squinted across its shallow, muddy waters into another world. A rooster called in the distance, and several bored-looking donkeys were drinking from the shore. Nearby, a man waited in a rowboat. I was rushing to finish the last of my bird surveys before the buzz of cicadas drowned out all other sounds and before the crushing heat of midday. I had jumped the only official border crossing within Big Bend National Park. It didn't open until 9 a.m., and I had birds to count.

Across the Rio, Boquillas was waiting impatiently for the border crossing to open up and the influx of international tourists. In some ways, the minute-long boat ride from the shore of the United States to the Mexican side is like a journey back in time. Visitors pass from the sterile, climate-controlled Port of Entry to the dusty streets of a town that only a few years back didn't have electricity. Yet in other ways, Boquillas is more modern than the bordering national park community. The town recently transitioned from using propane lighting to being fully solar-powered. I distinctly remem-ber nights when the power was out in the park, and I'd look across the Rio and see the lights of Boquillas shining brightly against the darkness.

Refrigeration and television are not the only recent changes to this border town. Not long ago, the border was as fluid as the Rio and residents from both sides regularly crossed without passports or ID papers. Villagers from Boquillas would cross into Texas to do their weekly grocery shopping or to meet a friend for coffee. National park visitors would venture into Boquillas for the day, bringing with them an influx of cash. Anyone who has visited the Big Bend region of Texas knows how remote and inaccessible it is from airports and cities. However, most would be surprised to learn that the Mexican side historically has been even more isolated. When the crossing closed after 9/11, Boquillas was cut off not only from the United States but also from the world. Villagers suddenly had to travel to Santa Rosa de Múzquiz, over 160 miles away on a rugged dirt road, to resupply. Merchants were cut off from their customers, and what had once been a town of three thousand dwindled to only three hundred.

Although the Port of Entry reopened in 2013, Boquillas still hasn't recovered from its decade of isolation. Now, with tensions high on the border, many fear that the crossing will close again. The crew and I spent an afternoon exploring Boquillas and having what may have been the best tacos of the trip at Falcon's, one

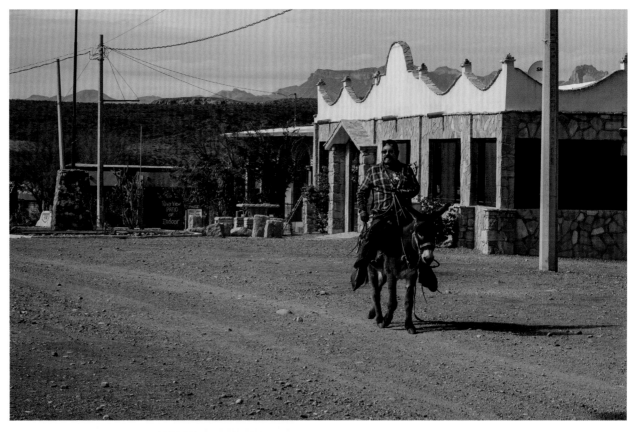

of two restaurants in town. As we walked into town, the main street was lined with mothers and children selling cloth banners and other goods bearing the words "No Muro." Jay was immediately surrounded by a troop of little girls selling these trinkets. He made sure to buy one from each young entrepreneur, quickly burning through his cash. All were curious about our group, accompanied as we are by unwieldy cameras and recording equipment, and we were approached by several people. One man approached us and began talking about the border wall and its potential impact on wildlife. His name is Chalo Diaz, and he's familiar with the success story of the Mexican black bear and speaks of the potential presence of jaguars in the Sierra del Madras, immediately capturing Filipe's attention. These mountains, and much of the land east of town,

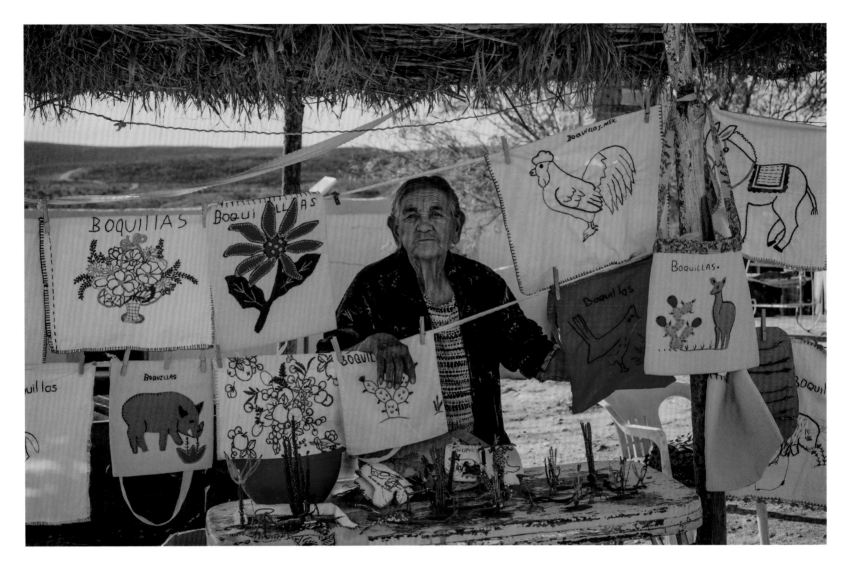

are part of the Area Natural Protegida Maderas del Carmen, which contains ecosystems ranging from upland desert to lush mountain meadows. A park administrator told us that the park hopes to attract international tourists to Maderas del Carmen, with Boquillas serving as a staging point for outdoor adventures. We agreed that this seems like a great way to spur economic development in Boquillas while conserving the area's natural resources. At the same time, we couldn't help but wonder what the future actually holds for this tiny border town. Its fate seems far from certain.

Boquillas residents rely heavily on tourism from Big Bend National Park. When the border crossing closed following 9/11, the majority of the town was forced to move elsewhere to make a living.

WILD AND SCENIC RIVER

Austin Alvarado

People can be quick to think of the Rio Grande more as a dangerous dividing line between two countries than as a beautiful, unifying river. Even when acknowledged as a river, it is usually thought of as a sluggish, dirty one. And, in truth, the Rio is indeed an example of what happens when humans fail to properly care for the earth's natural resources. In spite of human incompetence and disregard, however, this river manages to make its way to the Gulf, carving spectacular canyons along the way. Two sections of the Rio are considered so spectacular that they have been designated as National Wild and Scenic Rivers. By this designation, these two stretches of the river, one in New Mexico and the other in the Big Bend region of Texas, are legally protected. The goal of this

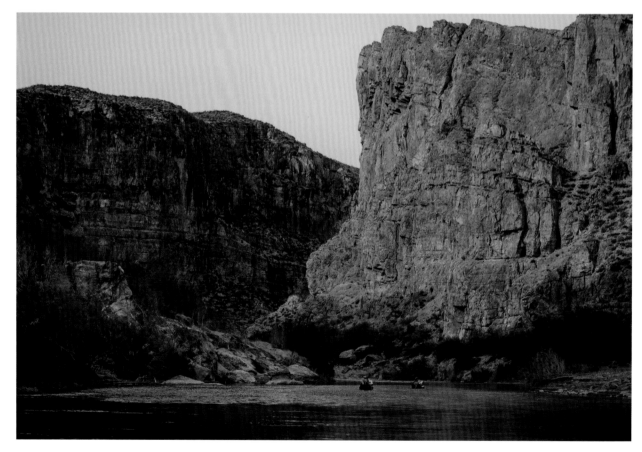

The Lower Canyons of the Rio Grande are part of the one hundred ninety-one miles of congressionally designated National Wild and Scenic River in Texas. Texas and Mexico become river left and river right, and the Rio unites the landscape rather than divides it.

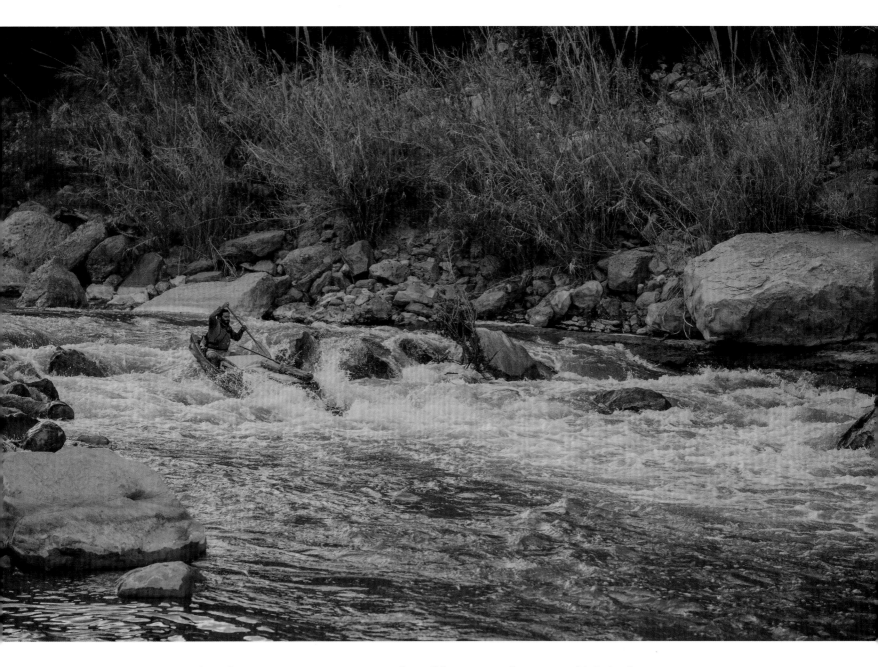

protection is to see that these sections remain pristine, assuring a level of riparian health in the area for future generations.

In Texas, the designated wild and scenic stretch of the Rio runs from right above Mariscal Canyon inside Big Bend National Park all the way to the Terrell–Val Verde county line. These 191 miles of the Rio Grande flow through the wildest parts of Texas, and it is in the Lower Canyons, an eighty-three-mile section east of the national park, where wilderness is truly defined. There is no stretch of the Rio in Big Bend more remote or technically difficult to paddle than the Lower Canyons.

The remoteness of these canyons is part of the attraction of running them, but it also

The Lower Canyons contain some of the most intense rapids along the river, and flipping canoes is a regular occurrence when paddling through here.

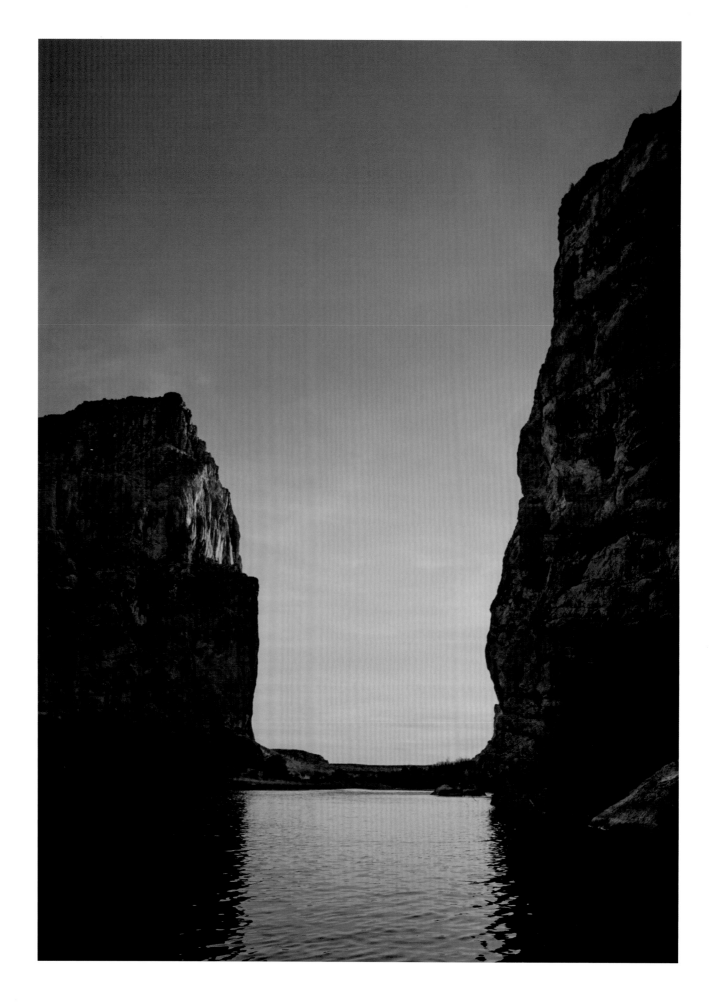

demands that you be precise in planning every aspect of the trip. Once you embark, help or resupply can be days away. Knowing this means that you have to be prepared for any scenario. Once you do launch, though, the remoteness of the canyons no longer presents a worry but rather becomes a gift. After all, the point of a river trip is to get away from the racket and worries of everyday life. The silence between the canyon walls reminds you of how distant you really are from those worries. But when the silence is broken by the roaring of rapids, you remember the vulnerability of being so removed from civilization.

The Lower Canyons hold some of the most challenging white water in the Big Bend region. This stretch of the river is typically run in canoes because of the fluctuating water levels. Often, rapids must be portaged because of the difficulty of running them in a loaded-down open canoe. Wrapping, swamping, and flipping a canoe in these rapids can be a regular occurrence. It is important to evaluate the risk of running each rapid, knowing that an accident can result in an extreme scenario with no help coming for days.

Paddlers who run the rapids, due to either their skill or stupidity, almost always earn a story to tell back home. Proudly talking about river carnage after the trip with river people becomes tradition. They start using phrases only others who have run the Lower Canyons understand, like "the wall shot at San Francisco" or "the rock garden before upper Madison falls." The white water in the lower canyons is by no means the most difficult in the country, but when you combine its respectable technicality with its remoteness, you have the mak-

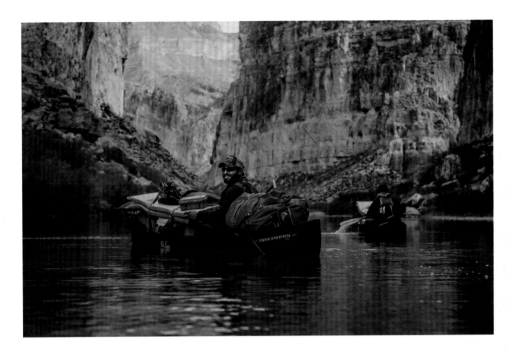

ings of an adventure. On top of the adventure add the beauty of the canyons, and you have one of the country's treasures at your disposal.

The canyons, with their constant changes in size, color, and geological features, demand your attention through the entirety of the trip. Cacti grow out of the rock walls, and the banks tend to be covered with rivercane. It is rugged country that will humble you if you're not paying attention. But for me, it's one of the most beautiful places on Earth, not just for the magnificent scenery but for what the landscape represents—a unique world that belongs completely to you as you float by. The only concern of the day is eating, sleeping, and playing. Texas and Mexico become river left and river right, the border is broken, and the world around you is your playground. To me, it is the most unifying stretch of river in the country, set apart by its immense beauty and wildness.

The canyons are consistently changing in size, color, and geological features.

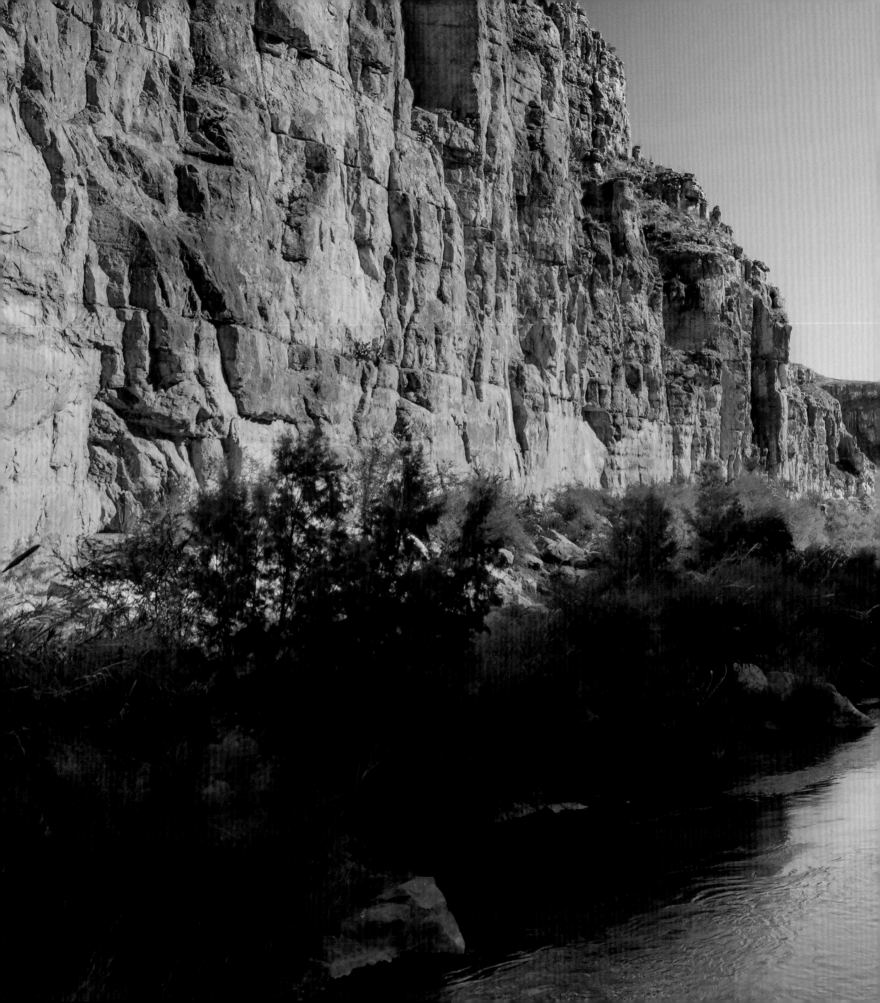

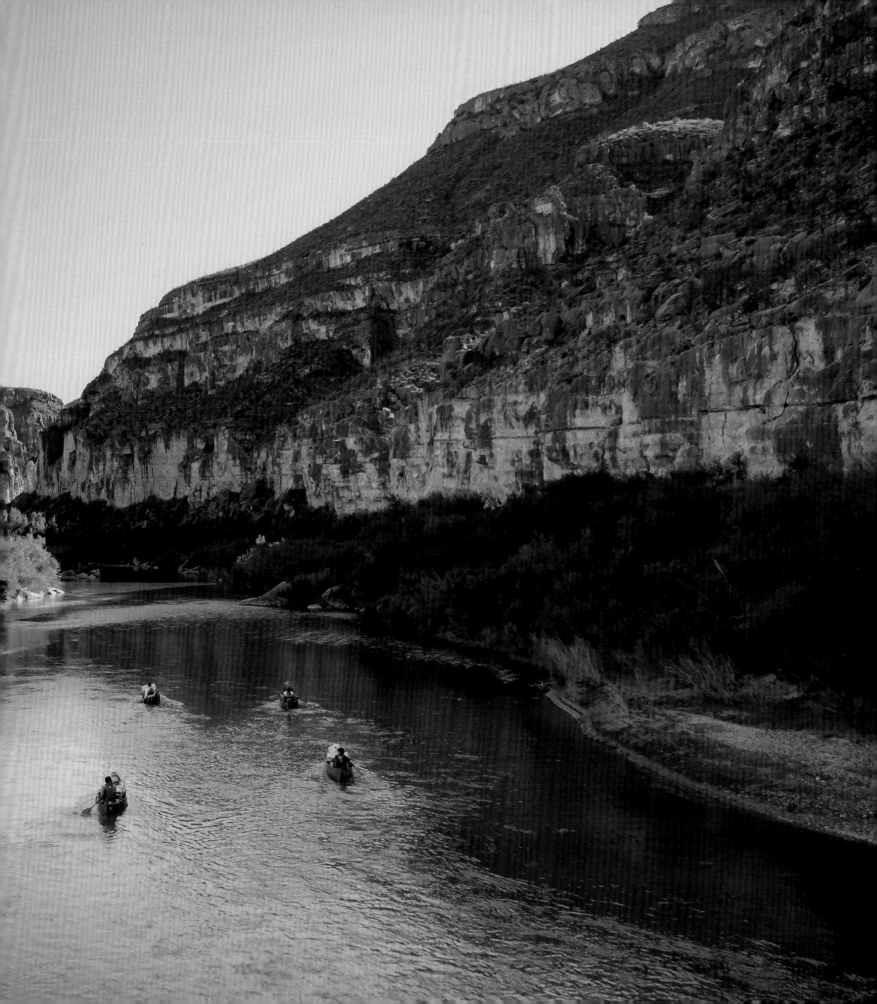

WATERLOGGED ON THE RIO

Korey Kaczmarek

I arrived in Big Bend National Park excited for the next leg of the trip—canoeing the Lower Canyons of the Rio Grande. As a former Minnesotan, I've spent hundreds of hours paddling on lakes, swamps, and channeled waterways. How different could it be on a river?

My paddle partner and coworker for the trip was Brandon Widener. We were invited by Ben Masters to document the next fourteen days on the most remote section of the Rio. Brandon was fresh off the plane from New York City, a mini duffel bag in one hand and a big-ass drone case in the other. We packed up our canoe and realized we had over $100,000 of film equipment and neither of us had ever paddled on a river. With our gunnels sticking only four inches out of the water, the seventeen-foot Old Town canoe was more like a small, overloaded barge.

I have worked as an outdoor freelance cinematographer for fifteen years, and I continuously seek out great adventures whenever possible. Early mornings and late nights in the wilderness have always attracted me to adventure work, guaranteed sunrises and sunsets, and this journey was no exception. We were about to travel twenty miles a day with an overpriced and overpacked boat for the next two weeks. The Rio in January has average water flow, still high enough to have good sections of whitewater and plenty of fast moving water

cutting through the gigantic canyon walls. The rapids sections have portages around them, but as cinematographers always looking for drama and great action, we would heckle the crew to run the rapids every time. The banks of the Rio are lined with a giant invasive river cane that can grow to twenty feet high and make impenetrable forests with impassable caverns. The walls of the cane extend into the river, creating obstacles that will easily swamp a boat.

Brandon and I got into our groove right from the start. I was steering and Brandon would be filming from the front of our boat. We were about an hour into the trip when reality hit. Literally, it hit us. We came around our first sharp corner, and I noticed a red life preserver with a human attached to it wading under a dead tree gathering his belongings. Jay Kleberg had dunked his boat. I quickly scanned my surroundings to locate the dangers. Flipping is not an option when a forty thousand-dollar camera is out of its case. Conversely, making a ninety-degree turn with a heavy canoe is not easy. Brandon was up front shooting and unable to grab his paddle to help me with the difficult maneuver. I dug in and gave it my all to turn the boat, but it was too late. We were pushed into the dead snag, and, before we knew it, water came gushing into the boat and we were sinking fast. Brandon panicked and fell overboard but had the most miraculous camera

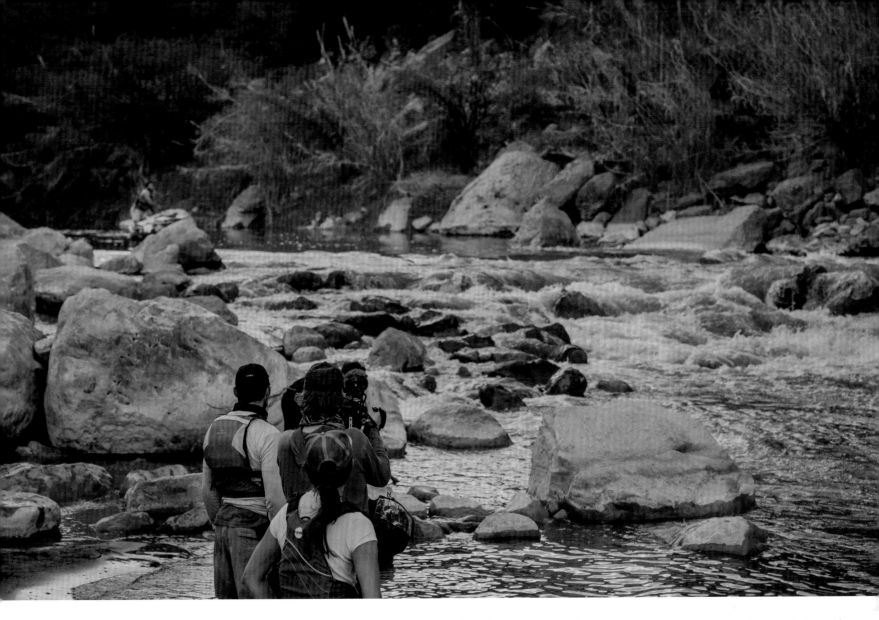

save I have ever witnessed. He was completely submerged and all I could see was an expensive video camera sticking out of the river with an arm attached to it. As I swam the boat to shore I counted the Pelican cases, water bottles, sound equipment, batteries, and whatever else we didn't have tied down floating on down the river. You know you're in for a treat when you find yourself soaked on a forty-degree day with thirteen days to go!

Day after day, Brandon and I battled every wave as if our lives depended on it. It didn't matter if the wave was six inches or three feet—we avoided swamping our boat at all

costs. Drying clothing or rubber boots next to a fire at night was nearly impossible in those low temperatures. I was a happy camper when I had dry gear for a short time before the next dunking. One memory that stands out is when I went to pick up Brandon on shore: as I nosed in the boat, Brandon pulled it up the bank, stepped in, and ass over teakettle I went into the river. Nothing like dunking yourself on land. There's never a dull day on the Rio!

The reeds that grew over the river's turns were ruthless. Multiple times we would be filming the crew side by side, and multiple times we would end up racking ourselves among the

I didn't particularly want them to wreck . . . but if they did, I wanted it on camera!

reed forest. There were places where the current would thrash us for a good fifty feet until we had to come up for air, just to be whipped in the face by the reeds' sharp leaves. Camera out, camera back in case, camera out, camera back in case. A constant cycle. We had no choice but to be careful. There was no backup camera, so we took every precaution we could, but we still had to gamble with our shots in order to successfully document the trip.

Any images captured along the lower Rio are magnificent—truly a cinematographer's dream when it comes to beautiful scenery. The canyon walls lit up with alpenglow in the morning, and the light bounced off the walls again in the evening for the golden hour. We learned our lesson early on—"portage whenever possible" was our motto. We dunked ourselves at least half a dozen times and thankfully never lost a camera (at least not one that mattered). Brandon and I would portage our gear boat around the whitewater and film the crew as they ran class three and four rapids with their heavy canoes. Sometimes they would make it, other times they would wreck.

The most memorable disaster we had was at Upper Madison Falls, about two-thirds of the way through the Lower Canyons. Brandon and I portaged around the intimidating rapids, grabbed our cameras, and prepared ourselves for the ultimate show. The nervous crew studied their routes intensely from shore. I could tell this was going to be the rodeo Brandon and I had been waiting for. I am not one to wish harm on anyone, but I love when shit's about to go down. I gave my infamous lasso gesture (meaning giddy-up, let's get goin', we're losing light). The setting sun added stress for the already stressed out team.

The most experienced paddler of the group, Austin Alvarado, went first. If anyone could run it, this guy could. Austin has been a guide

on the Rio Grande for years. He was paddling solo the entire time in the lowers. His boat was the heaviest of them all, sitting just two inches above the waterline. Austin's paddling power and finesse were a joy to watch. "You got this!" I shouted as I propped myself on top of a boulder near the rapids' exit so I could get the shot. Grinning ear to ear, I filmed Austin powering through his line. He pinballed off every rock possible and managed to make it through. His gunnels were so low that he took on quite a bit of water, causing him to sink slowly. "It's about to go down for these other guys," I thought to myself. Gear started floating down river. Austin's boat guideline was wedged in the rocks, anchoring the boat in the strong current. The canoe started to fold, and the river was too deep and fast. Austin hung on to the steep bank with all his energy, trying to pull himself to a safer place. Meanwhile, it was getting dark quickly.

Ben jumped into his boat next and ran full speed ahead without hesitation. I could see the whites of his eyes as he center-punched a large rock at the top of the rapids. His canoe was pinned between two boulders, bringing him to a complete stop. Ben's boat started taking on water and gear started floating past Austin as he clung to the side of the bank. Brandon and I grabbed our portable lights that attach to the top of our cameras to illuminate the situation. Everyone hustled their way across the boulders to help pull Ben's canoe away from the rocks. Against the current, Jay, Ben, Austin, and Heather pulled with all they had and finally freed up the battered boat. While Jay was positioning himself in the eddy, Ben noticed Austin's boat was about to completely fold. The cowboy jumped into the raging whitewater with his knife clenched between his teeth, dove underwater, and cut the guideline free.

Panning my camera back at the rapids,

Jay was attempting a different line than his comrades. He centered up to run the gauntlet, but a last-second effort forced him sideways, T-boning his boat perpendicular to the flow. Jay was pinned against his boat under the water. I took my eye away from the viewfinder, worried a horrible accident was about to happen. However, he popped up and was able to get out of harm's way. With a couple of pulls and pushes, Jay got his waterlogged boat out and was able to guide it to shore.

One last boat to go. It was time for Filipe and Heather to tackle the beast in the pitch dark of night. With their headlamps glowing, they circled the eddy above the falls and aimed toward their line. Earlier during the scout, Austin said, "Whatever you do, do not go river right." Once the two paddled out of the eddy, the current instantly pulled their boat to river right. Without enough time to correct their direction, Heather and Filipe went sideways into the first set of rocks they encountered, the current pinning their boat up against the boulders. Piece by piece, their gear floated down the Rio. The force of the current was so strong that everyone had to help unload their boat in chest-high water.

The team threw ropes across the river for hours, dragging boats left and right, trying to get the canoes out of the river's current. Finally, the boats were lined up on shore waiting to be bailed. It was like the midnight hour on shipwreck island where we all huddled next to a huge campfire. I was glad to see nobody was injured, but I was ecstatic to have filmed one hell of a wild scene. As we passed around the last surviving bottle of whiskey, we couldn't wait to jump in our boats the next day and do it all over again, even if we did have to eat soggy lunches for the next six days!

After Ben's canoe got lodged between two rocks, it took the strength of the whole team to pull it free.

LANGTRY

Hillary Pierce

As our team rounded the final bend of the wildest stretch of the river in the tiny town of Langtry, the last light of day was fading and a mysterious figure perched on a canyon ledge overhead. The team didn't notice him, but there he stood, keeping watch until he was sure they all made it in safely after an arduous and frigid run through the Lower Canyons. Whether he knew it or not, Keith Bowden had already been playing the part of godfather to our motley crew. Wise sage of the Rio Grande, he had been our guide from the earliest days of planning the trip by way of his memoir, *The Tecate Journals,* which reveals his intimate relationship with the river.

The book was invaluable when it came to navigating a river so few venture down, and I relied on it heavily when it came to assessing the trip's challenges and plotting logistics. A retired professor of creative writing, Keith calls Langtry home for now. It allows him proximity to the Lower Canyons, which he runs about five times a year, almost always solo. Once he caught sight of the team rounding the bend, Keith drove back to the take out and alerted the onshore crew that they were near. The team soon arrived, cold, hungry, and almost feral from twelve days in the heart of the only true wilderness left in Texas.

I had driven in that night from the hustle and bustle of ever-growing Austin, but by the time I actually met Keith in Langtry that night, I felt like I already knew him, having read his book several times. I was a bit concerned our rowdy bunch would be off putting to someone who finds such value in solitude, but we soon realized that we were all cut from the same cloth and that anyone who dared to take on the Rio was a member of an elite, albeit grungy, community.

After a night of Tecate, tequila, and storytelling, the morning light revealed that upon landing in Langtry, we had all traveled back in time. With a whopping population of just twelve individuals, the most development Langtry has seen in recent years is Keith's personal mission to replant the entire town with native flora, ridding the empty streets of invasive buffelgrass. Established as a railroad camp and made semifamous by Judge Roy Bean, "the Law West of the Pecos," Langtry had barely entered the twentieth century. What wasn't immediately visible was that this tiny town on the banks of the Rio was even more deeply connected to ancient history than its Old West demeanor would indicate.

While most of the team rested, Keith led Ben, Jay, and me on a hike into the box canyon adjacent to the previous night's take out. As we descended into the canyon, a huge natural rock shelter opened up before us. On the limestone wall at head height, ancient pictographs were clearly visible and my perception of the timeline of this place lurched backward by cen-

When the crew reached Langtry after a long trip through the Lower Canyons, we were welcomed by Keith Bowden, who let us take a break in "the town that time forgot" and led us to explore incredible historic and archaeological sites.

Ancient pictographs were clearly visible on the lime-stone walls of a natural rock shelter.

turies. We learned that this overhang was probably the earliest southernmost bison jump site in North America. At the end of the last ice age, Paleolithic nomadic people used the shelter to drive bison off the cliff, resulting in a bounty of meat, fur, and bones for tools from the pile of dead bison below. Roughly eight thousand years later, a group of Native Americans used the same technique at this same location.

We followed Keith deeper into the canyon, past a huge hive of Africanized "killer" bees, and came upon another archaeological site, this one with an excavation in progress. Keith said that Texas State University archaeology students were uncovering another key to the way these ancient people survived—by slow-baking plants that you would never guess were edible. It was incredible to look around and imagine the structures and activities of these ancient people from the very clear remnants of a lifestyle lived more than eleven thousand years ago. I envisioned huge bonfires at the base of the bison jump and pondered

how similar they must have been to those our team had built on the Rio. They were undoubtedly much larger, but some things never change. I know they cooked and ate food, and I bet they shared stories and laughs together as the flames burned the rocks and bones that left clues of those nights behind for ages to come.

After some exploring and tiptoeing past the killer beehive once more, we arrived back at the house and began to prepare to get back on the river. The supplies I'd brought were packed into the boats, and everyone seemed grateful for the brief layover. An unexpected ice storm made my trip back to Austin a little hairier than expected at the same time it made the team's trip across Lake Amistad even more of a challenge than anticipated. As I struggled to find my way through a maze of icy roads back to civilization, I couldn't help but think how much I'd rather have stayed a few more days, spending time around a bonfire, listening to stories of Keith's river adventures in a box canyon outside Langtry, the town that time forgot.

LAKE AMISTAD

Heather Mackey

In my mind, Lake Amistad was always going to be the crux of the journey. This reservoir, which spans ninety miles from end to end, is known for its bass fishing and meandering shoreline. The lake can also be up to six miles wide, and its size can make it rather treacherous for a small watercraft like a canoe. Three-to-five-foot whitecaps are not unusual in the afternoon, and the presence of motorized fishing boats means there's potential to capsize in a wake. When we hit Amistad, the elements were shaping up to make our crossing a memorable one. The temperature wouldn't break forty degrees in the next week, and although we'd have one day of ten-to-fifteen-mile-per-hour tailwinds, the following three were predicted to bring headwinds of equal strength. With these rotten conditions in the forecast, we decided we'd have to make some serious miles on day one, then take each subsequent day one at a time and hope for the best. We went to sleep with the wind rattling our windows and Keith Bowden's whitecap horror stories fresh in our minds.

Lake Amistad (meaning friendship) is a reservoir created by the damming of the Rio Grande, Pecos, and Devils Rivers. The sixty-mile-long reservoir is six miles across at its widest point and is renowned for consistent headwinds. These are not ideal paddling conditions.

We awoke to a brisk but sunny morning. We were planning to put in our biggest day yet, thirty miles, which would land us just beyond the head of the lake. We had been doing ten-to-fifteen-mile days in the Lower Canyons, which was a leisurely pace considering the river's current. Lake Amistad was going to be a major step up, but our boats were light and our spirits high. I remember layering up like I was going skiing, with the notable exception of my footwear, which had been reduced to Chacos and socks after the river took one of my boots. We started out making good time and quickly reached the confluence of the Pecos and the Rio Grande. Somewhere around 5 p.m. we emerged onto the open lake and attempted to regroup. Dusk was quickly approaching, our support boat was nowhere in sight, and our prospects for finding a decent campsite were virtually nonexistent. Steep, limestone cliffs lined the shore for as far as we could see, and even if we could somehow climb ashore, we had ditched our camping supplies to save weight in the canoes. Fortunately, we soon spotted our support boat and beelined to the shore to make camp before dark.

As expected, we awoke the following morning to heavy winds and another cold day. We planned to make our way from the sheltered eastern shoreline to the heart of the lake, where it resembles the open ocean and whitecaps the height of a canoe gunwale are common. Most of the day was a blur of frantic paddling and trying to consume enough calories to stay warm and energized. Riding in the stern of the canoe that Ben and I shared, I controlled the direction of the boat and felt responsible for making sure we didn't lose too much ground when he paused to take a photo or study the GPS. This meant I had to give up on spotting waterfowl with my binoculars and had to try to sneak snacks while keeping my paddle in

the water. With both Ben and I paddling hard we were making about one mile per hour, and when Ben stopped even momentarily it took all my strength to keep the boat from being swept backwards. Austin was paddling by himself, somehow managing to keep pace with the boats that had two paddlers. He never seemed to tire, and there didn't seem to be even a single moment when he became dispirited.

We finished the day after making only ten miles, and we faced the prospect of doing the same the next day, plus another five miles across open water to reach the dam. As I lay down to sleep that night, I was sore in ways I never thought possible. My shoulders, back, neck, and arms were all on fire. Heck, even my hips hurt from squatting in the canoe all day. I had long feared that this would be the part of the journey that I might be the weak link of the crew. I knew I had the determination and endurance to keep up, but not so much the upper body strength. Now, I was heading into the widest stretch of the lake with weakened muscles, and I was determined not to hold back the crew. As I fell asleep that night, my mind was filled with images of whitecaps, flooded canoes, and boots sinking to the bottom of the reservoir.

The following morning we were faced immediately with rough water. Progress was painfully slow right from the start. Ben and I followed the shoreline closely, and it often seemed as though we weren't getting anywhere at all. We had settled into a routine of walking the canoe along the shoreline when the bays were shallow and the route minimally circuitous. It had worked fairly well the day before, when the shore was open and the boat could be dragged along through the shallow water. Now, the shore was rocky and the waves were breaking hard, and if we were going to take the overland route we'd have to carry the canoe.

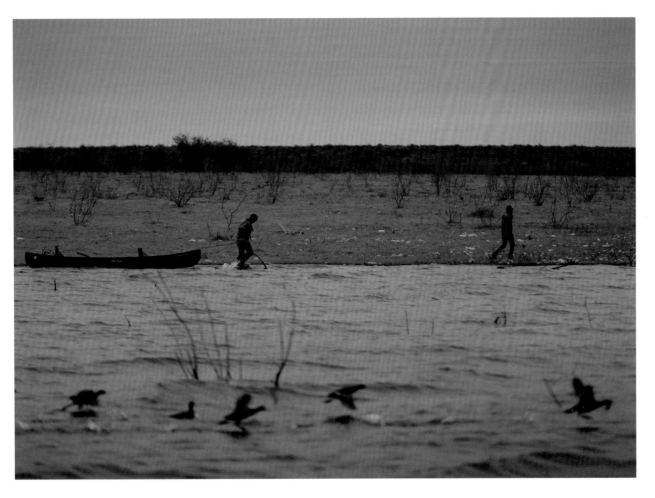

With vicious headwinds and rough water, Ben and I resorted to dragging the canoe along the lake's shoreline.

I was immediately dubious of this strategy. I knew we would take on water getting to land, struggle to get the canoe over our heads, and inevitably end up soaked in the process. Then, if we were lucky, we might stumble along the shore for a few hundred meters before having to put in again. As miserable as this sounded, the lake didn't seem to offer us much choice.

We repeated this process three or four times before we reunited with the rest of the crew, tired and slightly defeated. At this point, Austin suggested we try roping the boats together for the remainder of the crossing, with two boats tied stern to bow and the other two on either side. We figured we'd be more stable as a unit and less liable to swamp. We took off in party boat formation, with music blaring and the sun finally breaking through the clouds. As we sang along with classic crowd pleasers like "American Pie," water lapped over the sides and filled the bottom of the boats. We were going maybe a mile per hour faster than we had on our own, and were taking on water almost as fast as we could bail, but we had crossed the sanity threshold long ago and now our only goal was to make it to the dam. With the end of the lake in sight, everyone paddled with renewed vigor. With smiles on our faces, we reached the dam and promptly shotgunned beers as a team, the dreaded crossing of Lake Amistad now behind us.

(following page) Below Lake Amistad, the terrain flattens out and the Rio widens.

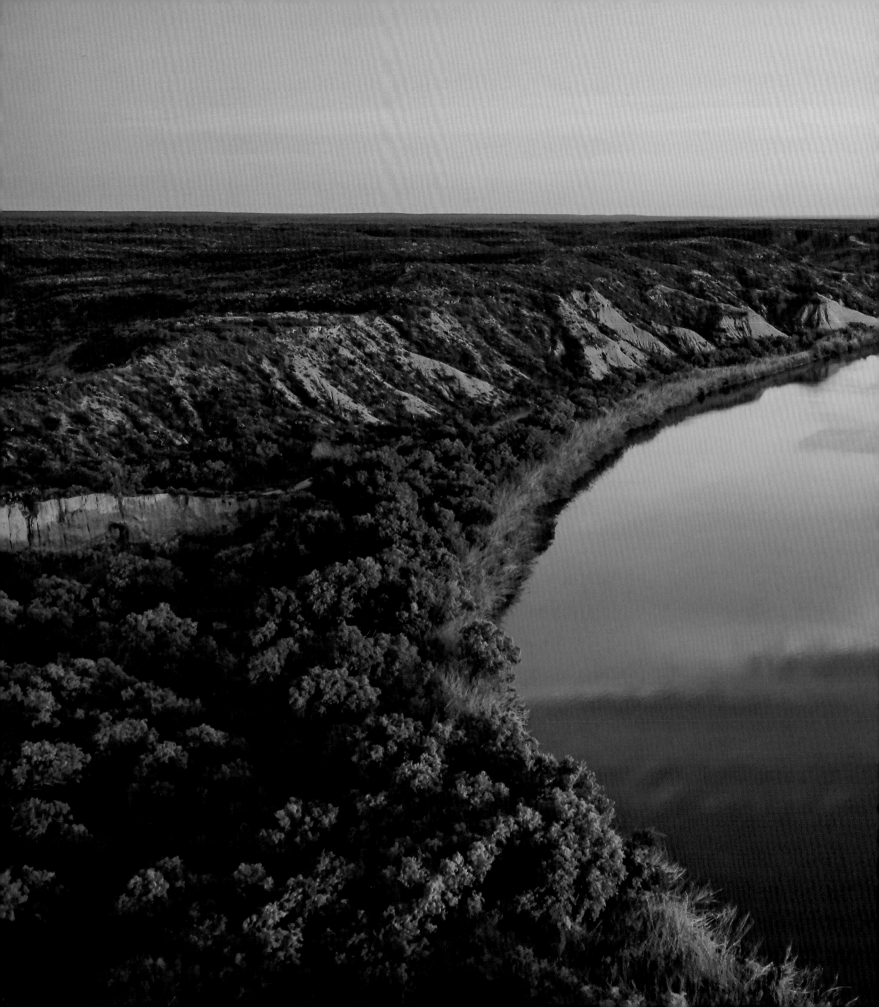

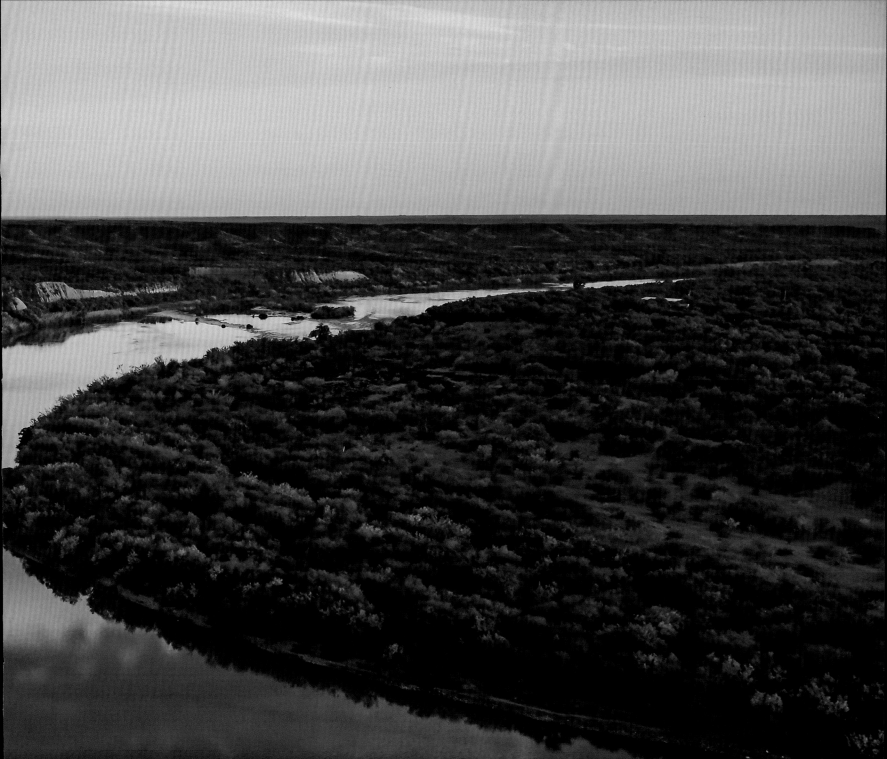

CROSSERS

Ben Masters

My first encounter with people crossing illegally into the United States was near the border town of Quemado, Texas, in January of 2008. I was nineteen, a freshman at Texas A&M University, hunting on a friend's ranch about ten miles north of the Rio Grande. The hunting in South Texas is awesome, and I was hoping to shoot a wild hog or a buck to supplement my college diet of ramen noodles and PB&Js.

I was up well before dawn for the morning hunt and drove out to my spot, a hunting blind overlooking a ravine filled with big mesquite trees and South Texas brush. It was still pitch black when I climbed into the blind, a twelve-foot-high tripod stand with an exposed seat on the top surrounded by camouflage netting. I got settled in, checked my rifle, chambered a round, turned the safety on, and began the anticipated wait for daylight that every hunter knows well. I sat in starry silence, patiently waiting for the sun to come up, listening to the birds come to life as the sky went from black to gray and the stars slowly disappeared. As it became light, I gradually began to see shapes around me. A *sendero*, a strip of cleared brush, led into the ravine below me. Another *sendero* went to a corn feeder that was timed to go off at sunrise and hopefully bring in some feral hogs that had been in the area. The elevated blind gave me a much better line of sight than being on the ground, where the brushy landscape blocks your view.

The first wildlife I saw were a doe and her fawn. I could barely make them out in the gray light. They were walking on the *sendero* up out of the brushy ravine toward me. I didn't want to kill a doe, especially one with a fawn, so I watched them go about their morning routine, nibbling buds off the different brush species, pawing the underbrush for forbs, and being on constant lookout. As I watched them through my binoculars, the doe's head suddenly shot up in alarm; she stamped her foot and gave a warning snort before raising her white tail and leaping into the brush. I looked to see what scared her and pointed my binoculars down the *sendero*.

It was still pretty dark, but there was no mistaking what my eyes were looking at. Humans. About twelve of them. They were about three hundred yards away, coming down the *sendero* directly toward me. They were carrying big backpacks, wearing dark camouflage clothes, and walking with a purpose. The leader, an athletic-looking man dressed head to toe in camouflage, was staring straight at me as he walked. I froze. For a full twenty seconds his eyes were directly on me as I sat in an exposed tripod stand with only some worn out camouflage netting to hide behind. It was dark, he wasn't looking through binoculars, and when he lowered his gaze, I quickly shrunk down

into the blind, behind the camo netting to hide myself from view. Fear seized me. I was alone, outside of cell service, with twelve people in camo walking my way. They were likely either smuggling drugs or otherwise entering into the country illegally. Whichever the case, they were engaging in an activity they didn't want me or anybody else to know about. They were probably on high alert, under high stress, and going for higher stakes than anything I'd ever done in my life.

There was a small hole in the camouflage netting large enough for me to see through, and I slowly moved my eye into position. I stared at them and started praying they wouldn't see me. I hoped they would turn around, go into the brush, or do anything other than continue walking directly to the blind. I considered running for it, standing up and yelling, or firing a round into the air to let them know that I was there. But I didn't do anything. I crouched in silence, scared, with my hand on my rifle and my eyeball peering into the gray dawn at twelve potential drug traffickers coming closer and closer to me. I didn't move a muscle as they closed the gap—two hundred yards, one hundred yards, fifty yards. My heart started pounding, and I could hear their footsteps. The crunch of gravel, the breaking of a twig, the sound mesquite branches make when they get hung up on clothing.

Thirty yards from the blind the group stopped. A crossroads between *senderos* pointed to ranch roads and old seismic lines. The leader looked down all the roads before turning down an old seismic line. He knew where he was going. Without a word, everyone else followed. They walked out of my field of vision, but I didn't move. I didn't want the stand to creak. I was already afraid they would hear my heartbeat. I counted to two hundred to do something to occupy my mind, knowing I needed to stay silent and still. At the end of my count I slowly lifted my head and rotated my body to see where they went. Every tiny sound I made sounded like a fire alarm. Peering over the edge of the blind, I could barely see the tops of their heads and backpacks three hundred yards away from me again, walking in the opposite direction.

I waited another two minutes before I climbed out of the tripod stand and ran to the truck. I threw my stuff in, turned the key, and punched the gas. It took about fifteen minutes to get back to headquarters. I arrived just as the sun was rising. I ran into the house and told one of the ranch workers what had happened. He said we needed to call border patrol immediately. The number was written down next to the landline and I dialed it. A border patrol agent answered. "How many people were there?" About twelve. "Were they carrying large backpacks?" Yes. "Were there any females or kids?" Yes, maybe, I'm not sure. I think there was at least one female. "Was anybody armed?" No, not that I could see. "Which direction were they headed?" Northeast.

After a few minutes of questioning, the agent thanked me for calling, asked us not to go in the direction we last saw them, and said they would deploy some agents. Thirty minutes later, we heard the low beats of a helicopter. From the ranch house we watched the helicopter crest the horizon and begin searching the area where I last saw the group. We saw green and white SUVs and trucks come in on the roads. For over three hours, the helicopter hovered overhead and agents scoured the brush on foot. They told us they apprehended eight individuals. They didn't tell us whether they found drugs or not. To this day, I have no idea whether they were drug smugglers or migrants

looking for work and a better life. The border patrol took them to a processing facility, and I have no clue what happened next.

I've thought a lot about that day. It's possible that I stopped hundreds of pounds of illegal substances from entering the country. It's also possible that I ruined somebody's dream of immigrating to the United States to find a better life. I have no idea, and never will. For much of my life, I've worked on ranches, in feed yards, on farms, in construction, and on oil rigs. Many of my coworkers and even bosses have been immigrants who crossed the border illegally. They have taught me many skills and have been my mentors and role models; I'm friends with them to this day. I don't want them to be deported, and I'm thankful that somebody like me didn't call the border patrol when they were crossing.

After this encounter, I went to work on a ranch about twenty miles from the US-Mexico border between Laredo and Hebbronville, Texas. From 2009 to 2013, I dropped out of school every fall to spend October through January managing the hunting operation and habitat management of the ten thousand-acre Jacalon Ranch. My job was to manage the harvest of about one hundred deer a year, to monitor the oil companies that had wells on the property, and to conduct habitat improvements for the incredible diversity of life found in the South Texas brush country. The ranch owner was a wildlife aficionado who gave me the flexibility and budget to consult with some of the best wildlife biologists in the region and to try a variety of projects to bring back native species, mitigate oil field surface damages, and improve land health. It was an incredible job and opportunity for an aspiring wildlife biologist. Ranch headquarters was about twenty-five miles from the border, and I got a firsthand experience of what it was like to live and work where both illegal immigrants and drug traffickers crossed the property on a nearly daily basis.

During my four years working at the Jacalon Ranch, I saw about two dozen groups of people crossing. Some groups were all young males carrying big backpack loads that were likely bales of marijuana. Other groups were carrying smaller backpacks and included kids and women. We constantly found footprints on roads and *senderos* where people had crossed in the night, and we often saw people on motion sensing trail cameras that we had positioned to take photos of wildlife. Twice, I had crossers come up to the house in the middle of the night, bang on the door, and ask me first for water and then to call the border patrol because they were lost. I was happy to give them water and a phone, but I have to admit, it's really scary having a group of desperate people banging on your door at night in the middle of nowhere. Desperate people do desperate things. Each time they came to the house, I fed them, gave them water, gave them clothes, and let them use the landline to call border patrol. A man my age from Honduras once offered me $500 for a ride to Houston, which I declined. He then went on to eat an entire gallon of ice cream before border patrol arrived about four hours after we called them.

I had some frightening experiences along the border, but I was never personally threatened. We never had someone steal a vehicle from the ranch, break into the house without knocking, or approach us about trafficking drugs or people through the property. I also never saw or got pictures of anyone carrying a gun. At first, dealing with the crossers was a novelty, but over time it became a way of life. That's the way it is down there, and you get used it.

There are a lot of inconveniences about

A border patrol agent was chasing a group of traffickers near the ranch I worked on near Laredo when brush got trapped in his undercarriage. It caught fire, and the truck exploded. While this was an exceptional moment, living on a working ranch along the border has difficulties that don't exist in the interior of the country. Gates were often left open, fences were cut, cattle got into the wrong pasture, water tanks were turned on or off, and so on, along with the constant concern of not knowing who you might run into in the brush.

ranch life on the border that you don't have to deal with in other parts of the country. The border patrol was a constant presence and often an annoyance. Agents would get lost and stuck, and I once encountered an agent who caught his brand new diesel truck on fire because he thought he could drive it through the thick South Texas brush. I couldn't help but snap a photo. Our fences were constantly getting cut and our gates left open by both border patrol and people crossing illegally. Livestock would get into the wrong pasture, and sometimes it took days to get them rounded back up.

According to the border patrol and our surrounding neighbors, if you don't call border patrol when you see a group of crossers, it increases the likelihood of that route being used over and over again. We didn't want the ranch to become a well-known safe traveling corridor, so it became ranch policy to call the border patrol every time we encountered a group of crossers. During my employment there, I made fifteen to twenty phone calls to the border patrol. While we had legitimate reasons to do so, I always felt conflicted making that call—like I could have been betraying my friends. My coworkers at the ranch were all first- or second-generation Mexican Ameri-

cans. They called border patrol for the same reasons I called them and with the same trepidation.

A conundrum often manifests along the border. While there are some really stellar human beings who cross the border illegally to flee violence and chase the American Dream, there are also some really terrible humans who smuggle drugs, initiate violence, and have little respect for the law. In the brush, whenever you see someone dressed in camouflage and carrying a backpack, you don't know whether they are good or bad or how they will respond to your presence.

I left the Jacalon Ranch in 2013, when my passion for film and photography became a full-time endeavor. For the next five years, I didn't encounter a group of crossers in the brush. I didn't have to face the conundrum of whether or not to call the border patrol on people who were either drug runners or families. During that time, I matured a lot, I researched our immigration system at length, and I planned for the trip you're reading about. Over that time, I often wondered if I did run across another group of crossers, how would I react? That dilemma presented itself on our journey south of Quemado, Texas.

The Rio Grande below Lake Amistad is a completely different river than the Rio Grande above it. The water out of the dam is crystal clear and the terrain flattens out. When you're at canoe level, you often can't see over the dense forest of river cane that lines the banks. And in some places, the river is so wide and filled with a tangle of cane that you can become lost searching for a channel large enough to float a canoe through.

It's really hard to get separated from your fellow paddlers on a river, but I somehow managed to succeed. Camera operator Phill Baribeau and I were canoe mates for the day, and we were moving as an entire team down the Rio Grande. It was getting late, and we wanted to reach a friend's ranch, where we knew we had a place to spend the night. As the evening light turned golden, we came to a big split in the river. Phill and I decided to go down the right side of the split, which then took us into a forest of river cane. We struggled through shallow water, tiny channels going through small openings in the cane, and massive networks of spider webs. Thirty minutes later, we managed to pop out into a large lake-like portion of the river, where we could see both upstream and downstream. I couldn't see Heather, Austin, Filipe, or Jay, who had gone left at the split, so we decided to stay put and wait for them.

We ate some jerky, drank a beer, and chatted for about ten minutes before we started to get worried. The sun slipped behind the horizon and it began to get dark. Earlier that day we had met with border patrol agent Stevie Sauer, who firmly advised us not to paddle the river at dusk, night, or dawn because that's the time when most human and drug traffic comes across the Rio Grande. Phill started asking what we would do if we did come across a group of drug smugglers or immigrants crossing the river. I didn't know. It was a situation about which I was woefully ignorant. I told him my experiences in the past, when I had encountered immigrants dozens of miles inland, but I had never run into any illegal activity on the Rio Grande at the borderline. Inevitably, our minds went to worst-case scenarios. For someone to evade the law on the border, all they have to do is cross the river into Mexico.

The wind picked up as it got darker and darker, and the rest of our group was nowhere to be seen. I didn't know if they were upriver, downriver, stuck in a canoe wreck, held up for some reason, or what. I didn't want to move because I didn't want to get farther away from

them. I assumed they were doing the same for us, so I began trying to call everyone on their cell phones. No service. I got the satellite phone out and texted everyone asking them to send me a GPS coordinate so I would know whether to go upstream or downstream. Clouds prevented the satellite phone text from going through and I couldn't get a call out. Phill and I sat on the river, discussing options, and turned our headlamps on so our friends could spot us.

Finally, I got a call out to Heather's cell phone. It rang once before dropping signal. A few moments later, I got a return phone call. Austin was on the line, adrenaline pumping through his voice, "Masters! Listen, listen. Can you hear me? We just ran into a bunch of people putting backpacks into a boat and crossing the river. They were only seventy-five yards away. I don't know how many there are or which side of the river they're on now. Can you hear me?" Static. More static. Unintelligible words. "Where are you? Are you okay?" I could hear him but he could barely hear me. I then

received a text on my satellite phone from Jay's satellite phone. It included a latitude-longitude of their location. I texted back that I was coming, and Phill and I started paddling like mad men through the pitch-black cane forest.

Our adrenaline was soaring but we couldn't make fast time. Our canoes were heavy and we kept getting stuck on rocks in the shallows. We couldn't see the river channels through the millions of bugs attracted to the light from our headlamps. We wanted to paddle like hell and reach our friends as fast as possible, but we couldn't. We alternated between getting the canoe stuck in the cane, pulling the canoe over sharp rocks, and pushing the canoe through the small channels the river afforded. I was scared. I was scared of the unknown, and my mind went to all the times I had called the border patrol when I was working at the Jacalon. There was no way to know who the rest of the group had run into. They could be asylum seekers in search of safety, immigrant workers wanting to increase their opportunities, or drug traffickers

under an extreme amount of pressure to move product. We didn't know. We didn't know if it was a big operation, if there were more people, and if they were looking at us like sitting, wet ducks in the middle of a river pushing a loaded-down canoe.

As scared as we were, I can only imagine what the crossers were feeling. If I was a drug smuggler or an immigrant about to cross the Rio Grande at dusk in that part of the country and I saw green boats paddled by English-speaking white people, I would take that as a pretty good indication of border patrol. Inevitably, my mind continued to go to worst-case scenarios, and I thought about the stories of border patrol agents who had rocks thrown and bullets fired at them while patrolling the river.

Struggling around a bend, we finally saw the headlamps of Austin, Jay, Heather, and Filipe. As we paddled up, they briefed us on what happened. First, when we went right and

they went left, a small, fast channel took them past the forest of cane where Phill and I got stuck. When they reached an open spot in the river, they waited for fifteen minutes, unsuccessfully tried to contact Phill and me, then continued to paddle, assuming we were ahead of them when, in fact, we were still behind. As darkness settled in, they took a turn in the river and spotted a canoe a mere seventy-five yards downstream. At first, they thought it was us until they saw about ten people on the bank of the Mexican side. They were loading a boat with backpacks, but when they spotted Austin, Jay, Filipe, and Heather, they quickly grabbed the backpacks and the boat and ran into the forest of river cane and out of sight.

Austin, Jay, Filipe, and Heather didn't know where Phill and I were. They didn't know if we were ahead or behind them or if we had run into the group, and they became very worried for our safety. They couldn't paddle upstream because

the canoes were super heavy and there wasn't a well-defined channel. They didn't want to paddle downstream because then the crossers would potentially be between them and us. So, stuck on a river between Mexico and the United States too shallow to run, and possibly right in the middle of a human or drug trafficking operation, they got out some candy, cracked a beer, and nervously waited until we showed up.

As they told us this story, they showed us exactly where they saw the group of crossers. I couldn't believe how close it was. Then Heather told me about how she kept hearing crackling in the river cane on the US side of the river. It was possible people were only a few dozen yards from us, face down in the river cane trying to avoid detection, probably scared shitless under the assumption we were border patrol there to apprehend them. They were there for half an hour at least, and I can only imagine the options possibly going through their minds as they listened to a bunch of English speakers on the river. Do I run? Do I hide? Where is my coyote? Where is the rest of the group? Where is my child? Where is my family? How many of them are there? Can we overpower them? What do I do?

The gravity of the situation hit me as I began putting the puzzle pieces together. We were easy targets, stuck on the rocks in the river and in the middle of a potential drug smuggling operation, possibly led by violent cartel members. The smugglers were lying still in the river cane mere yards away from us weighing their options. They likely assumed we were border patrol, the enemy, and may not have understood enough English to realize that we were actually a group of recreational paddlers out enjoying the Rio Grande in the middle of the night. The stakes were probably very high, and it was possible that they were armed, on drugs, trigger happy, and very dangerous, and the only thing between them and the "safety"

of Mexico was us. We decided to get the hell out of there.

We frantically shoved our canoes downriver until the Rio Grande opened up enough for us to paddle. My brain was firing as my mind wandered. Maybe those people weren't drug runners. They probably weren't. They were probably good people seeking a better life. A mother and her son lay in the dark river cane, scared out of their minds, wondering if they were about to be caught by the border patrol. A man my age, wondering if his dream of a better life and years' worth of savings were about to be dashed away. A teenager, wondering if he'd be deported back to the country he was fleeing to escape the gangs trying to recruit him. People willing to go through hardships so difficult that I cannot even comprehend or relate to them. People taking huge risks to obtain things that I take for granted on a daily basis—a stable society, food, clean water, a job, and a chance at the American Dream. But then again, maybe they were attempting to carry over hundreds of pounds of heroin and meth? We paddled harder. Nobody said a word.

We turned our headlamps off as the moon rose over the horizon, casting the river into a magical world of black and white, darkness and light, the moonlight bouncing off the Rio merging with the stars above. The old conundrum hit me. Should we call the border patrol? A call that could lead to the arrest of dozens of drug runners? Or should we stay silent? Avoid the call that could lead to the splitting of families and the dashing of dreams?

With my canoe floating down the geographical boundary between the United States and Mexico, my mind floated between the ethical boundaries of right and wrong. Who is good and who is bad? Who judges the gray areas in a world of black and white? What is the purpose of calling border patrol when there

are already more than eleven million undocumented immigrants in the United States? What is the purpose of arresting drug smugglers from Mexico when they are supplying a demand created in the United States? Why am I so fucking scared of the cartels and the drug runners, yet I've supported them myself? The hypocrisy hit me like a train.

In high school and college, I experimented with various drugs. I used them recreationally, what I thought was "responsibly," and, thankfully, didn't get addicted. I can't say the same for some of my friends, a few of whom got addicted to opioids and spent hard time in the slammer and rehab. At the time, I thought what I was doing was pretty innocent. Obviously drugs are illegal, but so is going fifty-five mph in a fifty mph zone. I felt rebellious, and as long as nobody got hurt, arrested, or addicted, I didn't see the problem. The dots I never connected were that my "innocent" recreational drug use was financing and supporting cartels in Mexico, destabilizing governments, and fueling the gangs in Central America, gangs that so many migrants coming to the United States are fleeing. That primary problem of cause and effect surrounding our border security issues stared me in the face every time I looked at my moonlit reflection in the Rio Grande.

I wish that as a teen, instead of somebody telling me to "just say no to drugs," they would have said "just say no to supporting criminal networks, financing gangs, uprooting families from their homes, costing taxpayers untold billions of dollars, destabilizing governments, extorting millions of people, and muddying the ethics of our border policies." I know dozens of conscientious consumers who buy local, eat organic, source their clothing from "ethical" companies, and pay a premium for "clean" energy, yet they support cartels, drug runners, and gangs when they buy a quarter ounce of weed for a music festival or an eight ball of blow for a rowdy weekend.

The hypnotizing sounds of paddle strokes and the serenity of the moonlit river was broken when Filipe turned his headlamp on and yelled for us to come to the bank where he had found a spot good enough for a camp. We unloaded our gear, and I gathered the team to discuss whether or not we should call the border patrol. The dilemma of not knowing who we were actually calling about was on everyone's mind. Austin, whose parents entered the United States illegally from Guatemala, didn't weigh in. Heather wanted to call. Jay supported the group's decision. Filipe wanted to call the border patrol if they were drug runners but not if they were families. Everyone looked at me for direction. I thought hard about it.

"I believe we should call border patrol, tell them what we saw and where we saw it, and let them know our location and that we are okay." Austin's head lowered. Filipe's head lowered. Heather looked relieved. Jay gave a small nod of approval. Not another word was said.

I walked away from the group and sat on a promontory rock overlooking the Rio Grande into Mexico. I pulled out my cell phone and turned it on. As I was waiting for reception, the sounds of the river came to life and I thought about how fortunate I was to have a cell phone in the other, a full belly, warm clothes, money in the bank, a vehicle, a canoe, a good sleeping bag, a loving family I get to see anytime I want to, good health, and a life in the United States of America. I turned my phone off and went to bed.

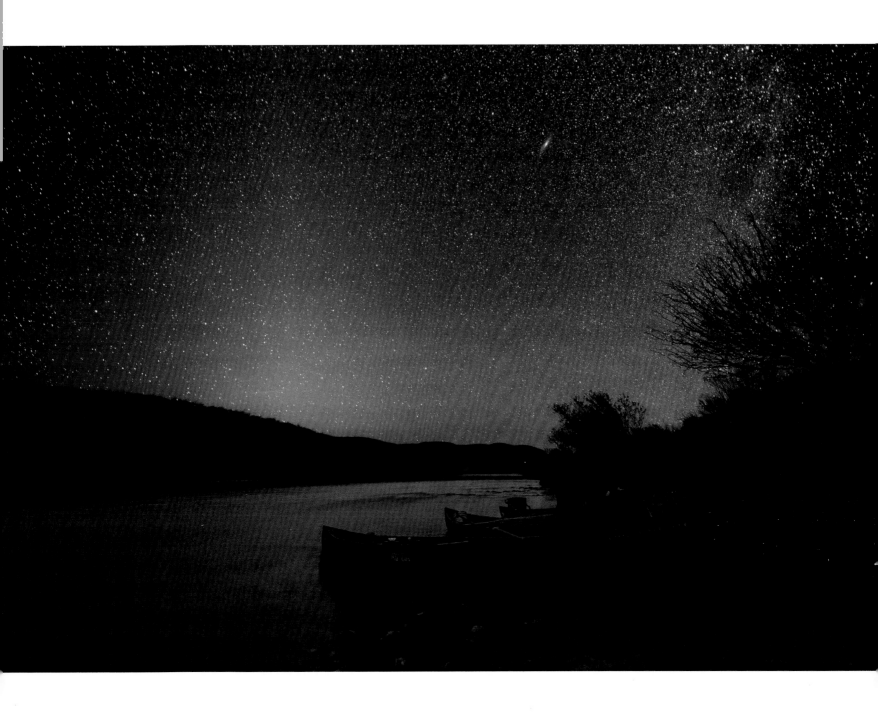

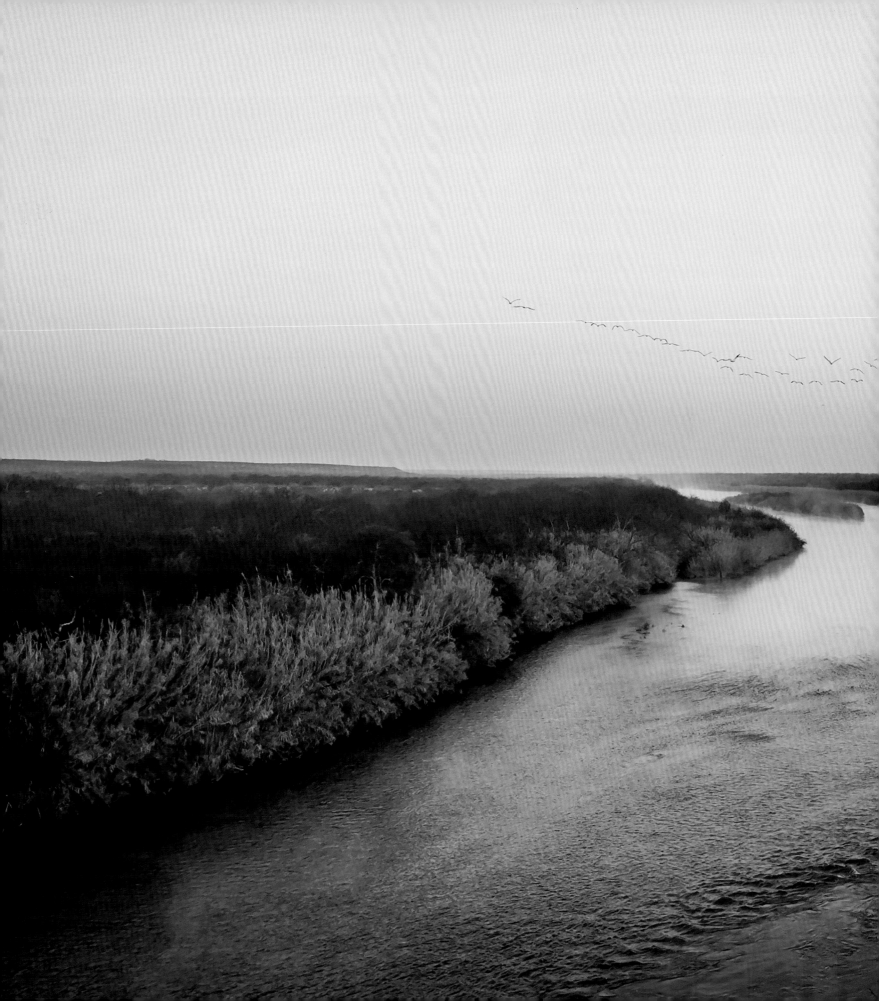

THE RIO GRANDE VALLEY

Laredo to the Gulf

A LANDOWNER'S VIEWPOINT

Becky Jones

Our family farm along the Rio Grande started with my father, Frank Schuster. As a fourteen-year-old boy, he emigrated alone on a ship from Austria to America to work for his uncles, who had settled along this wonderful river. In her memoirs, my great aunt called the Rio Grande "life-giving"—a most fitting tribute. My father came home from serving in World War II and used his military savings to piece together a seven hundred-acre farm from seventeen parcels of land. The verdant alluvial soil along the river is among the most productive in the nation, supplying record-setting yields in sugar cane, cotton, many varieties of vegetables, and other vital agricultural staples for both national and international demand. My father's love of this country, its freedoms, and the abundance it provided set the respect my family has for the soil and the appreciation we have for its bounties.

I grew up next to Santa Ana National Wildlife Refuge. Our home was located near the entrance to that rare and precious parcel of native habitat filled with hundreds of bird, plant, and butterfly species not found anywhere else in the United States. It was the best place in the world for adventure and learning about wildlife. In those days, from outside our house, few lights could be seen in the distance at night. Our only neighbors were cousins who farmed the adjoining acreage and lived at least a mile down the road. My father's daily conversation was a mixture of German with his older relatives and Spanish with the employees on the farm. And our holiday gatherings were a blend of cultures—tamales and old European recipes along with American celebrations and Mexican ballads. It was a vivid confluence of lands and cultures.

Every Sunday afternoon my father would reach for his binoculars and his worn copy of Roger Tory Peterson's *Field Guide to the Birds*. He took my siblings and me into the refuge, following a familiar path through the native brush and past lakes teeming with wildlife. There would be a contest among us to see how many different species of birds we could identify. The tour usually ended near the Altamira Oriole's hanging nest next to the bull pasture on the north side of the refuge. That ending spot for our weekly outings—experiences filled with a love of nature, musings of a father about cattle and farming, and family recollections and aspirations—will now be the starting point of the concrete and bollard border wall splitting our farm in half.

I am now part of an American farming family on American soil whose family farm of three generations will be cleaved by a physical wall that is supposed to define the new border with Mexico. Our family hasn't moved. But, with this impregnable barrier, we will need a gate code to enter our own country from working land that is defined as US territory yet arbitrarily separated by a capriciously defined boundary.

My father, Frank Schuster, immigrated to the United States at the age of fourteen to work for his uncles who had settled along the Rio Grande.

When reports indicated that the wall would affect our farm, I tried to learn from landowners who already had faced a taking of their property. For me, the defining moment of this sad divide came when I visited a farming family whose farm was split by the wall, situating their home on the Mexican side. Although the massive gate was open as I drove through it to approach their house, it was closed when I attempted to leave. The gate was heavy, metallic, and foreboding. I realized that once this exit closed, any American situated on the "other" side of the thirty-foot concrete and bollard wall would be isolated and caged with the very dangers the wall was meant to keep out. The wall would thus create two distinct and disparate levels of security and freedom for Americans. It would arbitrarily pick winners and losers, not by following the true and established boundary of Texas with Mexico, but rather hewing to a new, arbitrary path inside of Texas configured not by treaty but by political expediency.

For several months I called and wrote congressional representatives and senators who served on various committees forming border security policy and funding. I tried to make my conversations brief and use appropriate terminology to explain the impact a wall would have not only on my farm but also on precious habitats and local communities. To my astonishment, many of the interns and staff in the legislative offices of Washington, DC, didn't know where the border between the United States and Mexico was located. Labeling the wall a "border wall" seemed to indicate it was actually on the border, not two miles inside the United States. So far away and without a personal stake in the outcome, few staffers could comprehend the resulting no-man's-land of US territory between the wall and the river.

In an effort to inform the public, I wrote to newspapers and websites to describe some of the unintended consequences of a physical wall and explain that Americans who lived on the border were those most in need of border protection. I proposed putting funds toward proven security that included additional border agents, technology, and boats on the Rio Grande—the actual border. For those Americans who didn't live near the border, I compared building a physical wall that gives away part of the United States to a homeowner who would build a fence that gives part of his or her homestead to his or her neighbor. I tried to describe the taking in terms that could be understood in Iowa or anywhere else in the country. But explaining the incongruous placement and impact of the wall was too nuanced to fit into neat sound bites.

In October 2017, while the matter was being debated, I traveled to Washington, DC, with members of several well-respected wildlife conservation organizations. Although more doors opened to me when I mentioned the words "eminent domain" rather than "environment," I found the experience disheartening. From my research on the history of eminent domain actions, I understood the rationale of balancing the good of the nation over the sacrifice of the few. However, I felt that no Americans on American soil should be singled out to sacrifice their personal freedom and security. Those were fundamental rights that should be protected for all citizens. The staff of one congressional representative explained that there were layers of security, such as road checkpoints, that started at the border. I visualized this tiered approach to national security as layers of an onion. The border of Texas along the Rio Grande was the outermost layer—the one that was conveniently discarded.

My greatest disappointment was saved for several legislators who represented Texas. Did they not learn in their seventh grade Texas

history class that the Rio Grande marked the boundary between Texas and Mexico? As an avid reader of history, my husband liked to say that those legislators were accomplishing what General Santa Ana couldn't do—establishing a border in Texas north of the mighty Rio Grande. Because Texans have always been proud of their state and heritage, it seemed impossible that those legislators couldn't understand the beauty, the value, and the legacy they would be surrendering with a wall that abandoned almost twelve hundred miles of Texas.

Ultimately, I thought that legislators would understand the obvious loss created by a physical wall that would cede access to the vital waters of the Rio Grande, an essential resource to people of this area. The river was not only the source of our farm's irrigation, it has been the main source of drinking water for the 1.3 million people living in the Rio Grande Valley.

Growing up next to Santa Ana National Wildlife Refuge, I would often explore the small lakes and passages through Spanish moss.

The American family farm operated by Becky Jones and her brother Frank Schuster, which has now been in the family for three generations, would be cut in two by a border wall.

I asked, "Why construct an impervious wall that separates the river from the people who depend on it?" The question seemed inconsequential to Washington, DC, decision makers.

Walking the cold, hard surfaces between the senate and congressional offices I visited that October seems so distant from today. It's an early September (2018) afternoon as thunderheads power up and distant thunder echoes. This is a favorite time of year for my family and friends. White-winged dove hunting begins, welcoming the fall hunting season and cooler breaks from the summer heat that has parched the earth. It's a tradition that brings extended family and old friends together. The unique habitat along the river provides coveted hunting areas for wildlife not found anywhere else in such abundance. These harvested doves will be a treasured part of special family meals. My husband packages them with care and notes the weather, friends hunting alongside him, the birds that got away, and other descriptions of that day's hunt to be recounted with

tender appreciation when he opens the frozen package months later.

The breeze is humid and rustles the sugarcane during this hot afternoon. As I walk in the soft dust beneath the immense cypress tree "el Sabino" that grew from river waters, I am reminded of what one columnist recently wrote after visiting our farm. He called it "the magical wonderland." This lush land has provided so much to my family. And my memories once again surface. Many years ago, as my father checked the irrigation pumps along the river, my brother and I would play in the river sand— our own beach. The water gushed from the irrigation pipe, filling the cement irrigation canals alongside the earthen levees my father built to keep floodwaters out. Long days and dreams of a young immigrant were intertwined with the river's soil.

In 1968, Hurricane Beulah quickly developed into a catastrophic flooding event. My father knew his crops in the fields were destroyed and realized he would lose half of

what he had built up during his lifetime of work. He scrambled to save what he could and herded his young bulls over the earthen levee near the swollen waters of the Rio Grande to the safe pastures on the north side. When the powerful floodwaters of the river started seizing his prized older bulls to take them downstream, my father instinctively began to jump into the waters to save them. He abruptly stopped as he realized the immense power of the engorged river. Beulah was a violent lesson in the unpredictable forces of nature that can destroy the plans and actions of man. The river took life as well as gave it. I wonder, "Who and what will be trapped on the wrong side of the

wall when those inevitable flood waters quickly rise again?"

On this September day as I walk the levees, I see the white-winged doves following tree lines to feed on sunflowers and dip into the water that lines the fields. The river flows brown and silent. It has been a part of the lives of people who live on both sides. The Rio Grande has defined not only our area of Texas but the whole of Texas. It has created a glorious tapestry of wildlife, crops, family gatherings, and historic events. And, with the coming wall, it will now become but a remnant of that wonderful fabric.

THE SANTA ANA RALLY

Hillary Pierce

In August of 2017, I heard about a protest march and rally taking place in Mission, Texas, in the Rio Grande Valley, to save Santa Ana National Wildlife Refuge from border wall construction. With a trip start date set for December 1, I knew we had limited time to wrap our heads around a rapidly changing and increasingly tense debate surrounding a border wall. I thought there would be no better way to delve into the issue than to head to the border to see for myself where the wall would go. The tiny town of Mission was slated for the first phase of wall construction and was ground zero for the battle against the wall. Sarah Kuck and Tito West joined me to shoot the events of the weekend in case it proved elemental to the film. On the way down, I imagined what scene we might find upon arrival. I assumed it would mirror what we had seen on the news: angry faces from both ends of an extremely polarized political spectrum, shouting at each other and finding no common ground. What I found when we arrived at Our Lady of Guadalupe Catholic Church on Saturday morning at 6 a.m. was something entirely different.

I was immediately struck by a vision of unity amidst diversity in the crowd that had assembled. People of all ages and races representing more than fifty different organizations had arrived to participate, at least six of which were faith-based, including the host church where we assembled. Farmers, environmentalists, birders, immigrant rights activists, conservationists, and church folk filled the space and the street in front of the church. A team of volunteers hurriedly handed out black t-shirts with "NO BORDER WALL" emblazoned on the front. Others passed out handmade fabric signs that went above and beyond the usual hastily scribbled posters you see at protests. These were carefully painted by hand and depicted the treasures of the region: "Salvar Santa Ana" with the image of a Green Jay, the electric blue and green bird whose northern range only extends to this region, and "Protect the Wildlife Corridor" with the face of the endangered ocelot, the small spotted cat with large, cartoon-like eyes more often associated with the jungles of Mexico than the coastal plains of Texas where it also still roams, albeit in dwindling numbers. Others read "Save Our Homes," "Salvar Ecoturismo," "Protect Immigrant Families," and "Salvar Nuestro Rio," collectively painting the full picture of what was at stake for this community.

The trip marked my first visit to the area, and I was struck by how familiar it felt to me. Raised a preacher's daughter in an eastern North Carolina farming community, I was reminded of my sleepy, swampy hometown by the Spanish moss hanging in the trees at Santa Ana and the smell of the freshly-plowed fields surrounding it. The Rio Grande Valley is equal

parts agricultural powerhouse and vibrant, ecological marvel. Rod Santa Ana in *AgriLife Today* reported that agribusiness in the region accounts for an annual statewide economic impact of about $1.1 billion. Nearly half of all North American bird species can be found in the region, making it one of the top bird-watching destinations in the world. Another Texas A&M Study found that the region sees over 165,000 ecotourism visitors each year, accounting for a $463 million infusion to the local economy. Santa Ana National Wildlife Refuge is known as the "crown jewel of the National Wildlife Refuge system." Whether you cared about the wildlife, the farmland, or both, you had something to lose to a border wall. Knowing this, I shouldn't have been surprised by the kind of folks who showed up that morning.

Blaring from the speakers of the church was an odd assortment of river-themed songs, comprising a playlist I later learned was assembled by Father Roy Snipes, the priest of the parish.

The Rio Grande Valley is one of the top birding destinations in the world, with nearly half of North American bird species found here, including the Green Jay.

They ranged from Alison Krauss's version of the spiritual "Down to the River to Pray" to a modern country tune that made a good argument declaring "Jesus Was a Country Boy," which as the song's inclusion on the playlist seemed to imply, would certainly have not let a border wall get in the way of swimming or fishing in the Rio. Father Roy led the parade in a powder blue 1980-something Ford Escort wagon, adorned with flowers, tinsel, a three-foot-tall effigy of the Virgin Mary, and magnetic signs that read, "No border wall between amigos." His small herd of

rescue dogs filled the car, one of which, a Jack Russell terrier, was dressed as a friar. For four miles, Father Roy led the procession of smiling, singing faces to his congregation's home church, the historic La Lomita Chapel. The tiny church is the town's namesake and it is slated to end up behind the wall.

There they held a rousing rally under a white tent in the humid South Texas heat that more closely resembled a revival than a political rally. A community picnic followed and before the weekend was over, I watched

seven hundred people hold hands raised high standing atop a levee, the foundation for the border wall in Santa Ana National Wildlife Refuge. They became a human wall, comprised of a unified but diverse community that has everything they hold dear to lose. It was the most peaceful and loving protest I'd ever witnessed. I never saw angry counter protesters that day. Either the pro-wall crowd doesn't exist in Mission, or they aren't the morning people that this group of farmers and bird-watchers are. The people I met that day were characters I knew we had to return to. Mission, Texas, would certainly be a stop on our team's journey along the Rio Grande.

In late January, the team came through the area as another rally was planned. This time, it fell on the seventy-fifth anniversary of the refuge. Instead of a party to celebrate, and more impassioned than the rally I'd attended

six months before, this event reflected the feeling that time was running out. I remember the high energy vibe of our crew as we drove to the rally that day. Austin had never been to any rally other than a pre-football game pep rally and he was really amped up. Once we arrived, everyone seemed to realize the gravity of the situation and, for the first time on the trip, they met some of the people a wall would most affect.

In a freshly plowed field adjacent to the white tent, Heather, Austin, Jay, Ben, and Filipe met with Abraham, Allyson, and Christian, three "Dreamers" whose parents had brought them to the United States as children. These Dreamers are part of the Deferred Action for Childhood Arrivals program (DACA), which protects eligible immigrant youth who came to the United States when they were children from deportation and gives young undocumented

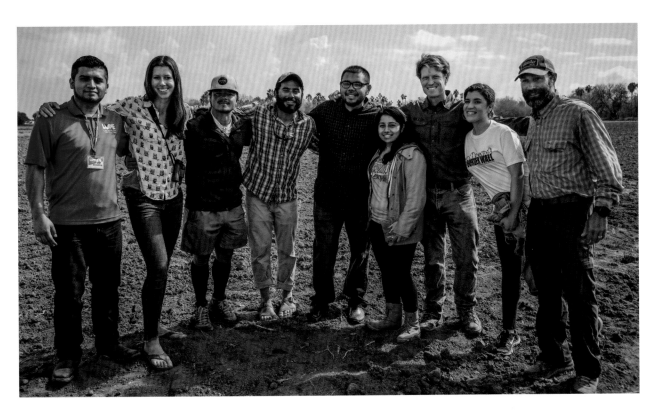

The crew met with Dreamers Abraham, Allyson, and Christian at the January 2018 rally to discuss how they would be impacted by border wall and DACA issues.

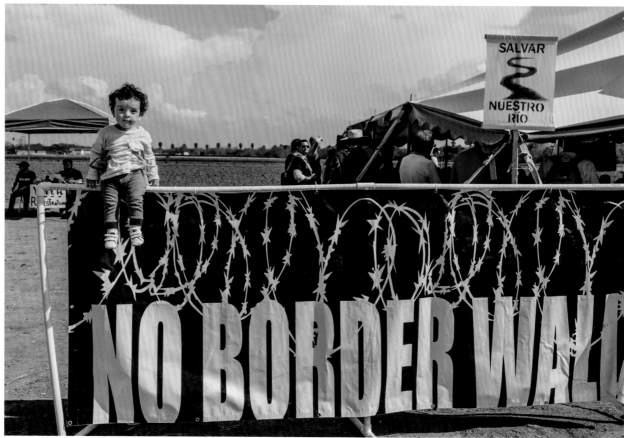

immigrants a work permit. The program expires after two years, but participants can file for renewal. The very day we were at the rally, Congress was using the border wall and DACA as bargaining chips against one another. It seemed as though the only possible outcomes our new friends faced were to be sent back to a country they'd never known or have a wall built through their hometown. Later I saw that Ben and Jay were chatting with members of the Carrizo Comecrudo Tribe, an indigenous group who have called the area home for centuries. I watched as Austin grew emotional listening to the poetry being performed and stories being told in the tent by immigrants and children of immigrants like himself.

As the rally wrapped up, Scott Nicol from the Sierra Club Borderlands Campaign gave our team a tour of the refuge, explaining in detail where the wall would go and what it would impact. I watched my team that day as they met so many familiar faces from my first trip. They, too, witnessed the unity and diversity I'd already discovered in this community, and it was a pivotal point for understanding the human facet of the wall's potential impact.

When the appropriations bill passed in late March, after we had completed the trip, Santa Ana National Wildlife was explicitly spared from border wall construction. Three miles of wall would not be built through Santa Ana (this fiscal year), but funding for twenty-five additional miles on either side of the refuge was approved. Once built, the community of Mission and many of its sacred spaces, such as La Lomita Chapel, Bentsen-Rio Grande Valley State Park, and the National Butterfly Center, would be walled off from the rest of the United States.

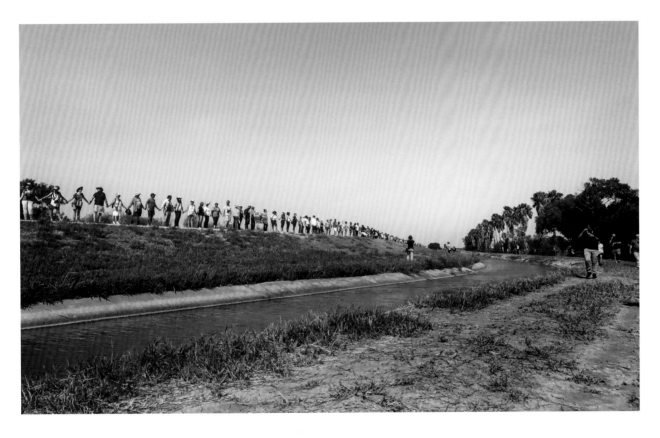

Wanting to see the border and its community for myself before beginning *The River and the Wall*, I headed to the Rio Grande Valley for an anti-wall rally in August of 2017.

THE NATIONAL BUTTERFLY CENTER

Heather Mackey

As we made our way down the Rio Grande, the diversity of wildlife around us had been growing at a tremendous rate. In the Lower Canyons we had encountered desert bighorn sheep and a fair number of birds, but not much beyond the typical residents of the Chihuahuan Desert. Downriver from Lake Amistad, the floodplain opened up and waterfowl and other birds started to become increasingly abundant. Now, as we moved south into the Rio Grande Valley, we witnessed a sudden explosion of tropical species, and for a biologist, it felt a bit like reaching the Promised Land. The Valley has nearly the highest diversity of plants and animals of any region in the United States. Many of these species, like the northern ocelot and the Northern Aplomado Falcon, are found nowhere else in the country. Incredibly, over half of the 750 butterfly species that reside in the United States are only found here.

The rich biodiversity of this area is explained by the great variety of habitats found here, including the Chihuahuan desert, Tamaulipan thornscrub, and Gulf Coast prairies and marshes. Most importantly, the Rio Grande Valley represents a stunning juxtaposition of temperate and tropical climates. As such, it is the northernmost limit for many tropical animals, especially birds and butterflies, and the southernmost limit for nearly as many temperate species. The Central and Mississippi flyways, migratory routes shared by millions of birds and bats, also converge at the Rio Grande Valley. But birds and bats aren't the only travelers to cross through this region. The area is also a major migratory corridor for humans, with some of the highest numbers of illegal crossings anywhere along the border. There is a robust border patrol presence in the Valley, and it is the site of more than one hundred miles of existing border wall. The high volume of human traffic brings with it a great deal of tension.

The National Butterfly Center in Mission, Texas, has been ground zero for renewed border wall conflict. The executive director of this nonprofit reserve, Marianna Trevino Wright, encountered contractors here in July 2017. The work crew, which had been hired by US Customs and Border Protection, was staking out an area to clear for border wall construction deep within the center's boundaries. When we visited the National Butterfly Center, Marianna brought us to the spot where she confronted the crew along one of the center's private roads. Marianna was walking down to check on a habitat restoration project when she encountered a crew armed with chainsaws and heavy equipment. No one at the center was notified about the crew, and no permission had been granted to clear vegetation from the property. That was the beginning, Marianna told us, of the fight to protect the reserve from the ravages of border wall construction.

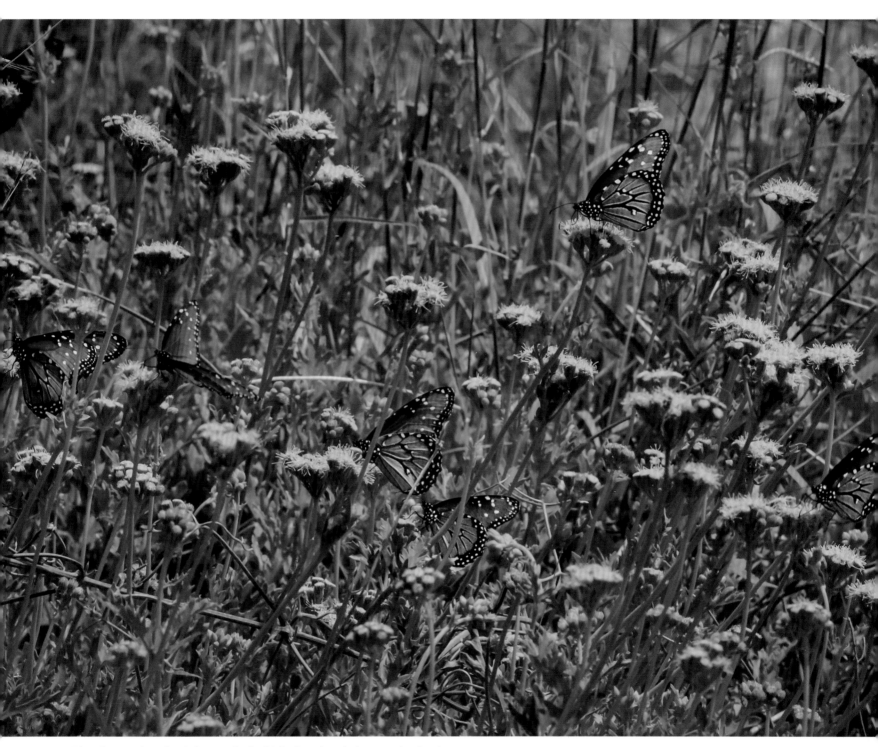

The Rio Grande Valley is known for its high diversity of plants and animals.
Over half of the 750 butterfly species in the United States can be found
here, and Mission, Texas, is home to the National Butterfly Center.

The National Butterfly Center is one of the first places slated for continued border wall construction, which will put approximately two-thirds of its property, including a planned monarch waystation, in a no-man's-land between the wall and the river.

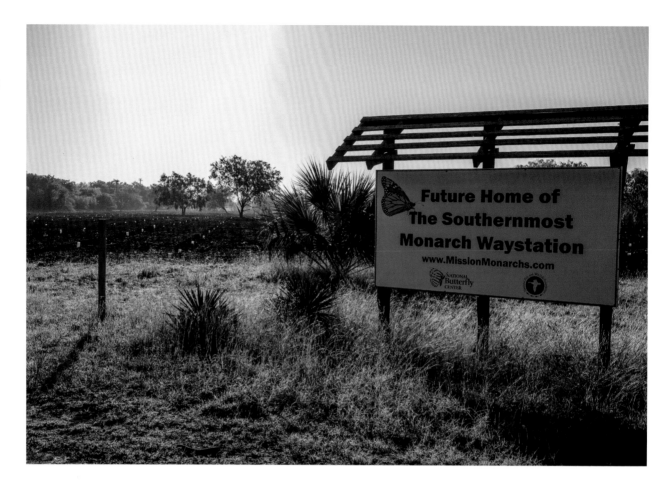

If a border wall is built along the levee that lines the Rio Grande here, it would excise two-thirds of the center's property, effectively placing it into a no-man's-land outside the artificial boundaries of the United States. As Marianna led us down from the levee to the banks of the Rio Grande, it became immediately apparent that the border wall would irreparably harm the healthiest, most vibrant wildlife habitat in the preserve. As we walked along the road, thick, native vegetation grew on either side of us, and every few seconds a butterfly would flit by, offering a riotous burst of color against the lush, green vegetation. Here the Rio was the widest we had seen, and seemed alive with winter bird song. Even after a short visit, I could tell this place was special. The idea of sacrific-

ing it so casually seemed unconscionable.

The National Butterfly Center filed a lawsuit against the Trump administration, demanding that they complete an adequate environmental impact investigation and follow due process. Since encountering the contractors, Marianna has been at the forefront of the struggle, speaking with local lawmakers and community organizers. She explained to us how she felt that this issue had chosen her. As a passionate, confident woman, she has always stuck to her beliefs with great conviction, but this struggle in particular was one she didn't have the option to ignore. This, she told us, was her destiny. As I looked around at my fellow adventurers, her words resonated deeply. We, too, felt compelled to share this story.

OCELOTS

Katy Baldock

distinctly remember the first time I learned about ocelots. I was in a graphic design class at Texas A&M University—not your typical ocelot education setting. For an upcoming project, we each had to choose a troubled species in Texas, create a fictional company or organization that supported conservation efforts for this species, and design a full branding package for that company or organization. As an art student with an interest in wildlife conservation, I was pretty stoked about this project.

That day in class, everyone was presenting information about their chosen animal or plant. I had picked the pronghorn, so I presented my professor and classmates with information about the species and its status in Texas. Another girl in the class did her project on ocelots. When she pulled up photos of ocelots onto the classroom screen, I was immediately intrigued by this incredibly beautiful animal. She showed us photos of their wide, curious eyes and unique spotting and explained their history and situation in Texas. I wanted to know more about them. I wanted to see one in the wild. And I wanted to help protect them. So, about a year later—after I began working as associate producer for the film *The River and the Wall*—when Ben Masters called and asked if I wanted to go to the Texas Zoo in Victoria to take photos of ocelots, of course I couldn't say no.

Ocelots have been listed as an endangered species in Texas since 1972. Historically, they've roamed throughout South Texas and the Southern Edwards Plateau, along the Coastal Plain, and into Louisiana and Arkansas. There have even been a few spotted in Arizona. Worldwide, their population is not an issue. The International Union for Conservation of Nature classified them as a species of "least concern," and large populations inhabit Mexico, Central America, and much of South America. Currently in the United States, however, only an estimated fifty to one hundred ocelots remain. The small population is found only in the South Texas brush and the Lower Rio Grande Valley.

The majority—about 95 percent—of their former habitat in the Valley has been cleared due to industry growth, cities, and agriculture. It just so happens that some of the best soil for farming is also found in some of the best habitat for ocelots. In that area, of the approximately 5 percent of the original vegetation remaining, only about 1 percent is considered optimal habitat for them.

Ocelot kittens normally stay with their mothers for about one year before they are forced out by older, established ocelots in the area to find a new territory. Since the suitable habitat is spread out into small patches throughout the Valley, the ocelots have to cross through a number of human-made dangers to connect the dots. It's during this roaming period when they're transitioning from one habitat to another that they face difficulties.

Wild cats and busy highways don't mix very well, and cars have become the number one cause of ocelot deaths in the United States.

Additionally, as a contiguous wall along the border between the United States and Mexico is a primary focus for the current administration, many biologists fear for the future of ocelot populations in the United States. A barrier between the two countries could make it impossible for the ocelot population in Mexico to breed with the endangered population in the United States, which would result in decreased genetic diversity for the US ocelot population. Some biologists believe extensive development in the Lower Rio Grande Valley has already effectively cut off potential travel corridors for Mexican-American ocelot interactions. A border wall would be the nail in the coffin for naturally occurring genetic exchange.

To get ocelot footage for *The River and the Wall,* Ben sent wildlife videographer Skip Hobbie to shoot video and me to assist with video equipment and take photos. With all the forces acting against Texas ocelots, it was pretty clear that our chances of getting footage of one in the wild were slim. So, we headed to the Texas Zoo in Victoria. Victoria's zoo was hit pretty hard during Hurricane Harvey, and there's still a lot of construction and remodeling going on to make repairs and improvements. But, they have arguably the best ocelot exhibit in the state and an incredibly helpful staff that is dedicated to protecting wildlife.

We met with Jay Jensen, the zoo's curator, once we got to Victoria to go over the plan for the next few days and to check out the exhibit. It was then that we also got a first look at the ocelots.

There are four at the Texas Zoo—Bonnie, Clyde, Obidiah, and Laguna. Obidiah, an older male, spent much of his time sleeping and ignoring our presence. Bonnie, a shy, beautiful female, was smaller than the males and stared at us with an innocent, curious, heart-melting gaze. Laguna, the young kitten of Obidiah and Bonnie named after Laguna Atascosa National Wildlife Refuge, was undoubtedly the cutest. Unfortunately, due to some tail injuries, she was no longer spending time in the enclosure with the rest. But she was well cared for by the zoo staff and was being nursed back to health. Then there was Clyde.

Clyde, Bonnie's brother, was the ocelot we would film and photograph. He was by far the most bold and curious of the bunch, walking up to the cage door each time someone stood on the other side, begging for forehead scratches. He was fierce, playful, and a handsome feline. It was evident from the beginning that he would be the least camera shy.

After getting a good look at the enclosure, we set out to collect items for the shoot. While there are the obvious advantages to shooting at a zoo, such as ease of access and guaranteed exposure to the animal, it still presents some challenges—like the fact that it looks like a zoo. So, to create a more natural look that resembled that of native ocelot habitat, we gathered grasses, tree branches, palmetto leaves, vines, and logs to set up our scene. Skip has lots of experience filming animals in captivity and knew how to set up the habitat and use lights and shadows to create a natural, wild look.

Since ocelots in the wild are normally nocturnal, we filmed after dark. Once the sun started to set, we gathered all the camera gear and Skip prepared to film, tucked into the opposite corner of the habitat we had set up. Jay and Alex, one of the zoo employees, were helping us with the shoot. With Skip in the enclosure and Jay and I out front on the other side of the fence, Alex stayed in the back to let Clyde in and out of the enclosure.

Almost immediately after the door opened,

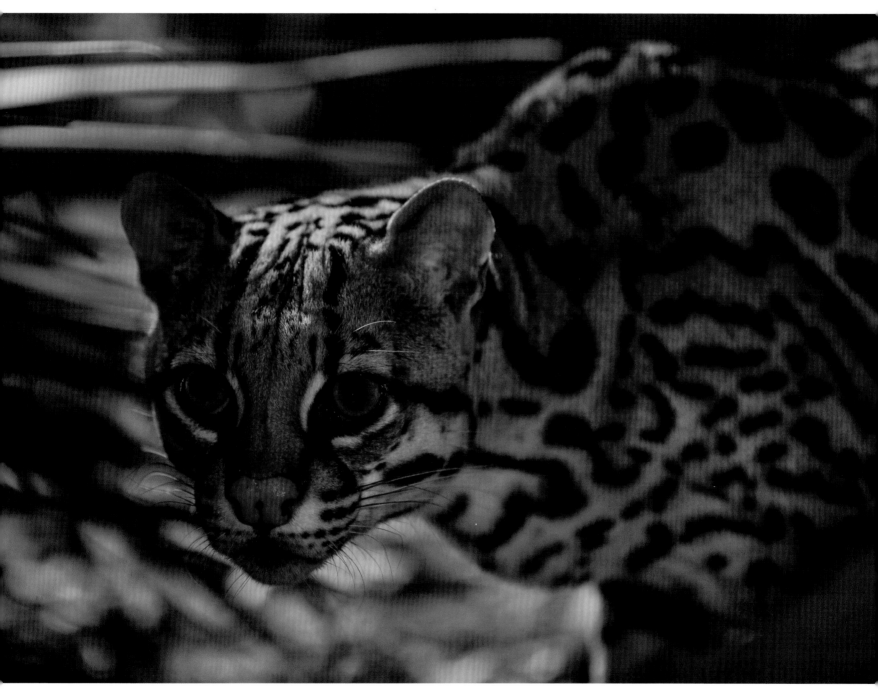

While healthy ocelot populations inhabit Mexico and much of Central and South America, the species has been listed as endangered in Texas for more than forty years. Habitat destruction and difficulty crossing highways contribute to their decline.

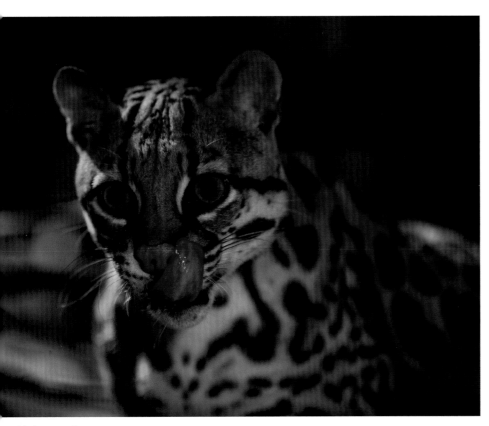

Clyde was the most out-going ocelot at the Texas Zoo.

behavior. I understood the risks and recognized that we were strangers in his territory. I wasn't scared, though. I trusted Jay and Alex, and I was pumped for the rare opportunity to photograph one of these endangered, exotic cats.

We made the transition smoothly, and I got situated with my camera in the little nook of the enclosure. I took a couple test shots to get my settings right, then I started taking photos of Clyde, who took no time getting used to the presence of a new human. It was actually only about a minute before he walked right up to me and was too close for my camera to focus on. My heart was pounding with excitement, and I just sat there and stared at him for a while. He was beautiful. Fierce, but delicate. Confident, but vulnerable. I ended up getting what are now some of my most treasured photos.

While the Texas ocelot story is a sad one, there are projects in place that provide hope for their future. Since 1979, organizations and wildlife lovers have come together in an attempt to establish a wildlife corridor along the Rio Grande in South Texas. The Nature Conservancy, the Lower Rio Grande Valley National Wildlife Refuge, US Fish and Wildlife Service, Texas Parks and Wildlife, and local landowners have their sights set on restoring and protecting native habitat along the border from Falcon Dam to the Gulf of Mexico. Land that either contains suitable habitat or connects to an area of suitable habitat is purchased from willing sellers to be included in the wildlife corridor. Once complete, the Lower Rio Grande Valley National Wildlife Refuge Wildlife Corridor will follow the Rio Grande and link to the southern tip of Laguna Atascosa National Wildlife Refuge just north of Brownsville. Protecting the remaining habitat and establishing corridors that connect these habitats is critical for the future of ocelot populations in Texas.

In addition to a wildlife corridor, the Texas

Clyde walked out and headed straight for the corner with the new habitat—until he spotted Skip. When he noticed a human in his space, he was understandably startled. After a few long, nerve-racking moments of Clyde intensely staring into Skip's soul, he carefully made his way toward the opposite corner to explore the additions to his enclosure. Once he realized Skip was not a threat, he thoroughly enjoyed himself on the stage we had set up. He chewed on the clumps of grass, sniffed around the log, and ate the food Alex had set out.

After a couple hours of Skip filming Clyde, we decided to switch out so I could get some photos. Jay and Alex warned us before the shoot of the potential dangers of working with zoo animals. While they were obviously tamer than their relatives in the wild, they weren't house pets and you couldn't always predict their

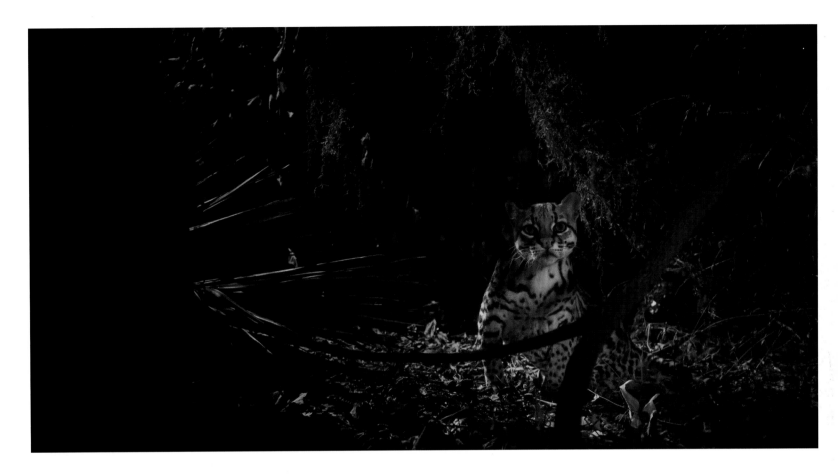

Department of Transportation has built wildlife crossings under some highways in South Texas to combat deaths from cars. So far, the ocelots have not been using these crossings, but some biologists believe they just need time to get used to them.

One of the most powerful contributions to ocelot conservation, however, comes from the efforts of private landowners. Private land donated to the National Wildlife Refuge System, along with landowners' efforts to conserve the habitat on their property, have played a key role in keeping ocelot populations alive in Texas.

The number of organizations and people in the Lower Rio Grande Valley that truly care about wildlife gives me hope for the future of this species and others in Texas. From my time spent in South Texas throughout the making of *The River and the Wall*, I've developed a deep appreciation for the area and all the unique qualities it has to offer. It's obvious that this region's parks, wildlife refuges, employees at the various facilities, private landowners, and local communities take pride in their home place and all the species that inhabit it.

ROMA, CAPTAIN RICHARD KING, AND THE RIVER

Jay Kleberg

Standing atop the cliffs of Roma, staring across the narrow stretch of the Rio Grande into Ciudad Miguel Alemán, I imagined my ancestor Captain Richard King's steamboat, *Colonel Cross*—her wooden bow facing upriver and paddlewheel idle in the shallow, brown water with mules and wagons waiting on the Texas side of the river bank. It would have been 1847 or so, when ships and mule trains were part of a transborder trade route of foreign goods headed upriver to northern Mexico and Mexican products flowing downriver to world markets. During the Civil War, I might have seen bales of cotton being loaded aboard, having traveled overland by wagon from the interior of Texas, destined for the Mexican port of Matamoros where it was exported illegally to manufacturers in Europe. Behind me were remnants of the original wharf with its warehouses, mercantile store, Catholic church, customs house, and residences of river sandstone, limestone, and brick that reflect the Hispanic and Euro-American settlers of the region.

If a border wall were built from Brownsville to El Paso, it would most likely run on the north side of Roma, separating it and the river from the rest of Texas. Roma is similar to many of the small towns along this stretch of river from Laredo to the Gulf of Mexico—founded by immigrants, built on binational trade, and interspersed between military forts constructed in the mid-1800s to keep bands of Comanches and Kiowas from crossing the Rio Grande from Texas and raiding communities in Mexico. Now, more than 170 years later, a second wave of militarization is occurring, except this time it comes in the form of a wall and portends to prevent the illicit transport of goods and people north.

Richard King, my great-great-great-grandfather, was born in New York City on July 10, 1824, to poor immigrant Irish parents. At the age of nine, he was apprenticed to a Manhattan jeweler, but grew bored and at age eleven stowed away on the steamer *Desdemona* destined for Mobile, Alabama. He did not return to New York and stayed in Alabama to later become a riverboat pilot at the age of sixteen.

King came to Brownsville in 1847 at the behest of his partner, Mifflin Kenedy, who, along with King, piloted boats on Florida's Apalachicola and Chattahoochee rivers during the Second Seminole War. They both answered the call of the quartermaster department of the United States Army to captain and pilot some forty-two military steamboats on the Rio Grande between Brazos Santiago Pass, northeast of Brownsville, and Camargo, a Mexican port more than one hundred miles upriver. After the annexation of Texas brought war between the United States and Mexico, Gen.

Zachary Taylor called for steamboats to get his troops and supplies to Camargo to stage what would be a successful siege of Monterrey.

The Mexican-American War brought a new level of commerce to the river and communities along its banks flourished. The Treaty of Guadalupe Hidalgo ended the war in 1848 and established the Rio Grande as the US-Mexico border. The new international boundary launched the foundations for a cross-border flow of illicit trade. Goods previously part of local trade patterns became subject to high tariffs from both countries. In defiance, local communities on both sides of the border developed trade networks outside of the new regulatory framework, a practice that continues today with drugs, human smuggling, guns, and cash, both within and outside of legal ports of entry.

The Treaty of Guadalupe Hidalgo also established the first attempt to secure the southern border in Texas. The treaty obligated the US government to protect northern Mexico from raids across the new international border by South Plains Indian tribes. In October 1849, Brevet Maj. Gen. George M. Brooke, commanding the 8th Military Department at San Antonio, ordered the establishment of a line of forts along the Rio Grande from Brownsville to Eagle Pass and northward from there to the Red River. By 1856, 25 percent of the entire US Army was based in Texas. Our travels by bike, horse, and canoe along the Rio Grande would trace a path through the remnants of some of those efforts—Fort Bliss (1849), Fort Quitman (1859) in far West Texas, and Fort Ringgold (1848) and Fort Brown (1846) along Military Highway in the Lower Rio Grande Valley.

King remained on the border after the war and, along with Kenedy as his partner, established a steamboat enterprise with ships adept at navigating the narrow bends, fast currents and shallow waters of the Rio Grande. King

My great-great-great-grandfather, Richard King, was born to Irish immigrant parents in New York City in 1824, became a riverboat pilot when he was sixteen, and came to Brownsville in 1847. Courtesy King Ranch Archives, King Ranch, Inc., Kingsville, Texas.

and Kenedy's firms dominated trade on the Rio Grande through the mid-1870s. During the Civil War, he and his partners set up operations in Matamoros and flew their ships under the Mexican flag to evade the Union blockade. Under this arrangement, they supplied European markets with Confederate cotton and the Confederacy with beef, horses, imported munitions, medical supplies, clothing, and shoes.

With earnings from his enterprises on the river, King invested in land in Cameron County and then in 1853 purchased 15,500 acres near present-day Kingsville with the intention of raising livestock. King understood trade and markets, but knew nothing of being a cattleman. In 1854, he traveled to the small hamlet of Cruillas in Tamaulipas, Mexico, to purchase cattle. In addition to several drought-starved herds, he recruited more than one hundred

Along with his partner, Mifflin Kenedy, Richard King piloted steamboats along the Rio Grande to transport troops and supplies during the Mexican-American War. King and Kenedy later established a steamboat enterprise that dominated trade on the Rio Grande. National Archives photo no. 92-F-95-19A (American Wests Photographs).

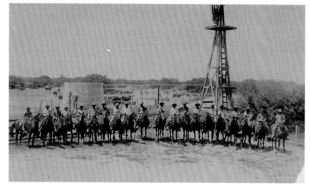

When Richard King purchased cattle in Tamaulipas, Mexico, he also recruited men, women, and children to assist him in working the cattle and maintaining the ranch. These Kineños were critical to the success of the King Ranch. Courtesy King Ranch Archives, King Ranch, Inc., Kingsville, Texas.

In 1852, Richard King purchased 15,500 acres of land near present-day Kingsville to raise livestock, the first step in establishing what would become the King Ranch of Texas. Courtesy King Ranch Archives, King Ranch, Inc., Kingsville, Texas.

men, women, and children to help him establish a working ranch on the banks of the Santa Gertrudis Creek. The Kineños, as they would come to be known, played a critical role in the establishment and success of the King Ranch. Their descendants became my classmates, coworkers, and friends more than 150 years later and have become an inextricable part of a Texas legacy.

The stories of Roma, war and trade on the Lower Rio Grande, and Captain Richard King are grounded in a partnership with Mexico. In 2017 alone, Texas exported $97 billion worth of goods to Mexico. Trade in labor and goods between our countries, both legal and illicit, is centuries old. While the volume and nature of commerce has changed, demand and ingenuity have always remained a constant. Just as historians have debated the effectiveness of stationary forts and increased military presence in Texas in the mid- to late-1800s to control an ever-changing landscape, so too should we question the rationale of utilizing a wall, contrived in the third century, to address the challenges of the twenty-first century.

THE MAQUILADORA

Ben Masters

Disclaimer: I'm not an international trade expert and don't pretend to be. I do have enough common sense, though, to recognize the impact of economics and trade on international immigration and, thus, the border wall. Mexico is the United States' third largest trading partner. And the United States is Mexico's number one trading partner. In 2017, $276.2 billion worth of goods and services went from the United States to Mexico, and $340.3 billion went from Mexico to the United States.

To learn more about international manufacturing and trade across the border, I reached out to Brad Wolfe, general manager of NovaLink Inc., an international maquiladora company with manufacturing facilities in Matamoros and Reynosa, Tamaulipas, Mexico. Brad is a US citizen and sits on the board of the Texas Wildlife Association. He regularly commutes back and forth from Texas to Tamaulipas, and to him, crossing the Rio Grande and the US-Mexico border is akin to crossing the street. When he offered us a tour of his Mexican factory, we quickly accepted.

We hopped into one of our vehicles, drove through customs, and crossed the international bridge at Brownsville, Texas, into Matamoros, Mexico. English billboards and street signs turned to Spanish, the streets narrowed a little bit, and we entered the bustling city of half a million people. I'll be honest, I was a little bit nervous. If you Google Matamoros, you'll find dozens of articles about drug cartels, abductions, and gunfights in the middle of the day. The US Bureau of Diplomatic Security has assessed Matamoros as a security level 4: Do Not Travel. Quotes from their website read, "There are no safe areas in Matamoros due to gunfights, grenade attacks, and kidnappings" and "U.S. citizens remain under constant threat of abduction, robbery, or violent crime." The primary threat stems from violence over territory between rival factions in competing drug cartels. I can only imagine how grateful the Mexican police and Matamoros citizens would be if the American demand for illicit drugs decreased and slowed the funding for cartel violence.

Statistically, a person living in the United States is more likely to die in a car wreck than an individual living in Matamoros is to be killed by the cartels. In Matamoros, I saw a difference between the stereotype and the reality of life along the border. If you judge Matamoros by what pops up first on Google, you'd expect a war zone where you'll likely get your head chopped off and your body parts sold to your relatives. In real life, Matamoros is a typical border city with a fascinating, three-centuries-old history and a strong economy, largely due to the maquiladora industry and international trade.

I don't want to downplay the atrocities committed by the drug-fueled cartel violence, but that isn't what defines border life. Street-

I was surprised to find that they made my Patagonia long johns at the maquiladora in Matamoros, Mexico.

side vendors in Matamoros sell tacos and compete with Little Caesars, Subway, and Church's Chicken fast food joints. There's a municipal park next to the Walmart, and the Home Depot is only a short five-minute drive away. Cartel violence undeniably exists, but so do universities that graduate thousands of law students and engineers annually. Driving through Matamoros and seeing the normal day-to-day lives of people going about their business, I felt my initial anxiety about traveling there dissolve.

When we pulled into the NovaLink factory, Brad greeted us, joined by Luis Muzquiz, the senior vice president of manufacturing operations. Luis is a Mexican national with a big smile, an outgoing personality, and a degree in economics from the University of Texas. The first thing he said to me was, "How do you like your vest?" I looked down at my vest, a Patagonia brand embroidered with the name "Borderlands Research Institute." I told him I liked it. He said, "Good, you'll get to see how they're manufactured today."

Before our tour, Luis and Brad gave us a brief history of maquiladoras and how they operate. A maquiladora in Mexico is a factory that operates under preferential tariff programs where raw materials, assembly components, and equipment enter into Mexico duty free. Products made in Mexico can then be imported into the United States at lower tariffs than other countries. Maquiladoras were first established in the 1960s, but they didn't really take off until the late 1970s, when inflation in Mexico devalued the peso and made outsourcing labor to Mexico attractive to American businesses. When the North American Free Trade Agreement (NAFTA) went into effect in 1994, it further incentivized the maquiladora industry.

For example, the John Deere company assembles their lawnmower and tractor seats at NovaLink Inc. in Matamoros. John Deere transports all the raw material to the NovaLink maquiladora, where factory workers in Mexico sew and stitch the seats. The finished seats are then sent back to the United States where they

are put on riding lawn mowers and tractors and sold across the country. Assembled in the USA. The advantages for John Deere are that the cost of labor is lower in Mexico than in the United States, the factory is closer and easier to travel to compared to China, and the trade agreements between the United States and Mexico allow the maquiladoras to be financially viable. From an environmental standpoint, Luis noted that the carbon footprint of products made in Mexico or partially made in Mexico and sold in the United States is considerably less than products made in China due to the difference in shipping logistics and costs.

As Luis and Brad were explaining their operation from the comfort of the boardroom, I couldn't help but wonder if they were operating a sweat shop, with dismally low wages, long hours, and rotten conditions. I imagined dusty, poorly lit rooms with thousands of people crammed into a tiny space, elbow-to-elbow, sewing for sixteen hours straight. I mentally braced myself for the human rights abuses

I was about to bear witness to, but when we began the factory tour, I was blown away.

They opened the main door, and the first thing that hit me was the enormous size. It was 400,000 square feet, larger than two Walmart Supercenters. It seemed to stretch on forever, and transportation "roads" were painted with yellow lines between the different sections of the maquiladora. It was clean and organized. As we began our walk, I saw many familiar brand names: Cabela's, Land's End, SeaDoo, and even the seats I sit on when flying American Airlines. Brad explained that when an American company decides to use a maquiladora, they typically send company representatives to train the employees of the maquiladora on how to use the company equipment and turn raw materials into products.

NovaLink is considered a shelter company, providing the less expensive labor and business know-how in Mexico so that the United States company makes more money. I couldn't help but ask Brad how he felt about taking jobs away

from Americans and sending them to Mexico. He looked at me kind of stunned and replied, "Would you rather these products be made partly in Mexico and partly in the United States or completely made in China? Manufacturing in the United States is simply too expensive for many businesses to price their products competitively."

I felt a little foolish for asking what seemed to him as a businessperson to be a simplistic question. Then as we made a bend in the factory, I saw a familiar sign: Patagonia. Patagonia is a brand renowned for creating eco-friendly clothing as well as for only using manufacturing facilities that meet strict guidelines for workers' rights. A few dozen workers were sewing clothing, and as we got closer, I noticed they were making the exact same long underwear I'd worn during the entire journey. There were stacks and stacks of Patagonia Capilene Polyester Baselayer long undies! I asked Luis about how they worked with Patagonia, and he replied that they, like many other companies that work with NovaLink, have strict guidelines for workers' conditions. The NovaLink Patagonia factory in Matamoros, for example, is Fair Trade Certified, one of the highest standards for workers' rights. The maquiladora has its own cafeteria for workers, provides benefits to its employees, and pays the baseline factory worker on average three times the Mexican minimum wage.

As we continued our tour, I asked Brad and Luis if the strong rhetoric coming from the United States about building a wall and renegotiating NAFTA had affected their business. They replied that it had. Many companies outsourcing labor in Mexico were concerned that NAFTA renegotiations could potentially hurt business. As a result, some were moving to China and other Asian countries. Luis explained that when those companies did move their manufacturing overseas, it often cost Americans jobs because the product is made exclusively overseas instead of made partially in the United States and partially in Mexico. Brad then noted that the "Build the Wall" rhetoric and hateful speech directed toward Mexico and the border have made many small-to-medium-sized US companies fearful of doing business in maquiladoras. Instead of employing Mexicans at the border to manufacture goods, the jobs are moving to China or Bangladesh or Pakistan, often with a much higher carbon footprint and turnaround time due to the distances and overseas shipping expenses.

During our tour of the factory, a man about my age introduced himself as Ricardo Perez. Ricardo's English was much better than my Spanish, and between the two languages, we discovered we both had a love of horses. He pulled out his cell phone and started scrolling through images of the horses in his life. I pulled out my cell phone and started showing him pictures of my horses. As we debated the positive and negative attributes of different horse breeds, I thought of what Brad said about American businesses pulling out of the maquiladora industry and going overseas.

Although I barely knew Ricardo, I liked his style and felt a common bond because he was a fellow horse lover. I asked him, "What would you do if you lost your job here because an American business pulled out?"

Ricardo thought for a minute, looked at me, and said words I'll never forget, "I don't want to, but I would probably have to move to the United States, work, and send money back to my family. It would be very hard for my family, but I need a job to pay for their school, for the house, and for food."

THE RESPITE CENTER

Hillary Pierce

During the preproduction phase of the film, much of my work consisted of planning logistics and making sure our team had a place to rest each night of the journey. I knew they would be covering long miles through harsh terrain in erratic and unforgiving winter weather. Each night, as their day came to an end, they would need a safe place to land.

If you are familiar with camping on the public lands of the American West, this task may not sound very daunting. But in Texas, a state where only 5 percent of the land is public, nearly every leg of the journey required securing permissions from private landowners to cross and to camp. We would map out our course and estimate each day's likely progress, then we'd make a loose plan for where to stop. Once we had an idea of the route, we would find out who owned the land and, in many cases, make a cold call to ask permission to camp there. This resulted in some unbelievable displays of hospitality.

Big Bend wildlife biologist Raymond Skiles put us up in the legendary town of Langtry after the team canoed twelve days through the Lower Canyons. We traded in the camp stove for a real kitchen and upgraded the Paco Pads for warm beds. Ray was out of town, but in his stead, we were regaled with stories by Keith Bowden, whose Rio Grande paddling memoir, *The Tecate Journals*, laid much of the groundwork for our journey. As a norther blew in

that night, and with the long slog across Lake Amistad waiting in the morning, Ray's home offered a brief respite from the howling winds and lapping waves our crew were sure to face the next day.

The word *respite* is defined as a pause or rest from something difficult or unpleasant. In so many cases, all along the Rio Grande, the team was given respite from the cold journey; they were often greeted with a warm smile and an unexpected welcome from those who live along the border.

When we arrived in McAllen, I surprised the crew with a chance to return the hospitality they had received in such abundance. Our friend Melissa Guerra told us several months before the trip that we absolutely must stop in McAllen to meet Sister Norma Pimentel, a nun with the Missionaries of Jesus and founder of the Catholic Charities of the Rio Grande Valley Humanitarian Respite Center. This center offers immigrants rest, cares for their most basic needs, and offers them guidance as soon as they arrive in the United States. Ben and I went down to the center one day to scout things out and made plans to return the next day to volunteer at the center with the whole crew. We showed up the next morning and went to work making sandwiches, assembling packages of toiletries, and organizing donations of clothing. The friendly volunteer staff of locals and winter Texans who spend their Decembers in McAllen showed us the ropes

and prepared us for the day's new arrivals.

The word *respite* can be traced to the Latin *respectus*, from the verb that means, literally and figuratively, "to turn around to look at" or "to regard." One of the first things our team learned from Sister Norma was to regard everyone who walked through the door with dignity, to recognize his or her humanity and to honor it. The Humanitarian Respite Center is not a shelter but rather a waystation that allows newly arrived asylum seekers and immigrants to shower, eat a hot meal, call their families, and receive guidance on their next steps. As they enter the center, everyone turns around to look toward the door, smiles wide, applauds, and exclaims "¡Bienvenidos!" or "Welcome!" as the tired travelers cross the threshold and catch their breath after a very long journey.

In 2014, Sister Norma noticed an influx of asylum seekers to the Lower Rio Grande Valley from the countries of the Northern Triangle: Guatemala, El Salvador, and Honduras. After being processed by US Customs and Border Protection, they were given a court date and dropped off at the downtown bus station. Realizing that they hadn't yet been given a moment to rest and regroup, Sister Norma founded the Humanitarian Respite Center.

In the United States, seeking asylum is one of the few legal forms of immigration available to Central Americans fleeing violence and persecution. To obtain legal status in the United States as an asylee, one must enter the United States and present him or herself to authorities to be granted asylum. Wall or no wall, these immigrants seek out border patrol agents rather than run from them. Crossing the US-Mexico border is more like crossing the finish line than confronting a climactic obstacle. They are then processed and given a court

Filipe meets a young father from El Salvador at the Rio Grande Valley Humanitarian Respite Center in McAllen.

date. Immigration courts conduct a "credible fear" interview to determine the eligibility of their claim that they will be tortured or persecuted if they return, and they are then passed on to a judge who rules on their status. If given approval, an asylee has the same legal status as a refugee in the United States. Asylees may apply for permanent resident status one year after their grant of asylum. If they meet further requirements after five years of permanent residency, they may be eligible for American citizenship.

When those doors opened that day and the room filled with people, we were overcome with the reality of the situation, confronted head on with the humanity at the root of this topic. Instead of an "illegal alien," we met Joel, a young father in his early thirties who had just arrived from El Salvador. To keep his preteen son out of the grasp of gang recruitment, avoid extortion of his hard-earned salary, and find safety and stability for his family, he and his wife made the decision to come to the United States. Joel and his oldest child came first, and I watched him tell his story to Filipe and Heather as they helped pick out coats to prepare for the cold winter weather of their new home in Iowa.

We also met a young mother of three who had come from Guatemala. Her youngest daughter, just ten days old, had been born along the journey as she was passing through Mexico. She spoke very little Spanish and no English. Absolutely nothing we had endured on our journey from El Paso even remotely compared to the stamina and determination this young woman had exhibited on hers. It was so utterly humbling to imagine crossing similar terrain in harsh conditions, but without gear, support, or provisions, and not only with toddlers in tow, but also after giving birth and continuing without pause. I was absolutely astounded by her determination and the raw maternal love that had brought her so far.

In the eyes of one of the little boys, Austin recognized something familiar. As the child played in the nursery, oblivious to the enormity and complexity of the world he was entering, Austin saw the flash of a familiar face. His older brother, Mynor, was just five years old, the same age as this little guy, when he and his parents crossed the Rio Grande. Born five years later, Austin had never come face to face with the reality of what his family had gone through to bring him to this day. I saw him walk outside

and take a moment to himself to reckon with the weight of the realization.

In those moments at Sister Norma's center, I felt politics, labels, and status fall away, leaving only humans reaching out to one another in a time of need.

A day later, I sat down for an interview with Austin to reflect on the last few days of the journey, and he remarked that sometimes the biggest impact you can have is in your community. I often get overwhelmed by the complexity of fixing our broken immigration policy. But I'm so glad we met Sister Norma and were reminded that the small, simple ways you can show kindness sometimes become the most meaningful impact you can make in the world.

One of the warmest welcomes we got on this trip was from Terrye, the manager at the historic Indian Hot Springs Ranch, who invited us to soak our aching bones in Big Chief Hot Springs after our first few days on the mountain bikes. Near Quemado, Tony and Cathy Castañeda welcomed us into their home and treated us like eight very dirty children of their own. We met Rene Salinas by happenstance at a river overlook in the tiny town of San Ygnacio,

and he invited us to stay at his home with his partner, Christopher Rincon, and daughter, Rosie. I'll never forget the care they showed us, or their adorable puppy, Ladybug, or how they surprised me the next morning with a birthday breakfast complete with a candle-topped muffin. We will always remember Dickie Billeck's enthusiasm for unexpected visitors, Elias Sandoval's patience, and Wack Ezzell's surprise margaritas, and we will treasure all of the memories made with those who welcomed our team with open arms along the way.

This unbridled hospitality was the essence of the whole experience for me. I felt a part of something bigger than myself; I felt accepted and loved; I felt welcomed without question or judgment. I wish that was the feeling every person encountered when setting foot on American soil, no matter what brought them here. I want them to feel dignified, regarded, and free. When it comes to something as complex and heavily debated as immigration reform, I hope we can remember that while we may not have all of the answers, we do have the ability to honor the humanity and dignity in everyone.

MY IMMIGRATION STORY

Geny Alvarado

My maiden name is Maria Geny Gusman Barrios, and I'm the daughter of Hortencia Barrios Barrios and Norberto Gusman Ramos. I was born in Retalhuleu, Guatemala, and when I was three years old, we moved to Guatemala City. When I was eighteen, I met my husband, and when I was nineteen, my first son, Mynor, was born. In order for me to help my family, I worked in a bakery. My shift started at 4:00 a.m. and finished at 8:00 p.m., and I made 300 quetzales (approximately $55) a month.

When Mynor turned three, we began to see that our salaries weren't enough to provide for our family. My husband and I talked, and we agreed that I should go to the United States because I already had siblings there. It was a very painful decision, and it's difficult to think about those times, because I had to leave my three-year-old son behind.

My siblings helped me come to the United States. The entire trip was about fifteen days, coming all the way through Mexico with three other people who traveled with me. We all missed our families so much. When we got to the US-Mexico border, we realized that we didn't have enough money for us to cross. The coyote that we were dealing with got sick and was sent to the hospital. My brother arrived at the hotel where we were staying and gave us food and money to make it back to Guatemala. We took four days to get back to Guatemala;

we didn't run into any problems on the way back. When I got home, I started working again and saving all the money I could so that I could try one more time. I worked really hard for four months, talked with my siblings who were living in the United States, and saved enough money to reach the United States. And I crossed.

I lived in the US for eighteen months. But it was really painful because I had left my three-year-old behind, and even today, I ask myself how could I have done that. I barely slept, and I missed my son so much that I finally decided to go back to Guatemala because I couldn't live without him.

I loved living in the United States. My boss made me feel like I was a valuable woman— they paid me a good salary, and they gave me a lot of love and respect. But, without my son, my life was worthless, so I flew back to Guatemala on Christmas Eve. I was really nervous on the plane because I just wanted to get there and hug and kiss my son. But when I arrived, I got a big and painful surprise: I tried to hug him, but my son didn't know me anymore. Eighteen months is a long time. When I told him that I was his mom, he would say I was lying to him. After a month, though, he finally understood that I was his mom, and I am very grateful to God that we overcame that situation.

Back in Guatemala, I tried to adapt again to my country. I saved a lot of money and started a grocery store. But because the delinquency

was terrible in that area, I got robbed. My entire savings were gone. My relationship with my husband was a bit complicated because I wanted to come back to the United States and he didn't want to leave. Finally, one morning, I was on my way to get merchandise for my grocery store, and I saw buses that had been set on fire because business owners refused to pay some very bad people the protection money they demanded. That day, I told my husband that my family in the United States could help us. It would be me and my son first to go, and I would come and work a lot and then send him money so that he could come. We decided that we would try one more time.

We met a coyote named Liliana. Mynor and I left one morning with Liliana, and we went from Guatemala to Mexico City. We were traveling on the buses as illegals. We had to be quiet

the entire time because if we spoke, people would recognize our accent. When we arrived in Mexico City, we had to wait because Liliana had to get her money, which she was going to receive from my family in the United States. By then, I didn't have any money for food or water or anything, and I remember that Mynor asked me for water because he was really thirsty, but all I could say was "please, son, go to bed. I don't have anything to give you."

We finally got to the hotel in Mexico City. We weren't there for three minutes before immigration came and took us straight to jail. We were in jail for two days. Since I didn't have any money to feed my son, I asked for a job as a cook's helper in order to get some food for him. They said yes, and I started working, but as soon as my shift ended, they told me I couldn't take anything for my son. I remember I was

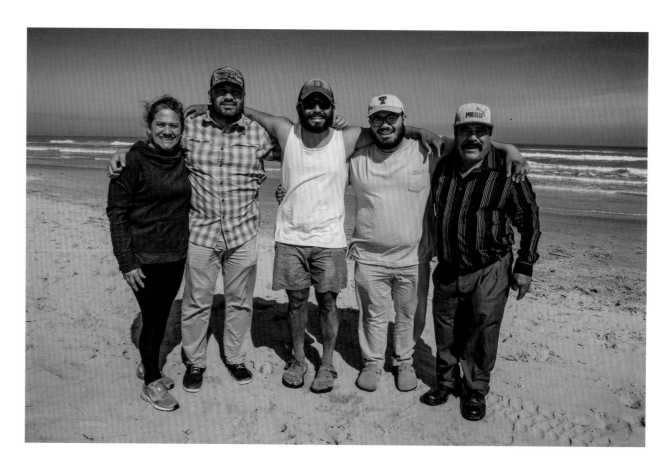

putting some juice cartons away, and when the ladies working there were looking to the other side, I took three tomatoes. When I returned to my son, a woman from El Salvador was watching him and had managed to get food for her kids, and she fed my son as well.

When they finally took us to customs and declaration, I couldn't even talk. My son saw that they asked me my name, and since I was silent, he answered, "Her name is Geny." After giving them our names, they put us on the buses that took us directly to the Guatemala-Mexico border. I was in Guatemala for the next six months, and then I talked to Liliana again. We decided that I was going to go on my own this time, and with all the pain in my heart, I left my son again.

I made my husband swear that I was going to be alone for four to six months at the most, and I would work really hard to send them money so that I could have them here with me. I came by myself to the US, and I started working day and night for five months. During the day, I cleaned houses, and during the night, I watched kids. Finally, I was able to save enough money to bring my husband and son over. We planned the trip in five months. Their trip had a duration of one month, and they arrived one day before Easter. Everything was a miracle to me.

I believe that with God's help and the great opportunities that we have here, we were able to send my sons to the best schools and colleges available. When my husband and my son first came, my husband said that he would be here at most for one year because he didn't want to be far away from his family. Thank

Geny and Austin at the finish line of the journey.

God we have been living here for almost thirty years! God is so big that my two sons, Mynor and Austin, who was born in the United States, have succeeded more than I could have ever imagined—they are great and successful men. The way I think about it, I was tough on my sons, but I would always tell them that we have to be very grateful to God for the opportunity we had to come to a free country and that we all have to work hard, and they had to study hard, to demonstrate that we were worthy of living in the United States. My husband and I work hard, and my sons studied hard at school, and that's the only way we can achieve what we want. I've told my sons that it doesn't matter how big the sacrifice was, it has been worth it and I would do it all over again.

Mynor graduated from St. Edward's University and Austin graduated from Texas A&M University. It was an important day in my life when each son graduated. I pinched myself, just because I could not believe that my sons were graduating. I think it has all been a dream, but thank God all our dreams came true.

THE RIVER'S END

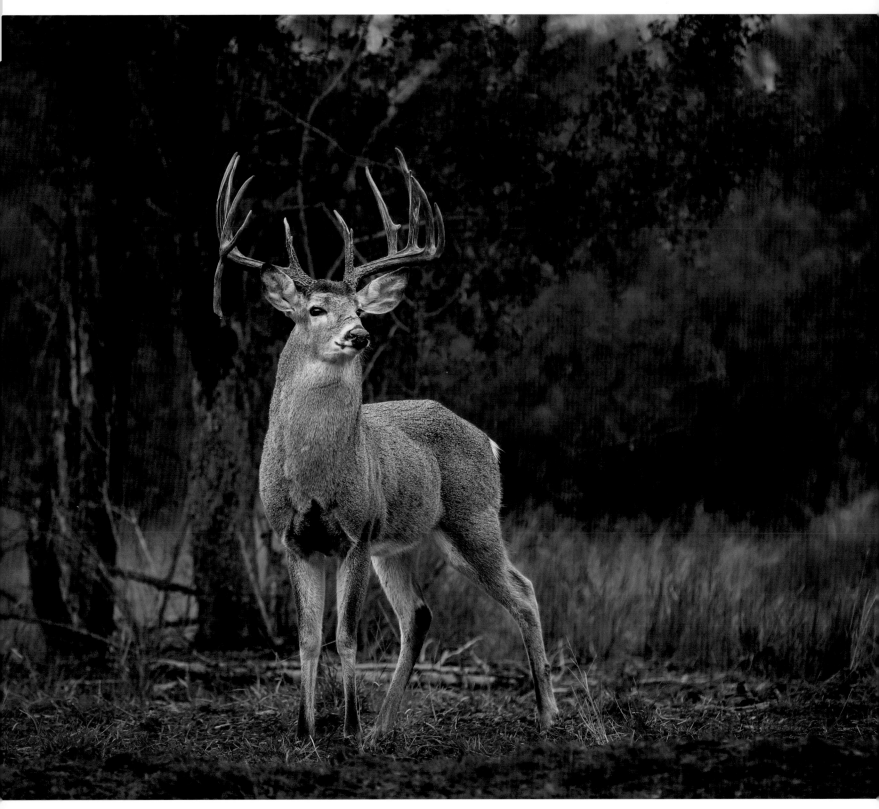

A big old South Texas buck

LOWER RIO GRANDE VALLEY
The Last Stand

Jay Kleberg

A 1927 silent, black and white promotional film titled *The Lure of the Rio Grande Valley* targeted Chicagoans looking for a winter home or agricultural investment property. The film pauses a third of the way into its thirty-minute pitch to show a title card: "This development stands today where there was nothing but desert and jungle ten years ago. The clearing still goes on." What follows are a few frames of dense brush similar to Tamaulipan thornscrub—blackbrush, guajillo, hackberry, honey mesquite, Spanish dagger, cenizo, tasajillo, prickly pear, and granjeno—too thick to see through and, I imagine, uninviting and fear-inducing to just about anyone from Chicago. The next frames show a quarter-acre area being cleared manually of brush by grub hoe and then a tractor and plow forming neat rows of elevated soil in a vast field. What began as a series of Spanish ranching settlements in the 1700s complete with twenty-four villages, fifteen missions, twenty ranches, and almost ninety thousand head of cattle flourished into one of the largest concentrations of irrigated land in Texas by the first part of the twentieth century. Today, it is one of the fastest growing regions in the nation.

The Lower Rio Grande Valley isn't really a valley, it's actually a floodplain that stretches roughly one hundred miles from the east end of Falcon Lake in Starr County to Boca Chica, the Rio Grande's terminus. It was coined the "Magic Valley" by promoters in the early 1900s as the railroad and large-scale private irrigation projects were under development. The 1927 film clearly defined the benefits that propelled agriculture and population development in the region for most of the twentieth century and have, in large part, resulted in the loss of more than 95 percent of the wildlife habitat in the Lower Rio Grande Valley. These benefits, as stated, are, "Just three things—1. The most matchless climate in the United States. 2. The most fertile soil in America. 3. The richest water (for plant food) in the world." The film continues, "Wild game abounds within two hours' ride of any point in the Valley. (These became pets when the land was cleared)" and, "Ducks by the million and no trouble getting your limit."

The Lower Rio Grande Valley is one of the most biologically unique areas in the United States, with much of the flora and fauna found nowhere else north of Mexico. It is considered one of the most species-rich butterfly areas in the United States, with more than 50 percent of recorded butterfly species rarely occurring anywhere else in the country. The state-threatened Texas tortoise can be found in the semidesert shrublands of Cameron and Willacy Counties. The variety of habitat—from thornscrub and coastal prairie to Chihuahuan Desert, sabal

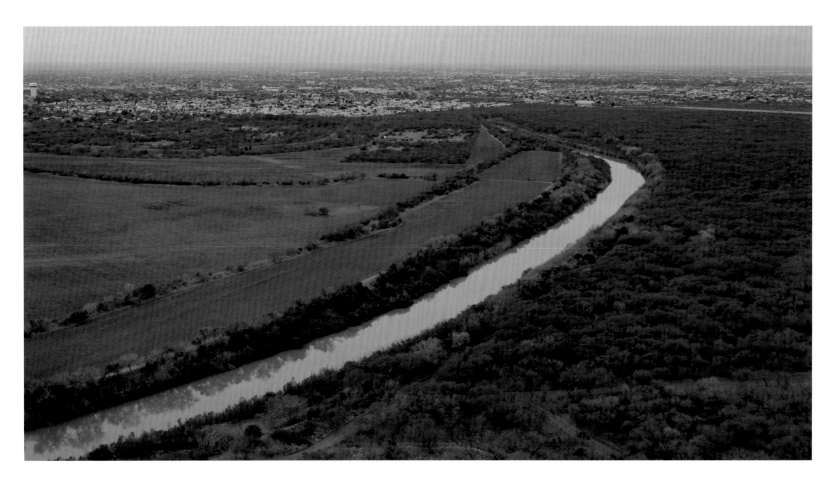

Once an area rich with dense brush and jungle, the Lower Rio Grande Valley is now one of the fastest growing regions in the nation and contains some of the most fertile farmland in North America. It is also a hotspot for illegal immigration and drug smuggling and is at the top of the list for new border wall construction.

palm groves, and subtropical oak forests—makes this a popular stopover for birds migrating along the Central and Mississippi Flyways between wintering areas in Central and South America and breeding areas farther north in the United States and Canada. Despite the loss of native habitat caused by human activity, it remains the richest bird community in the United States.

More than 165,000 nature tourists visit the Lower Rio Grande Valley each year, injecting $463 million into the local economy and sustaining 6,600 jobs, according to a 2011 Texas A&M University study. Starting some fifty years ago, US Fish and Wildlife Service, Texas Parks and Wildlife Department, and other conservation organizations began acquiring native

habitat to create a wildlife corridor that facilitates animal migration and supports plant and animal diversity. Altogether, federal, state, and nonprofit organizations have invested more than $150 million to conserve almost 200,000 acres along the banks of the Lower Rio Grande.

The challenges facing the region are numerous. The population is expected to double by 2050 to as many as three million people. Urbanization will outpace agriculture as the principal cause of habitat loss and fragmentation of native habitats. Modifications along the Rio Grande have vastly changed naturally occurring flood pulse cycles, which have severely modified the river ecosystem. From the time Falcon Dam was completed in 1954 through 2004, the average annual flow of the river past

Brownsville decreased 75 percent. In Santa Ana National Wildlife Refuge, mature bottomland forests are changing from riparian bottomlands that evolved with flooding to habitats able to withstand extended drought periods.

The greatest and most imminent threat to decades of conservation efforts in the Lower Rio Grande Valley is the construction of the border wall. As mitigation for habitat loss from construction of the border fence under the Secure Fence Act of 2006, US Fish and Wildlife Service anticipated $20 million from the US Department of Homeland Security for land acquisition in the Rio Grande sector. By 2014 only $3 million was received and in early 2015, DHS announced that it could not commit to the full $20 million.

Of the 136 miles of border fence constructed in Texas under the Secure Fence Act of 2006, fifty-six miles exist in the Lower Rio Grande Valley. It's an incongruous set of eighteen-foot-high, rusted steel and concrete structures built into the earthen levee crossing. These fence sections run through private irrigated farmland, golf courses, residential neighborhoods, the University of Texas–Rio Grande Valley campus, the Nature Conservancy's Southmost Preserve, several state wildlife management areas, sections of the Lower Rio Grande Valley and Laguna Atascosa National Wildlife Refuges, and Audubon's Sabal Palm Sanctuary. The fence was constructed without regard to more than thirty federal environmental and cultural laws.

In late March 2018, Congress allocated $1.6 billion to border security to include funding for twenty-five more miles of primary pedestrian levee fencing in Hidalgo County and up to eight additional miles of primary pedestrian levee fencing in Starr County. The Trump administration is expected to request an additional $1.6 billion for sixty-five miles of new wall in the Rio

The Lower Rio Grande Valley is one of the most biologically unique areas in the United States and contains critical habitat for resident wildlife, such as the Altamira Oriole and the Texas tortoise, as well as for migrating birds, bats, and butterflies on a continental scale.

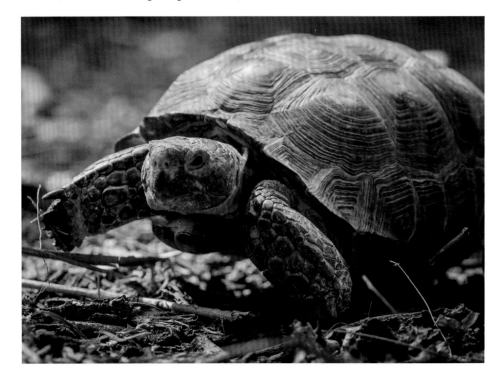

As of August 2018, fifty-six miles of border wall or fence, constructed in 2006 and 2007 during the Secure Fence Act building phase, currently exist in the Lower Rio Grande Valley. The wall is primarily located along a levee that serves as flood control for the Rio Grande.

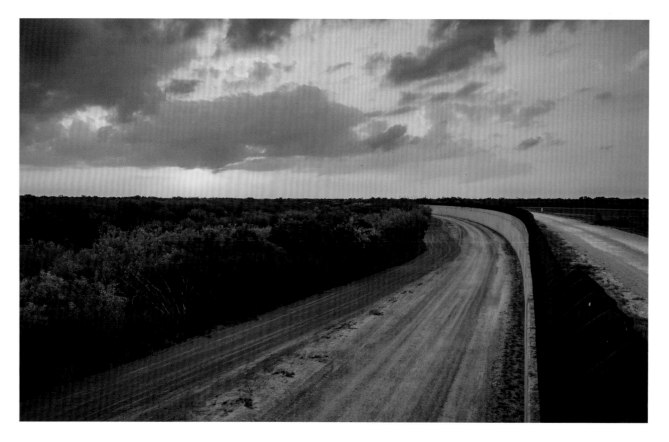

Grande Valley. The barrier, whether it is called a levee fence or border wall, will strand thousands of acres of Texas into a no-man's-land between the river and the wall. It will prevent wildlife and people from being able to access the Rio Grande, the river around which entire communities were built.

In addition to the wall, the Department of Homeland Security plans to create a 150-foot enforcement zone, complete with floodlights, that will accompany new construction. This enforcement zone will require bulldozing through some of the very last of the old growth habitat. There's no guess what the long-term impacts a wall of floodlights could have on North America's most important migratory corridor for bats, butterflies, songbirds, and waterfowl. To slam the last nail in the coffin, a border wall on top of the levees creates a virtual death trap for wildlife during a flood. When a large hurricane hits, the floodwaters of the Rio Grande will rise over the levee and will flow through the steel bollards of the border wall. The terrestrial animals, on the other hand, won't be able to get through or over the wall onto dry ground. They'll be pinned between a wall and a flood, unable to escape.

At 2,088 acres, Santa Ana National Wildlife Refuge, established in 1943, is considered the "crown jewel" of the 560 refuges in the United States. The March 2018 allocation of $1.6 billion to construct new levee fencing in Hidalgo County spared Santa Ana, but it will impact more than 6,500 acres of refuge tracts, state properties, county parks, and private nonprofit nature sites. One of the state parks impacted is Bentsen-Rio Grande Valley State Park, 766 acres of brushy woodlands on the banks of the river.

The park was deeded in 1944 by Elmer and Lloyd Bentsen Sr. to the Texas Parks and Wildlife Department to be used "solely for public park purposes and shall be maintained, operated, known and designated as 'Bentsen-Rio Grande Valley State Park.'"

The park hosts nearly 30,000 visitors annually and is the only entrance to the neighboring Brand Christian Youth camp, which hosts 4,000 visitors a year. The park serves as the headquarters for the World Birding Center, a network of nine sites along the 120 miles of river road from South Padre Island upriver to Roma. A wall constructed on the levee would sever the park's headquarters and visitors' center from the entirety of the native habitat, limiting Texas Parks and Wildlife from providing regular public access. If it were unable to operate the park as the Bentsens intended, a reversion clause requires the return of the property to the Bentsen family. The people of Texas, who only have 2–3 percent of the state available to them as public land, would lose one of its most magnificent state parks.

If construction of the border wall continues as planned, *The Lure of the Rio Grande Valley*'s claim that "wild game abounds within two hours ride of any point in the Valley" will be one less reason to flock to the tropical paradise of South Texas.

If a contiguous border wall were constructed in the Lower Rio Grande Valley, Bentsen–Rio Grande Valley State Park would be walled off into no-man's land. The 766-acre park, which serves as the headquarters for the World Birding Center, would be inaccessible to the public. When the park was donated to the state of Texas by the Bentsen family, they included a reversal clause that if the park was made inaccessible to the public, ownership would revert back to the Bentsen family. Thus, if a wall is built, it is likely that Bentsen–Rio Grande Valley State Park will be lost.

THE FINAL PADDLE

Ben Masters

We ditched our bikes for canoes on the last day of the journey, just ten river miles from the Gulf of Mexico. I wanted to finish on the water, on the Rio Grande, and see where the fresh water turned to salt. I wanted to feel again the sort of freedom I've only felt while paddling the Rio. It's a weird kind of freedom that feels slightly mischievous, like you're getting away with something. You're not really in Mexico, not really in the United States. Identity politics and stereotypes seem to wash away in a current of no-man's-land, where the only laws are natural ones and the Rio Grande seems more like a river and less like a border.

I dipped my hand into the water and tasted it. It was earthy. I couldn't taste the salt yet, nor could I taste the pesticides, herbicides, sewage, and filth that had accumulated during the

We made the decision to paddle the last ten miles of the Rio Grande instead of riding bicycles.

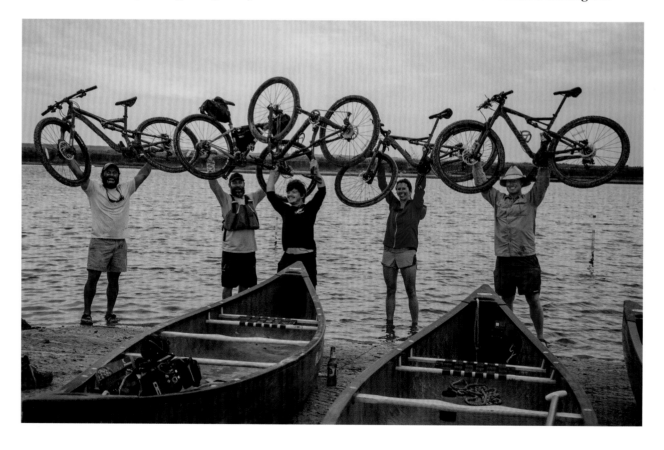

Rio's nineteen hundred–mile journey from its headwaters. I wondered where the water I saw here came from. Colorado dams and irrigation systems use almost all of the Rio Grande before it reaches New Mexico. New Mexico takes every other drop it can get. What little is left to flow to Texas is quickly siphoned off to satiate the thirst of pecan orchards and the booming metropolises of El Paso and Juarez. But maybe a drop of water got through? Maybe there was a drop or two that made it all the way from the headwaters? Probably not. To most people and politicians, the Rio Grande is just a border, a division between the United States and Mexico, and the topic of minimum environmental flows needed to preserve the ecological integrity of North America's fifth longest river isn't one that enters into most border conversations.

I kicked off from shore and propelled my canoe into a gentle headwind. I could smell the Gulf. My paddle felt the bottom of the Rio, and it blew my mind that less than a century ago there was so much water in the river that steamships and schools of tarpon regularly traveled this same waterway. But I was grateful for the water we did have. Some years, the Rio Grande doesn't reach the Gulf of Mexico at all; instead of a river dumping into the sea, a sandbar fills the river's mouth, and a border patrol truck is parked squarely at the terminus. To that agent, the Rio is definitely a border before it is a river.

I think about the border patrol agents a lot. They put their boots on their feet one at a time every morning, just like I do. They put on their green hats, step into green striped vehicles, and spend their time attempting to catch drug smugglers, terrorists, and immigrants sneaking into the country. I wonder how they feel when they catch a twenty-five-year-old El Salvadoran man fleeing with his five-year-old son because a vicious gang was trying to recruit his children. Do they get excited when they make a big drug bust? Who do they blame for those drugs? I wonder if they think about the more than eleven million undocumented immigrants currently living in the United States and that, no matter how many people they personally catch, it won't make a difference at a national level. I can't even imagine the pleading, the tears, and the shattering of dreams that border patrol agents have to listen to on a near daily basis. Maybe it rips their hearts out. Maybe it becomes easy to tune out. Maybe they think about an American citizen keeping the job the immigrant would've taken. Maybe they think about all the lives that they save every time they apprehend a load of fentanyl or methamphetamine. I'm not jealous of that job, but I understand the need for it.

During the journey I spoke to as many border patrol agents as I could. They were remarkably nice and helpful. Only one agent was authorized to speak in front of the camera, but I asked a dozen or more other agents if they supported a contiguous, physical wall along the entirety of our southern border. Not a single one said yes. Some agents wanted more wall to fill in gaps in the Lower Rio Grande Valley, but I have not personally met a single person familiar with border security issues who can intelligently give me a data-driven answer to why a contiguous border wall is an effective way to address our immigration challenges.

I understand why people want a barrier in urban areas. If I had dozens of people illegally entering the country by crossing through my neighborhood every week, I would be concerned. But more than six hundred miles of wall are already built in nearly every urban area along the border. That wall went up over a decade ago, and it hasn't yet fixed our immigration system. Building a wall along the

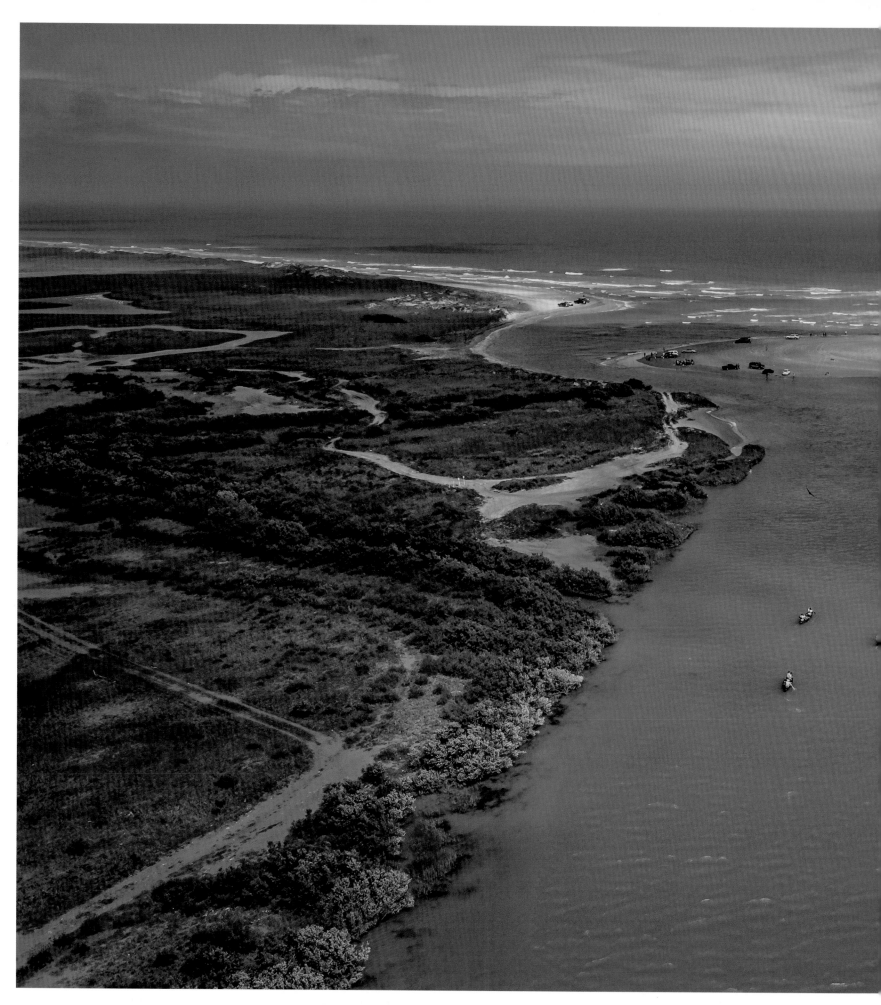

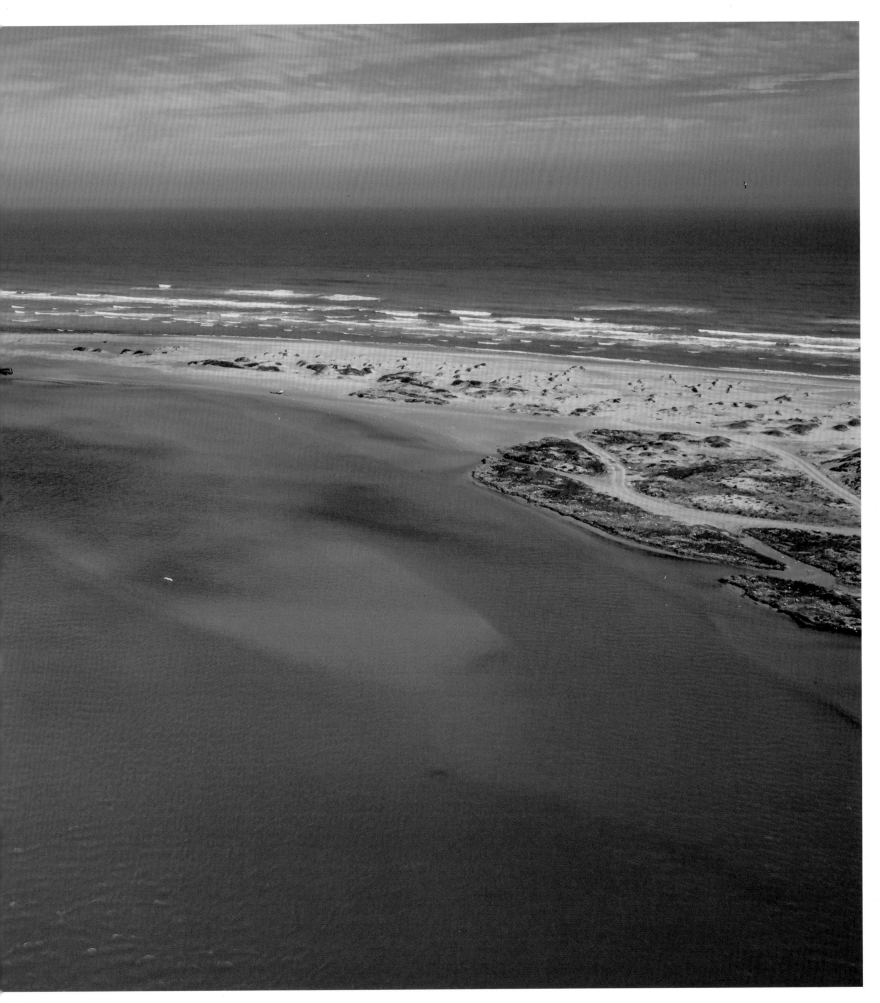

remaining 1,300 miles of border won't fix our immigration system either.

I believe that the "Build the Wall" rhetoric is a distraction from the complexity of the issue—a campaign promise that has done far more harm to achieving realistic immigration reform than it has helped. It gives people false hope for a simple solution, keeps them from looking at the root causes of our immigration problems, and gets in the way of discussing realistic reform. Further construction of a wall simply won't stop people from coming into the United States because there are airplanes, ships, cars, ladders, tunnels, and human ingenuity. With the help of a ladder, I can climb over the existing border wall in less than thirty seconds. Half a minute is what a wall buys. In an urban area, those thirty seconds can mean the difference between apprehending someone or not. But in rural areas, where border patrol response time can be thirty minutes, an hour, or six hours, that thirty-second advantage doesn't really matter. Detection matters, but that can be done with technology that doesn't steal land from thousands of Texans, block access to the only river running through a desert environment, and forever halt the north-south flow of wildlife on a continental scale. We can't wall our way to comprehensive immigration reform. We can't deport our way to it either.

We rounded a bend in the Rio and came across a Mexican fisherman poling his way through the river backward on a repurposed jet ski. I chuckled at the crudity of his craft until I realized he could travel faster by himself on a recycled piece of trash than I could with two paddlers in an $800, fairly new canoe. We hollered at each other through the sea breeze, and he told us the ocean was just a little farther ahead. We dug our paddles a little deeper, each stroke bringing us closer to the Gulf, a little closer to our finish line.

In 2017, Immigration and Customs Enforcement (ICE) deported 226,119 people, approximately 2 percent of the nation's population. During that period, as many or more people illegally entered the United States. There are currently more than eleven million unaccounted for individuals residing in the United States, 75 percent of whom have lived in the United States for more than ten years. These people live in fear of deportation. They don't pay federal income tax. They are often taken advantage of by employers, have little representation and limited benefits, are afraid of calling the cops or 911 in an emergency. They have limited ability to do things that citizens take for granted, things as mundane but necessary as opening a bank account.

Most people would agree that it is not politically or financially feasible to deport more than eleven million people. And if deporting this many people isn't realistic, then that raises the question: Is it better for these individuals to have a realistic path to citizenship or to continue living in the shadows? In the past, US immigration policies have included many large-scale amnesty programs, most recently one by Ronald Reagan in 1986. Critics claim that another large-scale amnesty program would incentivize further illegal immigration and reward lawbreakers for breaking the law. Proponents claim that a large-scale amnesty program would allow those individuals to pay taxes and legally start businesses, benefitting society in general because they would be part of the system. Maybe they're both right?

Put the paddle in the water, lean back, engage the arms, and propel your canoe another few feet forward. I love traveling in nature because it can be so damn simple. The simplicity contrasts so starkly with the complexity of our society's issues. Big problems are hard to understand, harder to fix, and nearly

Salt water never tasted so good.

impossible to communicate in our world of digital media. I think that's why people love the idea of a border wall. It's simple and quite literally concrete. People recognize that our immigration system is broken and they have been sold a simple narrative that building a wall will solve our immigration challenges.

The biggest shame of the whole border wall concept is that no matter where you are on the immigration political spectrum, from open borders to deporting every unauthorized immigrant and allowing no new immigrants into the country, a contiguous border wall isn't going to achieve what you want. Worse, the rhetoric of the border wall and the demeaning of Latin American people by top officials has made the topic of immigration reform so racially and politically charged that it is rarely discussed in a

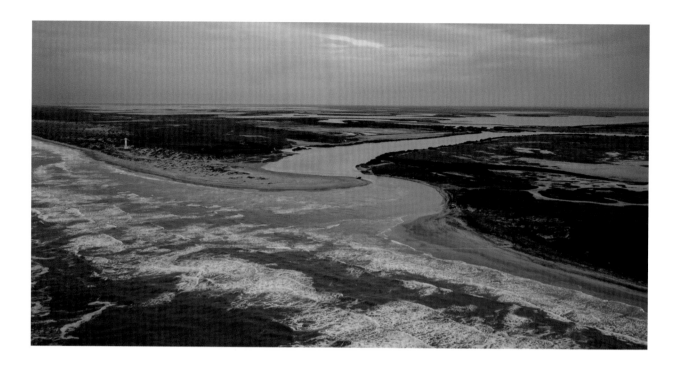

civil manner that seeks compromise, common ground, and a way forward. If the intention of the "Build the Wall" rhetoric was to distract the public from realistic immigration reform in order to preserve the status quo of abundant cheap labor by immigrants who aren't provided insurance, benefits, or representation, then it has been remarkably successful.

"HOWDY!" I shouted to Austin, the river-rat code word for "beer me." He launched a rodeo cold Lone Star through the humid gulf air. It landed in the Rio. When I fished it out and cracked it open, I could taste a slight hint of salt. We were getting close. We rounded a bend in the river and hundreds of redheads, teal, and bufflehead ducks lifted themselves off the brackish water and flew northwest, toward El Paso, where we started two and a half months ago. Like every extended journey I've been on, the last few miles conjured a flashback of where we'd been. But unlike on other journeys, I didn't think about what the Rio Grande looked like today or two hundred years ago nearly as much as I pondered what it will look like one hundred years from now. The journey raised as many questions as it answered.

Will there be an international park symbolizing a renewed friendship between the United States and Mexico? Will the ideals of the United States prevail, or will it become a nation no one wants to immigrate to? Will struggling nations rise to a level of security and prosperity that enables people to find safety and opportunities without crossing borders? Will environmental flows be established to ensure that the Rio Grande always reaches the Gulf of Mexico, or will a booming population finally suck the river dry for good? Will there be a wall?

We heard the sound of waves hitting the beach before we could see them. Hearts raced, muscles pounded, calloused hands gripped familiar oars, and inch by inch, paddle stroke by paddle stroke, a sight we had envisioned in our heads for more than a thousand miles slowly materialized before our eyes. The Gulf of Mexico.

ACKNOWLEDGMENTS

Ben Masters

The book you're holding is the culmination of hard work from hundreds of people who contributed their talents, whether that be writing, copyediting, financing, shuttling canoes, organizing photographs, or any one of the many critical jobs needed to pull off a journey, a movie, and a book. It has been an absolute honor to work alongside such talented and gracious individuals.

First, I have to thank my wife, Katie, for encouraging me to get lost on the Rio Grande for months on end. I love you. Second, I have to thank Shannon Davies and the entire Texas A&M University Press team for breaking book production speed records and for their contributions to the conservation literature of Texas. To Emily, Katie, and Mary Ann especially, my sincerest gratitude for editing me to sound much smarter than I really am. You crushed it. To Gayla and her marketing team, thanks for the partnership in spreading the word about the Rio.

This book wouldn't have happened without my fellow Aggie Katy Baldock, who wrote a chapter, organized all the photos, kept all writers on track, took beautiful photographs, and shepherded this book from beginning to end. My deepest gratitude to producer Hillary Pierce. Thank you for constantly driving the journey, the book, and the film forward. To Austin, Jay, Filipe, and Heather—I couldn't have asked for better traveling partners and contributors. I am so game to do it again.

And my friend Travis Smith, you nailed it on the color! Thank you for bringing the images to their full potential. Kudos to Jacob White and Josh Cross for the stellar maps; they're awesome. And to conservation legend and personal role model Andy Sansom and The Meadows Foundation, thank you for your unending support.

The making of *The River and the Wall* was more than a journey. It was the result of many people coming together—people who believe that the Texas borderlands and its cultures, wildlife, landscapes, and people are something to celebrate. We are deeply indebted to each of you who believed in this project and helped see it to fruition.

Thank you Cindy Meehl for being the first person to throw your hat into the ring. The first step is often the hardest, and your leap of faith allowed us to take it.

Thank you Rod and Nancy Sanders for always bringing fried chicken and for loving wildlife, caring about conservation, and supporting work that will allow generations to know the wonders of this state as we have. More than just generous, you are both so kind, and we have been blessed to welcome you into this important project.

Thank you to Chuck Hedges, Cina Forgason, Tammy and James King, Kristin Oeschger, Myfe E. Moore, Robin Sugg, David Holmes and our friends at Santikos Entertainment, Carl Ryan, Will and Pam Harte, William and Patti Clifford, Lisa and Jesse Womack, and Harris and Lynda Kaffie. Your early and continued support as well as your creative feedback was invaluable.

To the leadership at the Caesar Kleberg Foundation for Wildlife Conservation, Jacob and Terese Hershey Foundation, L'Aiglon Foundation, Hunt Family Foundation, McKee Foundation, Reed Foundation, and the Alice Kleberg Reynolds Foundation, we thank you for your generosity and for trusting us to further your missions with this story.

To Howard G. Buffett and the team at the Howard G. Buffet Foundation, thank you for understanding the urgency of completing this project. We are so grateful for the stellar example you set in your own book *Our 50-State Border Crisis.*

Anne Brown, you are our hero. If we are able to give 1 percent of what you have given to Texas wildlife and habitat, then we would consider our lives well lived. We are honored to have the support of you and the Texas Parks and Wildlife Foundation.

To Stacy Ehrlich, Rebecca Borchers, and Amy Nunn, our sincerest thanks for helping us launch this project.

Chrissy Kleberg, Bob Taylor, and Soo Aldrich, we appreciate you for letting us borrow your loved ones!

Allison Ryan, you win the award for being our most dedicated and present supporter! No matter the event, we knew we could always count on seeing your face in the crowd. Thank you for all you've done for this project and for your friendship.

Our endless thanks to Sister Norma and the staff and volunteers at the Catholic Charities of the Rio Grande Valley Humanitarian Respite Center. Thank you for setting such a perfect example of how to give of your time, your talents, and your love. We are so grateful to have been allowed a window into your work and to participate in the fellowship with you all and the incredibly resilient souls you serve.

To congressional representatives Will Hurd and Beto O'Rourke, thank you for your public service and for taking time out of your busy schedules to speak with us on these important issues.

A la familia Alvarado, gracias por compartir su historia y su hijo con el mundo para este proyecto. Su vulnerabilidad y fuerza nos inspira a todos.

To the friends who helped us prepare for the journey and to those we met along the way who shared their stories and helped us make it all the way to the Gulf of Mexico: Grahame Jones; Mario A. Porras Benavides; Crazy Cat Cyclery; John Sproul; Tony Rancich; Terrye Shirley; Kit Bramblett; Louise O'Connor; Aaron and Britt Stech; Linda Walker; Bill and Lisa Ivey; Daphne Sewing; Jake Dodd and Sarah Kuck; Keith Bowden; Raymond Skiles; Tony and Cathy Castañeda; Dickie Billeck; Jonny Fitzsimons; Wack and Jacob Ezzell; Steve and Linda Lamantia; the friendly staff at La Posada Hotel; Hector Garcia; Voss and Becky Jones; Steve and Lisa Cofoid; Far Flung Outdoor Center; Christopher Rincon, Rene Salinas, and Rosie Salinas; Frank and Debbie Schuster; Susan Kibbe; Melissa Guerra; Marianna Treviño Wright; Tiffany Kersten; Scott Nicol and Stephanie Herwick; Cade Woodward; Brad, Jason, and Scott Wolf; Gerardo Rodriguez and Adriana Contreras Torres; Elias Sandoval; Tracy Roberts at Bicycle World; Mayor Tony Martinez; Dr. Juliet Garcia; Amanda Salas; Mary Margaret McAllen; and Alan Russell.

And to our incredible team: John Aldrich, Alex Winker, Dave Adams, Phill Baribeau, Korey Kaczmarek, Brandon Widener, McKenzie Barney, Lauren Betancur, Collin Bagget, Logan Lewis, and Ethan Forrester, thank you for your grit, your laughter, and your incredible hard work.

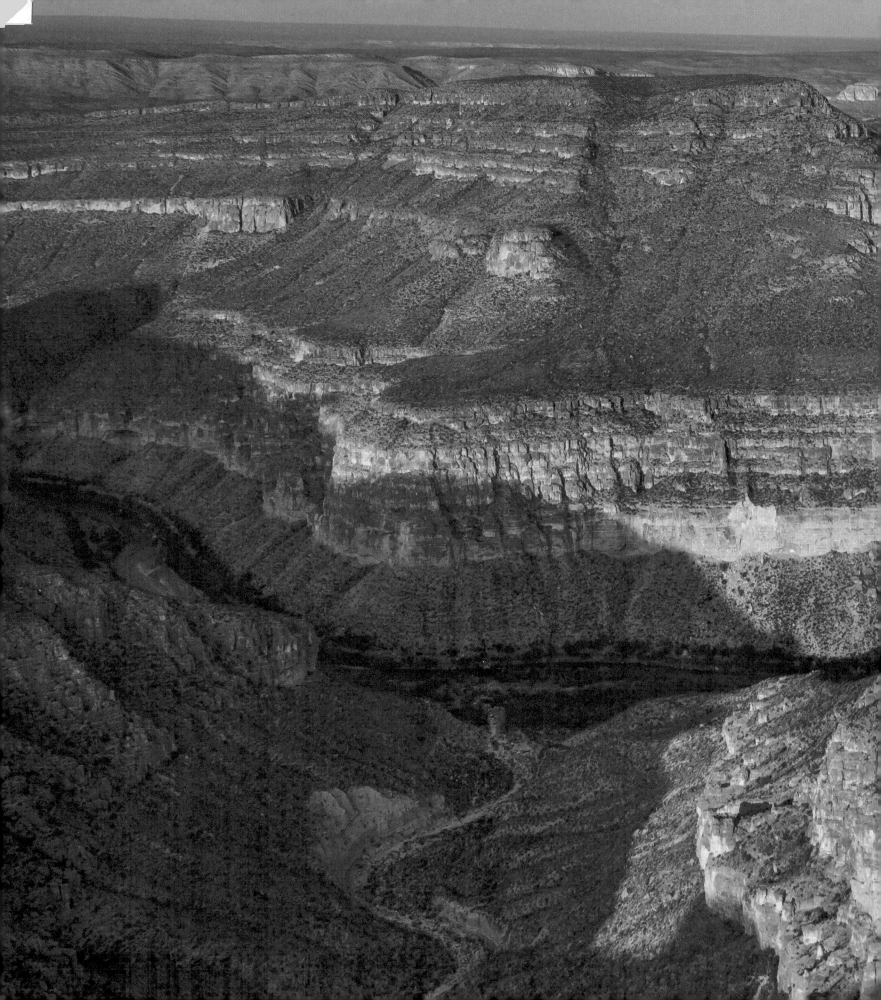